MANET
Peintre-Philosophe

A Study of the Painter's Themes

MANET

Peintre-Philosophe

A Study of the Painter's Themes

George Mauner

The Pennsylvania State University Press

University Park and London

Library of Congress Cataloging in Publication Data

Mauner, George L 1931–
 Manet, "peintre-philosophe".

 Bibliography: p. 187.
 Includes index.
 1. Manet, Édouard, 1832–1883. 2. Painting—Themes,
motives. I. Title.
ND553 . M3M37 759.4 74-31056
ISBN 0-271-01187-4

for Meyer Schapiro

Contents

List of Illustrations

Unless otherwise noted, the works are by Manet and the medium is oil on canvas.

Preface

This book grew out of the need to find an explanation for the peculiarities of composition and figure representation in Manet's paintings. The search led from the paintings themselves into Manet's world, his relationships, the ideas of his friends, the events of his time, and into the makeup of his personality. Consistently, however, it led back to the pictures for confirmation. These were the statements that he presented to his public without further comment. There is reason to believe that he expected from an enlightened spectator, one who shared his time and place, an understanding of a kind more difficult to obtain from us today, although on another level, that of his formal strength, we have the advantage over his contemporaries. He did not, in any event, receive that understanding and this, as Antonin Proust affirmed in his oration at his friend's funeral, was the great disappointment of Manet's life.

Manet was a painter whose work over a period of more than two decades reveals an organic unity not immediately apparent when it is studied in discrete units of time, style, or subject category, and consequently this study is composed of chapters that are particularly interdependent. Of those readers to whom a thematic study of a vigorous and, in many ways, spontaneous painter seems inappropriate, I make what I hope is neither an unusual nor improper request: that they read the book through to the end. A picture of the artist rather different from the familiar one will emerge, and the evidence in support of its authenticity is cumulative, remaining incomplete until the final chapter has been read.

The book has been a long time in the writing. An article in which I presented its central argument was published in 1968.[1] My discussion of *Le Déjeuner sur l'herbe* and *Le Christ aux anges* appeared there in shorter and somewhat different form. Since then, Manet scholarship has progressed at a rapid pace. Simply keeping abreast of the latest publications and incorporating the findings they contain into my text has been a particularly difficult problem. I have referred to

1. "Manet, Baudelaire and the Recurrent Theme," *Perspectives in Literary Symbolism, Yearbook of Comparative Criticism*, ed. J. Strelka (University Park, Pa., 1968), vol. 1, pp. 244–57.

tion,[3] and a great technician without feeling.[4] In short, his positive qualities have been consistently opposed to a series of alleged shortcomings that, if taken seriously, add up to more than enough to damage significantly the reputation of any painter. To his lack of feeling, poor perspective, inept composition, absence of imagination, and marked penchant for plagiarism add an ambitious personality with a longing for official honors, and we are not really left with much to admire in either the man or the artist. Yet we do admire him, and there is hardly a scholar or connoisseur of the art of the nineteenth century who, regardless of personal taste, would hesitate to include Manet among its most important painters.[5]

This importance rests upon his modernity, which, it has been agreed in the past, is expressed in his apparent indifference to subject matter, in his enjoyment of pure painting, in his fresh color and, at times, bright palette, which influenced the Impressionists, in his realization of the visual character of his own time (in a period when this was a common wish but an uncommon achievement), and in his exploitation of the flatness of the picture plane, which establishes him as a forerunner of the Synthetists of the 1890s. For those less concerned with works of art as links in a historical chain (and hence less concerned with the quality of innovation), Manet is simply a superb painter, whose still lifes are the equal of those by Chardin. His "faults," in such a view, although they may be evident, are of no consequence. But to forgive them in this way is gratuitous and does not bring us closer to an understanding of the contradictions in Manet's art. As long as we cannot decide to what extent Manet was being experimental and to what extent the "faults" are intentional breaks with the academic precepts of his time, we will remain unable really to appreciate the degree of his success. So it is that, whereas we admire the flatness of *Olympia*, we still tend to view the spatial ambiguities of the *Déjeuner sur l'herbe* as an example of poor perspective, and the same ambivalence exists in regard to all the perplexing aspects of Manet's painting which, all the while, imposes its stature upon us.

Manet himself, by his words and deeds—transmitted by his friends and supporters, notably Antonin Proust—has contributed substantially to this confusion. Thus the oldest and most persistent of the alleged weaknesses of the painter, his

3. See in particular J. Richardson, *Edouard Manet* (New York and London, 1958), pp. 12–13, 118; A. Perruchot, *La Vie de Manet* (Paris, 1959), pp. 109–10; and M. Florisoone, *Manet* (Monaco, 1947), who articulates all the ramifications of this absence of imagination: "Manet est dépourvu d'imagination; c'est pourquoi il ne sait pas composer. Il manque d'imagination géométrique comme d'imagination poétique, mais il sait voir et il est résolument de son temps" [Manet lacks imagination; that is why he cannot compose. He lacks geometric as well as poetic imagination, but he knows how to look and he is resolutely of his time] (p. xvii).

4. See Paul Colin, *Manet* (Paris, 1937), pp. 13–14; Florisoone, *Manet*, p. xxv; G. H. Hamilton, *Manet and his Critics* (New Haven, 1954), p. 276. Hamilton speaks of the "emotional negation" evident in the *Vieux Musicien*.

5. A resounding exception is Christian Zervos, who found little to admire in Manet's art after having seen the centennial exhibition held in Paris in 1932 ("A propos de Manet," *Cahiers d'art*, nos. 8–10, 1932, p. 309).

lack of imagination, originates with his confession of his need for a model.[6] But we should bear in mind other remarks by the artist, as well as the obvious clues in his work, which inform us of his idea that nature as a constant guide is absolutely essential to assure the viability of the work of art[7] and not, we may assume, primarily to provide the unimaginative painter with a motif. We might ask ourselves, too, why Baudelaire, for whom imagination was the queen of the faculties, would have admired Manet as much as he did, had this faculty actually been lacking in him.[8]

The old clichés have been challenged in recent years. Alan Bowness has suggested that the lack of imagination, at least in the matter of composition, was in reality a search for a new kind of pictorial arrangement and not at all a question of the artist's inability to work within a conventional framework.[9] Nils Sandblad has laid to rest the old notion that Manet was unfeeling, without any interest in subject matter or the newest artistic theories of his time.[10] Meyer Schapiro has long maintained that Manet did not choose his subjects indifferently.[11] Theodore Reff has demonstrated the importance of thematic content in his interpretation of *Olympia* and, further, that far from concerning himself only with technical problems and in addition to drawing only upon the visual attractions of modern life around him, Manet was, in fact, quite capable of producing a kind of emblematic and cryptic symbolism.[12] Beatrice Farwell has refused to accept the *Déjeuner*

6. P. Jamot, G. Wildenstein, M.-L. Bataille, *Manet*, catalogue with an introduction by P. Jamot (Paris, 1932), vol. 1, p. 102.

7. Antonin Proust, *Edouard Manet: Souvenirs* (Paris, 1913), pp. 90–91 (hereafter referred to as "Proust"). This work was originally published in slightly different form as a series in the *Revue Blanche* in 1897.

8. We must, at any rate, distinguish between Baudelaire's particular use of the word "imagination" and its ordinary usage. The poet calls attention to this difference himself, when he cites *The Night Side of Nature* by Mrs. Crowe: "By imagination, I do not simply mean to convey the common notion implied by that much abused word, which is only *fancy*, but the *constructive* imagination, which is a much higher function, and which, in as much as man is made in the likeness of God, bears a distant relation to that sublime power by which the Creator projects, creates, and upholds his universe" (Baudelaire, "Le Salon de 1859," *Oeuvres complètes*, annotated by Y.-G. Le Dantec and Claude Pichois [Paris, 1961]—hereafter referred to as "Baudelaire, *O.C.*"—p. 1040). For Baudelaire, imagination is the faculty that allows for the apprehension of what he called "l'analogie universelle," the obscurely revealed correspondences in a harmonious and unified universe (see *O.C.*, p. 1041, and idem, *Correspondance Générale*, ed. J. Crépet [Paris, 1947], vol. 1, p. 368).

9. Alan Bowness, "A Note on Manet's Compositional Difficulties," *Burlington Magazine* 103 (1961), pp. 276–77.

10. Sandblad, *Manet*; see, in particular, the chapter on *The Execution of Maximilian*.

11. Schapiro has written, "Manet has chosen only themes congenial to him—not simply because they were at hand or because they furnish a particular coloring or light, but rather because they were his world in an overt or symbolic sense and related intimately to his person or outlook" (review of Joseph C. Sloane, *French Painting between the Past and the Present; Artists, Critics, and Traditions, Art Bulletin* 36 [1954], pp. 163–65).

12. Theodore Reff, "The Meaning of Manet's Olympia," *Gazette des Beaux-Arts* 63 (1964), pp. 111–12, and the same author's "The Symbolism of Manet's Frontispiece Etchings," *Burlington Magazine* 104 (1962), pp. 182–87.

sur l'herbe as a subjectless picture and argues for the importance of taking Manet's choice of subject seriously in any attempt to understand his art.[13] Recently, Michael Fried has proposed a theory by means of which Manet's choice of visual sources and the order in which he used them might be explained.[14] It is clear that what we know least about in Manet's art is his content, to what extent it resides in his pure painting and to what extent it is to be found in his overt subject matter. If we make progress in such an investigation, we will then be prepared to inquire into the possible relationship between content and the "faults" of Manet's art and to have a more accurate idea of the nature of the *oeuvre* as a whole.

Joséphin Péladan, in 1884,[15] had spoken of Manet's "irréalisme," and the word was used again in 1947 by Michel Florisoone.[16] More recently, Georges Bataille referred to the "secret" of Manet,[17] another response to the evident enigmatic nature of his art. There is no doubt that when, in an effort to know the man, we compare Manet's paintings with the curiously unsatisfactory chronicles written by his friends—Proust, Zola, Duret, Bazire, and others—we are faced with inconsistencies that lead to the conclusion, difficult as it is to accept in view of the artist's legendary worldliness, that Manet was secretive, that much of what puzzles us was intended to do so, that much of what appears enigmatic is, indeed, rooted in mystery—in short, that Manet cultivated the disturbing character of his pictures. It is not difficult to recognize a mystic temperament in Redon, for example, or in Gauguin, but it is quite another matter in the case of a painter who surrounded his expressionless figures with a wealth of well-painted familiar objects, bathed in an atmosphere and light we all recognize. The word "irréalisme" was meant to convey this "mystère en plein jour," this paradox that greets us in the *Déjeuner sur l'herbe*, *Olympia*, *Le Balcon*, *Le Bar aux Folies-Bergères*, and most of the other major works. It is impossible to resist their silent appeal to probe beneath the surface brilliance of the painting for an understanding of an original, artistic transformation of familiar and timeless ideas. In fact, Manet has explicitly asked us to do so (a matter that will be discussed at the end of this study), and were it not for the tradition of taking a purely formalistic approach to his art, coupled with a fear of robbing him of his modernity, we would have heeded his admonition long ago.

In the matter of Manet's personality, we can make progress only if we correct certain errors that have been too readily accepted and repeated in the literature. There is, for example, the question of his reading habits, a matter that has a direct bearing on our investigation of his themes. Let us consider this point at the outset, for, in addition to lending itself to concise exposition, it may serve also as a model

13. Beatrice Farwell, "A Manet Masterpiece Reconsidered," *Apollo* 78 (1963), pp. 45–51.
14. Fried, "Manet's Sources," passim.
15. Joséphin Péladan, "Le Procédé de Manet," in *Manet reconté par lui-même et par ses amis*, ed. P. Courthion (Geneva, 1953), vol. 2, pp. 145–83. Originally published in *L'Artiste* 54 (1884).
16. Florisoone, *Manet*, p. xxiv.
17. Georges Bataille, *Manet* (New York, 1955), pp. 77–100.

case for the need to reconsider and reorganize even information that has long been available and well known to us.

Manet's biographers have given us the impression that he was not a reader, that his knowledge of literature was slim, and that he cared little for books. Yet even the few bits of information that we have concerning his reading habits are enough to suggest that this impression is, at least to some extent, misleading. They do not prove that Manet read voraciously; nevertheless, they do indicate that he read selectively and with intelligence. Proust himself, who writes that "Manet read little, did not write, but he observed . . . ,"[18] tells us elsewhere that as a schoolboy Manet was engaged in reading Diderot's *Salons*, concealed beneath his desk out of the teacher's view, and that he had made critical comments about it.[19] Proust also quotes Manet's reference to Théophile Gautier's poem "Symphonie en blanc majeur" while strolling along the boulevards during the transformations of Paris in the 1860s, a reference that indicates the painter's thoughtful response to that poem in the light of the visual stimulus of a construction site.[20] Tabarant has told us that Manet, deeply disturbed by a criticism of his art, locked himself for days in his parents' library.[21] We have, furthermore, the evidence of a letter from Mallarmé, in which he refers to Manet's having *reread* the *Confessions* of Rousseau and, again, a clear indication of Manet's appraisal: "Yes," wrote the poet, "you are right. This is a great book." [22] There exists, too, a copy of a letter from Manet written to the publisher Charpentier, whom he evidently knew well, in which he places an order for "the four or five volumes of the Goncourts on the eighteenth century,"[23] as well as another to the author Gonzales, wherein Manet writes, "I read with the greatest interest your famous novel of the *Frères de la Côte*. You are still the master of the genre."[24]

Manet's friends were, in large part, men of letters. We know that he was called upon to illustrate the works of Charles Cros, Mallarmé, Champfleury, Poe, and Armand Renaud;[25] that he himself held a competition among his poet-friends in an effort to find a suitable verse accompaniment for his experimental "Polichinelle" print; and that Baudelaire and Astruc had each written lines of verse in connection with two of Manet's major paintings. If we add the documentary evidence of his actual readings to this already well-known general information, we are obliged to modify our idea of what Manet's literary interests and habits

18. "Manet lisait peu, n'écrivait pas, mais il observait. . . ." (Proust, p. 24.)

19. Ibid., pp. 6–7.

20. Ibid., p. 40.

21. Adolphe Tabarant, *Manet et ses oeuvres* (Paris, 1947), p. 139.

22. "Oui vous avez raison. C'est un fameux livre." (Courthion [ed.], *Manet raconté*, vol. 1, p. 175, and Proust, p. 77.)

23. Cabinet des Estampes of the Bibliothèque Nationale, Paris. See under: "Manet, Don Moreau-Nélaton," box no. 5.

24. "J'ai lu avec le plus grand intérêt votre célèbre roman des frères de la côte. Vous restez le maître du genre." (See note 23 above.)

25. See Marcel Guérin, *L'Oeuvre gravée de Manet* (Paris, 1944), entry nos. 53, 63, 74, 85, and 86.

might have been. Obviously he read and read critically. His writer-friends esteemed not only his painting; they were exceptionally appreciative of his character and personality. And Mallarmé's note is the clearest evidence that he and Manet had discussed literature and that the poet took his painter-friend's opinions seriously.

An awareness of Manet's involvement, as a painter, with philosophical ideas, although helpful in answering many old questions, is not ultimately an indispensable factor in placing him in the first rank among artists. His pictures will always speak directly and eloquently to anyone with a taste for and an experience of great painting. It is our hope only to obtain a clearer picture of Manet's nature, and in this way to arrive at a more satisfactory understanding of the elaboration of his idea of art and the invention of his masterful and enduring style.

2 The Elaboration of an Idea

Le Déjeuner sur l'herbe

The painting *Le Bain*, which shocked Parisian society and its emperor in 1863, has provided us with a conveniently dramatic moment for the birth of modern art. Now familiar as *Le Déjeuner sur l'herbe* (fig. 1), it is honored as a major example of Manet's superb handling of paint and stark objectivity. Its subject, however, although no longer shocking to anyone, still lacks an acceptable interpretation and remains the enigma it has always been. Was it ever possible, despite Zola's well-publicized view,[1] to accept the subject of this picture exclusively as a pretext for pure painting? And is Antonin Proust's recollection that Manet felt the need to enter academic competition with a nude in any way a more adequate explanation of the complexities of the work?[2] No, we are not justified in ignoring the subject[3] or in dismissing it as genre, even if we admit that it is well painted, for a number of insistent reasons: the nude looks at us too intently; the conversational partners appear to ignore one another; and a distant, wading figure refuses to keep her distance and threatens to make a quartet of the foreground trio, whose existence she nevertheless seems to ignore. Undeniably, there is a greater burden put upon the viewer than he has ever been willing to accept, responding to the masterpiece with angry abuse a century ago and confused admiration today. Let us begin our study of the *Déjeuner sur l'herbe* in the customary way, with Proust's account of its origins.

1. In Zola, *Manet* (*O.C., Oeuvres Critiques*, p. 258), we find the following characteristic statement: "S'il assemble plusieurs objets ou plusieurs figures, il est seulement guidé dans son choix par le désir d'obtenir de belles taches, de belles oppositions." [If he brings together several objects or figures, he is guided in his choice only by the wish to achieve beautiful spots, beautiful oppositions.]

2. Proust, p. 43.

3. Beatrice Farwell, "A Manet Masterpiece Reconsidered," *Apollo* 78 (1963), pp. 45–51. Also, Philipp Fehl, "Hidden Genre," *Journal of Aesthetics and Art Criticism* 16 (1957), pp. 153–68, and J. de Mesnil, "'Le Déjeuner sur l'herbe' di Manet ed 'Il Concerto Campestre' di Giorgione," *L'Arte* 37 (1934), pp. 250–57 (see esp. pp. 256–57).

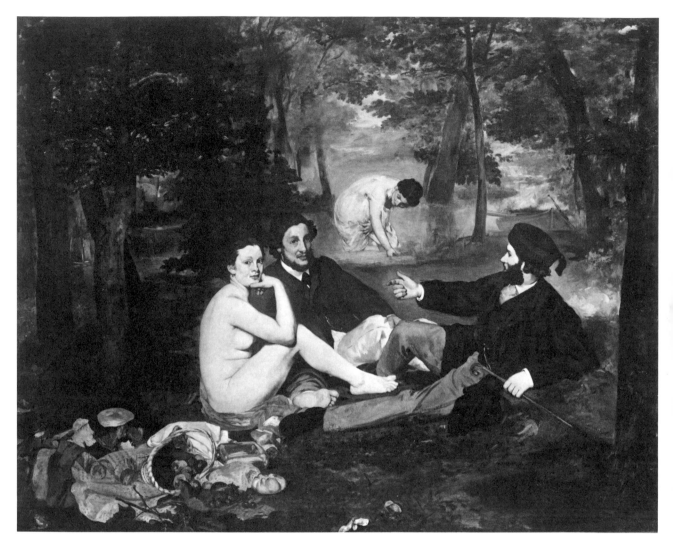

1. *Le Déjeuner sur l'herbe*, 1863, Musée du Louvre, Paris.

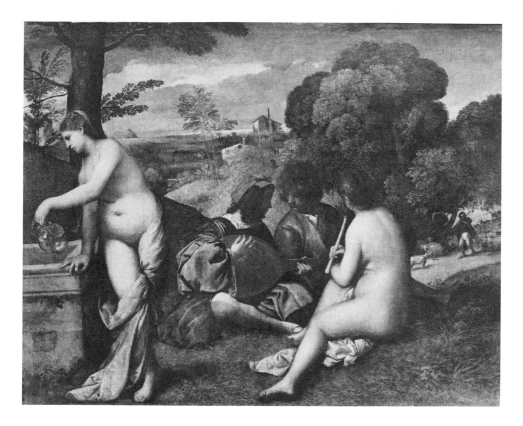

2. Giorgione, *Le Concert Champêtre*, ca. 1508, Musée du Louvre, Paris.

While strolling along the banks of the Seine at Argenteuil with Proust, Manet spoke of Giorgione's *Concert Champêtre* (fig. 2) in the Louvre and expressed his regret that the great work had darkened so much; pointing to a group of women bathing in the river, he voiced his desire to reinterpret the famous picture in the transparency of the atmosphere and with figures such as those in the scene before them.[4] This passage in Proust's memoir of his friend was obviously meant to stress Manet's precocious interest in *plein-airism* and to document his position as fore-runner of the Impressionists. At the same time Proust conveys a sense of Manet's fighting spirit in accepting the challenge implied by the academy to paint a nude, "the beginning and the end of art." But we should ask as well why Manet was specifically attracted to Giorgione's masterpiece. The Venetian's sensual style must have appealed to him, but this alone cannot entirely explain his desire to reinterpret the picture in question. It is, indeed, quite unreasonable to ignore the possible appeal that the subject may have held for him; in that regard, did Manet respond to the overt theme, that of four figures in an idyllic setting, or to

4. Proust, p. 43.

the allegorical one that Giorgione's style only obscurely suggests? Proust is silent on the matter, and it is likely that Manet had said no more about it to him. But if Giorgione's picture is mysterious, the same can certainly be said about Manet's, and if the *Déjeuner sur l'herbe* contains an allegorical subject, we may be sure that Manet intended it to be neither more nor less obscure than that of the old master.

Patricia Egan has demonstrated that the *Concert Champêtre* is an allegory of poetry, of which two types, described as "higher" and "lower," are symbolized.[5] Meyer Schapiro has found the duality of the *Concert Champêtre* embodied in the opposition of the urban and the rustic male figures and their relationship to landscape elements, as well as in the two female types.[6] All four figures are set into a divided landscape, a feature that Panofsky has called the "paysage moralisé."[7] This landscape, furthermore, contains two architectural examples, one rustic and the other formal. While the precise meaning of the double principle in Giorgione's work may long be argued, its simple presence is quickly apparent, and Manet, as we shall see, would have been the first to notice it.

Manet's interest in Giorgione's subject was strong enough to lead him to preserve the same number of figures, two men and two women, and to place three of the figures, two men and a nude woman, together in a social group while setting the second woman apart, as did the Venetian.[8] The latter figure is in both cases associated with water: Giorgione's lady is at the well, while Manet's is wading in the river. Manet has clothed her in a simple, timeless garment, perhaps taking his cue from Giorgione's woman at the well, who is partially draped.

It was recognized in Manet's lifetime[9] (and Gustave Pauli rediscovered it in 1908)[10] that the actual configuration of the group of three seated figures is based on the trio composed of two water gods and a nymph in Marcantonio Raimondi's engraving after Raphael's *Judgment of Paris* (fig. 3). Although this fact is mentioned in every discussion of the *Déjeuner*, no cogent reason has yet been discovered for Manet to have constructed his group of seated figures along the lines of this compositional detail. The arrangement of Giorgione's trio is close enough to that of the group in Raphael's composition to allow us to follow Manet's movement from the one source to the other, and it is by virtue of this movement that we realize the extent to which Manet understood and wished to preserve the relative isolation of one of the figures. Giorgione's woman at the well is the only one who stands and thereby rises higher than the others. She is further emphasized by the tree trunk directly behind her. Manet did not find his fourth figure in the Marcantonio

5. Patricia Egan, "Poesia and the 'Fête Champêtre,'" *Art Bulletin* 41 (1959), pp. 303–13.

6. Meyer Schapiro, "The Apples of Cézanne," *Art News Annual* 34 (1968), p. 38.

7. Erwin Panofsky, *Studies in Iconology* (New York, 1962; 1st ed. Oxford, 1939), p. 64. The author states that such a divided landscape is typical in pictures where "the antithesis between Virtue and Pleasure" is the theme (see also p. 150).

8. This has been recognized by de Mesnil, *"Le Déjeuner,"* p. 250.

9. Ernest Chesneau mentioned the relationship in "Le Salon des Refusés," *L'Art et les artistes modernes en France et en Angleterre* (Paris, 1864), p. 190.

10. Pauli, "Raffael und Manet," *Monatshefte für Kunstwissenschaft* 1 (1908), pp. 53–55.

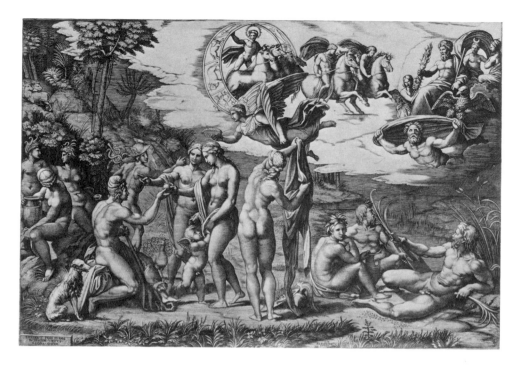

3. Marcantonio Raimondi (after Raphael), *The Judgment of Paris*, ca. 1520, engraving, The Metropolitan Museum of Art, New York, Rogers Fund.

print. He found it elsewhere, as we shall see presently, but for the moment let it suffice to observe that on the basis of the similarities between the two isolated figures noted above, the wading figure suggests that Manet sought an iconographical equivalent for Giorgione's woman at the well. Perhaps it was this figure that most strongly persuaded Manet of the dualism of Giorgione's subject, for, given his familiarity with the old masters and particularly his appreciation of the Venetians fostered by his teacher, Thomas Couture, Manet could not have missed the similarity between the woman at the well by Giorgione and the "sacred" figure in Titian's famous *Sacred and Profane Love* (fig. 4).

Manet, then, was seeking to reconstruct Giorgione's subject with the aid of other classical works of art and in the context of modern life. Why did he turn to the detail from the *Judgment of Paris?* I have already noted the similarity of the aquatic divinities as a group to the three seated figures in the *Concert Champêtre*. The seated nude, although seen from a different angle than Raphael's water nymph, is related to her in pose, and each figure sits on a bit of cloth that is wrapped around one leg. Manet may also have been pleased to find such a related group in which none of the figures meets the gaze of either of the others—a device that, more than any other, lends his own group subjects their air of timelessness. In the classical engraving, the central figure looks up at Zeus's chariot in the sky.

4. Titian, *Sacred and Profane Love*, ca. 1515, Galleria Borghese, Rome.

Since no such chariot appears in Manet's painting, he has changed the direction of the glance of his corresponding figure. He now looks almost, but not quite, at his conversational partner. This approximation of sociability is part of an elaborate and highly structured composition that obliges us to recognize the painter's intention of leading us beyond a genre reading of the subject. With this recognition, we can turn now from the formal relationships between Manet's picture and his source to a consideration of possible thematic ones.

The original title of Manet's picture was *Le Bain*, and Raphael's trio is composed, after all, of two river gods and a nymph. In neither case do the figures in question bathe, but the aquatic theme, in conjunction with a tight classical composition reminiscent of the seated figures in Giorgione's picture, was evidently what Manet sought in his source. In this connection, we might recall the presence of the well in Manet's point of departure, the *Concert Champêtre*.

In the matter of iconography, there is a curious transformation of a detail in Manet's use of Raimondi's print, one that has never, to my knowledge, been pointed out. Immediately to the viewer's left of the seated nymph and behind her back is Athena, one of the three goddesses awaiting Paris's judgment. She is identified by her helmet, which lies on the ground between herself and the seated nymph. Manet has appropriated it for his nude (that is, he has shifted it to Raimondi's adjacent figure, the nymph) by converting it into the stylish hat of his equivalent for that figure, the live model Victorine Meurend. The gesture is witty but, beyond that, it reveals Manet's awareness of the question of attributes in general and of the protagonists of the drama from which he has borrowed only minor characters.

5. Detail of fig. 3.

Finally, there is the drama itself—or, rather, its moral significance—as expressed in the traditional platonic interpretation, fully developed by Sallust[11] in the first century and taken up again in the Renaissance, notably by Ficino[12] and Hadrianus Junius.[13] In all cases, the goddesses represent three ways of life among which the soul (Paris) must choose: the contemplative, the active, and the sensual. It is essentially the same moral problem, in somewhat different form, as the one posed by the theme of sacred and profane love.[14] Sallust's view of the apple as an amalgam of opposites was obviously acceptable to Raphael who placed the hands of Hermes and Hera, hands that point in opposite directions, just above the fateful apple (fig. 5).

11. Edgar Wind finds Sallust's interpretation the most "haunting" of Platonic views of the subject. Sallust saw the golden apple as the universe, "which, as it is made of opposites, is rightly said to be thrown by Strife," and stated that "the soul that lives in accordance with sense-perception (for that is Paris), seeing beauty alone and not the other powers in the universe, says that the apple is Aphrodite's." Wind finds Sallust's interpretation of Paris "irresistibly suggested" in Raphael's design of the subject, itself drawn freely after a Roman sarcophagus. (E. Wind, *Pagan Mysteries in the Renaissance*, rev. ed. [New York, 1968], appendix 7, pp. 270–71, citing from *Concerning the Gods and the Universe*, ed. A. D. Nock [London, 1926], vol. 4, p. 6.)

12. According to Kristeller, "Ficino occasionally uses, as an illustration of the different human attitudes, the traditional scheme of the three forms of life, whose struggle for the soul of man is allegorically expressed in the judgment of Paris. There are three forms of life: the contemplative, the active and the voluptuous. . . ." (The reference is to Ficino's dedicatory letter in the commentary on Plato's *Philebus*.) "The poets called the first Minerva, the second Juno, and the third Venus." (Paul O. Kristeller, *The Philosophy of Marsilio Ficino* [New York, 1943], pp. 357–58.)

13. For Paris, according to this sixteenth-century Dutch commentator, "Three roads were open to the young shepherd: vita contemplativa, vita pratica, vita voluptuaria." (See Ingvar Bergström, *Dutch Still Life Painting in the Seventeenth Century* [New York, 1956], p. 307, n. 4.)

14. Whereas the theme of the Judgment of Paris expresses three possible roads of life, that of sacred and profane love allows only two. It is obvious, however, that the two subjects

In the convenient space within the closed form of Marcantonio's seated group, Manet has inserted the distant wading figure, the second woman demanded by the *Concert Champêtre*. To find Manet's source for this figure (and it seems reasonable to assume that he used one here as he did for the other figures), we would do well to suppose that he had iconographic as well as formal suitability in mind. We have assumed that it was the theme of Giorgione, in a setting of modern life, that interested Manet. He apparently set about finding his arrangement in the classical composition of a related work by Raphael. If the design of the foreground group is Raphael's (and in spite of the modernization of the figures, Manet remains very faithful to their poses and relationship), it is natural to suppose that the wading figure also owes her pose to the same master. And since she is associated with water—as is Giorgione's woman at the well, whom she replaces—we may further guess that it was to an aquatic subject by Raphael that Manet turned. These assumptions substantially limit the amount of material to be investigated; after doing so, it seems clear that Manet's bather derives from the figure of Saint John in Raphael's tapestry cartoon, *The Miraculous Draught of Fishes* (fig. 6).[15] The apostle stands "ankle-deep" in a rowboat and reaches down for the full net, while Manet's bather—separated from the boat that is over at the right—is ankle-deep

are related in that they deal with man's eternal dilemma, and it need not surprise us that Manet made use of this relationship in working from both Giorgione and Raphael. Nevertheless, it is the clearer, more focused form of a direct opposition that Manet chooses as the content of his painting. In so doing, he paralleled the procedure of Ficino, who, according to Kristeller (see note 12 above), in the appendix of the *Philebus* sees the active life as "farthest removed from the goal of man, because of its restlessness . . . and (in so doing) prepares the situation of the *Philebus*, which no longer deals with three, but only with two forms of life." Furthermore, it is clear from the painting itself that Manet does not seem to be making a moral judgment in his presentation of the "two Venuses." Ficino distinguished between the problem of Minerva, the contemplative life, versus Venus, the sensual life, in which the former is preferable, and that of the two Venuses, in which no superiority is stressed. Panofsky (*Studies in Iconology*, pp. 142–43) explains that, in Ficino's circle, love is a "*desiderio di bellezza*," and that this beauty "is spread throughout the universe; but . . . exists chiefly in two forms which are symbolized by the 'Two Venuses' (or 'Twin Venuses,' as they are often called by the Neo-Platonists) discussed in Plato's *Symposium* . . . Venus Coelestis [and] Venus Vulgaris. . . . With Ficino, both Venuses are 'honourable and praiseworthy,' for both pursue the creation of beauty, though each in her own way." This equality, as Panofsky shows, is evident in Titian's painting commonly called *Sacred and Profane Love*: "His figures do not express a contrast between good and evil, but symbolize one principle in two modes of existence. . . ." If a concern for the duality of good and evil enters Manet's art at all, it is never in a moralizing way, but as one manifestation of the universal principle of antithesis, as we shall see.

15. This source was originally proposed in my earlier essay on the *Déjeuner sur l'herbe* ("Manet, Baudelaire, and the Recurrent Theme," *Perspectives in Literary Symbolism*, ed. J. Strelka [University Park, Pa., and London, 1968], pp. 244–57). In his rebuttal to Michael Fried's article "Manet's Sources," Theodore Reff also proposes this figure as a source for the wading woman. However, he does not speculate on the possibility of a thematic relationship between the source and Manet's figure derived from it ("'Manet's Sources': a Critical Evaluation," *Artforum* 8 [1969], pp. 40–48).

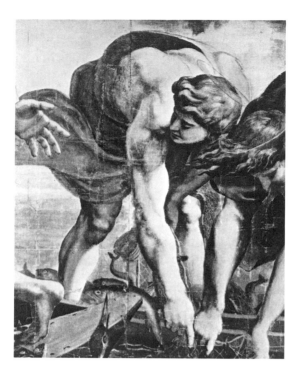

6. Raphael, *The Miraculous Draught of Fishes* (detail), ca. 1515, tapestry cartoon, Victoria and Albert Museum, London.

in the water and plunges her hand into it. It is the *combined* presence of three conditions, formal, iconographic, and methodological, that helps establish this figure as Manet's source: the similarity of pose, the association of the figure with water, and the authorship of Raphael.

It is fitting, furthermore, that Manet should have re-created Giorgione's aloof "spiritual" figure with the aid of a Saint John, the embodiment of sacred love. And it is with the recognition of this Christian source for the wading woman that we become conscious of the fact that a pagan figure by the same master served as the basis of the foreground nude. This unification of the antithetical pair (an antithesis found originally in his sources, to be sure) is but one expression of a fundamental duality of which the particular manifestations are almost inexhaust- ible.[16] It is one formulation, among many, used by Manet's friend Baudelaire:

16. Michelet, in the preface of his *Histoire de France*, dated 8 February 1840, uses Saint John as a similar symbol of the spirit in the dualism, "Deux églises, deux idées: S. Jacques et S. Jean. . . . Contre la *matérialité* de S. Jacques s'élevait à deux pas la *spiritualité* de S. Jean." (cited by P. Berrett, *Le Moyen-âge dans 'La Légende des siècles' et les Sources de Victor Hugo*, Paris, 1911, p. 258).

event (which included the child's mother's "inhuman" response to the tragedy) that he wrote of it, he explains, as it was told him by a painter-friend. Even if we allow for the poet's freedom to alter facts, it is surprising that the story has never been read more critically in an effort to determine better what Baudelaire may actually have known about Manet's artistic intentions. In a key passage, the poet has the painter recall the roles in which he had the boy pose:

> I transformed him sometimes into a little gypsy, sometimes into an angel, sometimes into a mythological cupid. I had him carry the violin of the vagabond, the crown of thorns and the nails of the Passion, and Eros's torch.[27]

The casual tone of the writing, with the repeated use of the word "tantôt," gives the impression of a random listing of traditional characters and obscures the fact that these have been carefully chosen. The two sentences that comprise the description are, in fact, parallel, each referring to three characters given in the same order. The first sentence names them directly, the second lists their respective attributes. Combining each role in the first sentence with its attribute in the second we have: "little gypsy"—"violin of the vagabond"; "angel"—"crown of thorns and the nails of the Passion"; "mythological cupid"—"Eros's torch." The first role is that of the beggar-philosopher, painted several times by Manet and specifically with the violin in the *Vieux Musicien*; the second is the symbol of Christian love, the third that of pagan love.

The nude and the wading woman in the *Déjeuner sur l'herbe* are, as we have seen, borrowed from a pagan and a Christian subject, respectively. The vagabond philosopher, as he had appeared in the earlier *Le Vieux Musicien* and *Le Buveur d'absinthe* (and as he was to reappear in the pictures entitled "Philosophe" of 1865) is absent, it is true. But he is present in another guise, that of the Parisian dandy ("in whom the pretty and the dangerous are blended," wrote Baudelaire),[28] who gesticulates with an aristocratic indifference as he speaks. We have seen that the "near-miss" of the glances of the two men in the painting is a device that, together with the great size of the picture, leads us to suspect a meaning deeper than that suggested by its genre aspect. The same double meaning is conveyed by the gesture of this reclining figure. Even in the context of a face-value interpretation of the subject, the viewer becomes sharply aware of the peculiarity of this gesture, since the two men are not really engaged in conversation. If we suppress the space that lies between the foreground trio and the more distant bather (and this distance, as the picture's detractors have always told us, is difficult to measure in any case), we more readily see that all the figures fall within an arc on the picture plane. This arc is defined by the contours of the figures and just encloses them, as shown in

27. "Je l'ai transformé tantôt en petit bohémien, tantôt en ange, tantôt en amour mytho-logique. Je lui ai fait porter le violon du vagabond, la couronne d'épines et les clous de la Passion, et la torche d'Eros." (Baudelaire, *O.C.*, "La Corde," p. 278.)

28. "En qui le joli et le redoutable se confondent." Baudelaire, *O.C.*, "Le Peintre de la vie moderne," p. 1180.

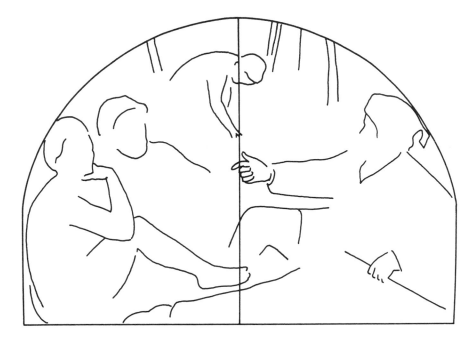

7. Diagram of fig. 1.

the diagram in figure 7. If we draw a vertical line through the center of the arc, we discover that it runs through the middle of the gesturing hand. We find, too, that the bathing figure is at the center and top of that arc. Given the following conditions—the reconstruction of Giorgione's painting from two separate classic designs by Raphael, one a pagan and the other a Christian subject, the collapsed space between foreground trio and distant figure together with a general flattening of the figures, the surface arc achieved by this flattening, and the hand at the center of the arc—we discover the remarkable fact that the hand that appears super- ficially to accompany the inflections of speech actually plays a key coordinating role. The thumb points toward the bather and, when the picture is seen as a surface (a reading made easy for us by Manet), almost touches her hand. The index finger points forward and left toward the seated nude (fig. 8). The hand, a single unit at the center of the design, makes a double indication and gives thematic unity to the more readily apparent formal one. It is instructive to note the way in which Manet has altered the thumb of the hand of his source figure, the river god of Marcantonio's print, in order to achieve his aim (figs. 9 and 10). This kind of calculated transformation had been used earlier by Manet and he was to resort to it again in several works after the *Déjeuner*, as we shall see. The surface arc and the flattening of the figures and the space they occupy can now be seen as purpose- ful devices in the elaboration of a theme, and the creation of a new art that eschews

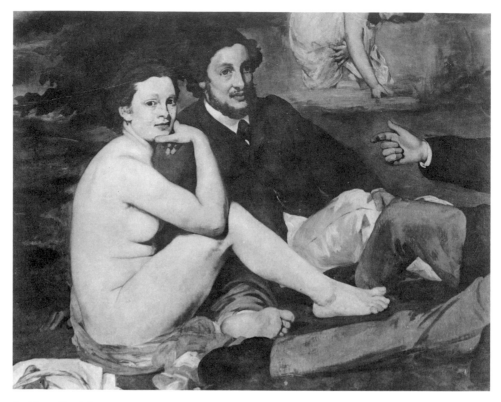

8. Detail of fig. 1.

9. Detail of fig. 3.

10. Detail of fig. 1.

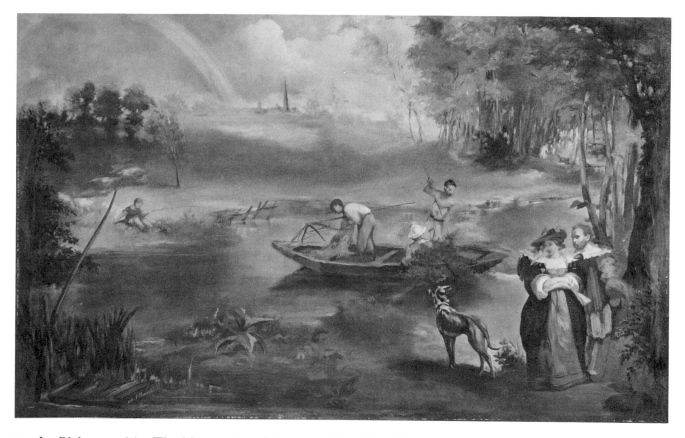

11. *La Pêche*, ca. 1860, The Metropolitan Museum of Art, New York, Bernhard Fund.

trompe l'oeil, an achievement that has long been recognized and appreciated as a discrete stylistic phenomenon.

The wading figure, as noted earlier, was derived from an image of Saint John as a fisherman. The theme of fishing, which may have led Manet to this source, was one that had occupied the painter before his work on the *Déjeuner sur l'herbe*. Manet's painting entitled *La Pêche* (fig. 11), usually dated circa 1860 but possibly closer in time to the *Déjeuner sur l'herbe*, contains, near its center, a fishing boat with a fisherman bent over his nets quite like Raphael's Saint John. The figure is in profile, but were he turned toward the viewer the similarity to the Saint John would be more readily apparent. In a related watercolor Manet does, in fact, turn the fisherman around, and the resemblance is plainer. Nevertheless, this is a general and relatively common pose, and it is quite likely that Manet worked from life and only later found the Raphael figure with which he could combine his direct observation. In the *Déjeuner sur l'herbe* the pose has been preserved, as has the presence of water, but the sex of the figure has changed, in keeping with the demands of the Giorgione painting. But this change from a male to a female figure,

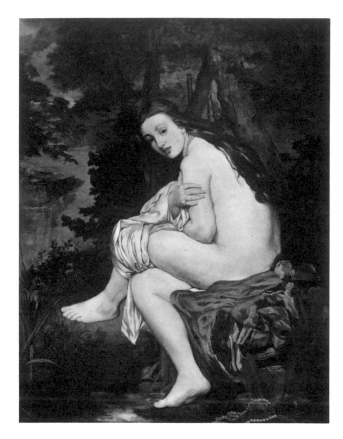

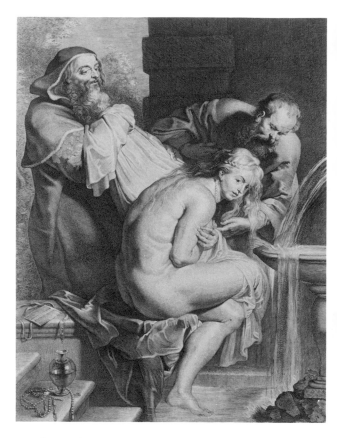

12. *La Nymphe surprise*, 1861,
 Museo Nacional de Bellas Artes,
 Buenos Aires

13. Lucas Vorstermans (after Rubens), *Susanna
 and the Elders*, seventeenth century, engraving,
 The Metropolitan Museum of Art,
 New York, Whittelsey Fund.

and from a fisherman to a bather, reminds us that Manet had also been occupied
with the bathing-figure subject during the two or three years before undertaking
the *Déjeuner sur l'herbe*. The obvious common denominator is the presence of
water, but the pictures may be related in another, thematic way. The first of these
earlier works that comes to mind is the *Nymphe surprise*, of which three versions
exist. The final one shows the cowering nude alone (fig. 12), Manet having removed
the additional figures present in the earlier versions in his habitual quest for
reduction and simplification. Although this figure can be likened to a number of
old master paintings of the bathing nude, Manet's bather is based directly on a
design by Rubens for a *Susanna and the Elders*, known to him in the form of an

engraving by Vorstermans (fig. 13).[29] The model for Manet's *Nymphe surprise*, the real person who struck the pose of Rubens's *Susanna* for him, was another Susanna, Manet's mistress, Suzanne Leenhoff, whom he married two years later. The story of Susanna and the Elders is a favorite parable of virtue, and the person of Susanna the prototype of the chaste woman. That this meaning was both known to Manet and of significance in his choice of subject here is proven by his inclusion of the lily, traditional Christian symbol of purity.[30] The crouching figure, striving to cover her nudity, becomes the incarnation of spiritual love in the more complex *Déjeuner sur l'herbe* of two years later. In that work, Manet has provided her with a suitable garment which she holds shut, while the nude, who has retained Susanna's outward glance, is essentially derived from another set of figures. It has been thought that Suzanne Leenhoff posed for the wading figure in the *Déjeuner*. If physiognomic resemblance is the sole criterion, then there can be no certainty on that point, due to the foreshortening of the head. There is, however, some resemblance in the girth of the figure and the dark hair. Once we have understood the role that the figure is meant to play, however, we can more securely make the identification by means of the *Nymphe surprise*, where the model is unmistakable and wherein she plays an analogous part.

We must here call attention to a curious alteration in Manet's adaptation of the Rubens-Vorstermans *Susanna*. On the whole, what is striking is the degree of fidelity Manet demonstrates in working from the old print, and it is for this reason that his changes have a calculated and purposeful effect. First, there is the replacement of the face of Rubens's model by that of Suzanne Leenhoff. Not quite so obvious, but perhaps equally significant, is the change in the configuration and pose of the left hand. Manet has rearranged this detail (figs. 14 and 15) so that the thumb points directly upward, the device that was later transferred to the "philosopher" in the *Déjeuner sur l'herbe* as he points to the bather, the equivalent of

14. Detail of fig. 12.

15. Detail of fig. 13.

29. See Charles Sterling, "Manet et Rubens," *L'Amour de l'art* 13 (1932), p. 290.

30. See G. Corradini, "'La nymphe surprise' et les rayons X," *Gazette des Beaux-Arts* 54 (1959), pp. 149–54.

this Susanna, placed in a more complex context. We shall, in a subsequent chapter, find still another instance of a similar use of this device, and with a similar intent.

Homage is also paid Rubens in *La Pêche*, wherein Manet is seen at the extreme right with Suzanne, both dressed in seventeenth-century costume, replacing Rubens and his wife in a landscape by that master that served as one of the sources of Manet's picture. The remainder of *La Pêche* derives, as has been demonstrated by Charles Sterling,[31] from another Rubens picture, *Landscape with Rainbow*, in the Louvre. In both cases, the images are reversed, probably because Manet relied on engravings by Bolswert. *La Pêche* is a case of Manet's overt identification

16. Detail of fig. 11.

17. Detail of fig. 11.

31. See Tabarant, *Manet et ses oeuvres*, p. 34, who credits Charles Sterling with having been the first to make this observation.

with an old master and, thanks to the rather obvious transpositions of costume and landscape details, suggests an allegory. Its meaning, however, is still more difficult to discover, and it is only after having made the foregoing observations in regard to the *Déjeuner sur l'herbe* that we can begin to make a few guesses about *La Pêche*. The picture has long been associated with the *Déjeuner*, notably because of the similar landscape setting by the banks of the Seine. But there are more specific and tantalizing similarities. For example, the Rubens-Manet figure, while casually holding his hat in the hand behind the Hélène-Suzanne figure's shoulder, is actually pointing with the sketchily painted index finger of the hand beyond the fisherman in his boat to the opposite shore, where a seated child is also engaged in fishing (fig. 16). This child is framed by a rainbow, itself placed next to a church spire, both details deriving from the second source painting by Rubens. This child, then, takes on a special meaning, which we can only associate with the idea of innocence and purity. The notion gains support from a detail above the strolling figures and in the distance, which has an antithetical quality. There, among the foliage, appears to be a group of seated figures, at least one of which is a nude (fig. 17). Manet points toward the left; the fisherman's boat moves in that direction, and a prominent single reed, rising from the water, also leads us to the child. Finally, on the bottom, also at the left of the painting is a raft, on which Manet has placed his signature. In this work it is Manet himself who indicates the attracting, spiritual embankment. In the *Déjeuner sur l'herbe*, he is replaced by his brother, Gustave, who took the pose of Raphael's river god. [It is, curiously, in the graphic work of Bolswert, whose engravings after Rubens were used by Manet in the creation of *La Pêche*, that we encounter several images in which a figure is made to indicate the above and below of heaven and hell to the viewer (fig. 18), only with the difference that the gestures are what they appear to be, and

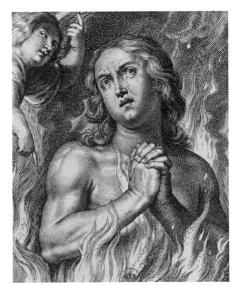

18. S. Bolswert, *Miseremini mei*, seventeenth century, engraving, Cabinet des Estampes, Bibliothèque Nationale, Paris.

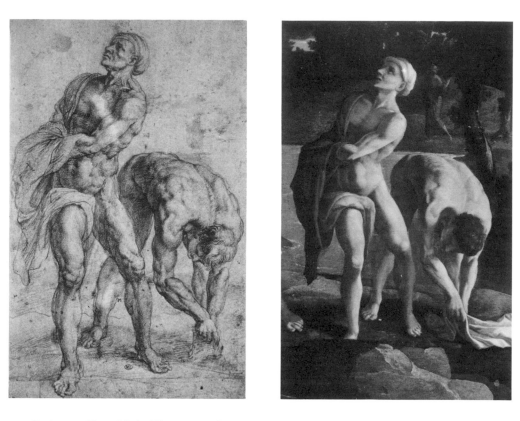

19. Rubens, *Two Male Figures*, early
seventeenth century, drawing, Musée du
Louvre, Paris.

20. Jan van Scorel, *The Baptism of Christ*
(detail), sixteenth century, Frans Hals
Museum, Haarlem.

are not concealed within the attitudes of more mundane behavior, as for Manet
they had to be.] Such disguises as were used in *La Pêche* could no longer be
employed in the modern life of the *Déjeuner*. Rubens, however, must enter our
study of the *Déjeuner sur l'herbe* in still another way. There is in the Louvre a
drawing by this master of two figures, one of whom crouches and turns his head
very much like Raphael's fishing Saint John, but the figure is nude (fig. 19).[32]
Rubens did not, however, borrow the figure from Raphael but, as Julius Held has
shown, from Jan van Scorel (fig. 20), who, in turn, is noted for his copies after
Raphael.[33] If Manet did not know of this earlier history of his source, we have a
remarkable coincidence in the fact that van Scorel used the figure in a composition

32. See Frits Lugt, *Musée du Louvre: Inventaire générale des dessins des écoles du Nord*,
vol. 2 (Paris, 1949). This comparison was suggested in a seminar report by Thomas Waynick.
33. Julius Held, *Rubens, Selected Drawings* (London, 1959), vol. 1, p. 53, and figs. 30 and
31. Charles Blanc (in his *L'Histoire des peintres de toutes les écoles: L'Ecole hollandaise*, vol. 1,

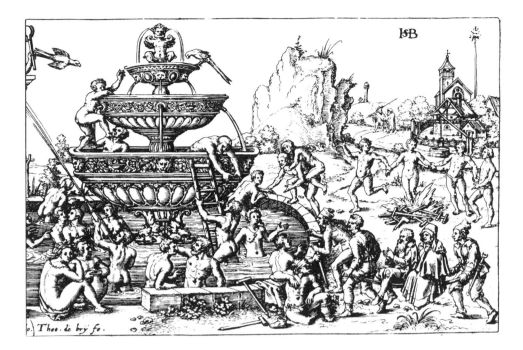

21. Hans Sebald Beham, *The Fountain of Youth*, sixteenth century, engraving,
Cabinet des Estampes, Bibliothèque Nationale, Paris.

representing the *Baptism of Christ*, once again in association with water, here
clearly a symbol of eternal life.

A parallel situation exists in the history of the other woman, the seated nude.
She appears—still in connection with water—in a famous print by Hans Sebald
Beham, *The Fountain of Youth* (fig. 21),[34] which, like the Rubens drawing, could
well have been known to Manet. The remarkable thing is that in each of these
earlier uses of Manet's Raphael-derived figures water is present as an avenue to
immortality; the baptism for the spirit, and the fountain of youth for the flesh.
In order to leave no doubt of his intentions, Manet has supplied each of his "deux
infinies," as Baudelaire called man's double attraction to the celestial and terrestrial
Venuses of *Tannhäuser*,[35] with an appropriate attribute. Above the wading figure,

unpaginated) speaks of van Scorel's "Baptême de S. Jean" and its figures "dans le goût de
Raphael" [in the manner of Raphael]. This volume of Blanc's monumental work was pub-
lished in Paris in 1861. For the importance of Blanc's series of monographs for Manet and
their availability to him before the dates of publication in the volumes, see T. Reff, "Manet
and Blanc's 'Histoire des Peintres,'" *Burlington Magazine* 112 (1970), pp. 456–58.
 34. This remarkable discovery was made by Price Amerson.
 35. Baudelaire, *O.C.*, p. 1224.

22. Detail of fig. 1. 23. Detail of fig. 1.

in the clearing and slightly to the left, he has painted a bird in flight (fig. 22), while beside the shed garments of Victorine Meurend sits a frog (fig. 23). It would, under any circumstances, be natural to assume symbolic roles for these creatures[36] (which have received no attention in the Manet literature). In view of what the structure and the sources tell us of the theme of the *Déjeuner sur l'herbe*, however, there can be no doubt that the bird and frog are here charged with underscoring that theme on an emblematic level, although even these ancient signs for the spirit and the flesh are made to appear plausible within the naturalistic context of the setting. The frog is associated with the shed clothing of the nude, notably with the hat, which, as we have seen, is a clear translation of the helmet attribute of Raphael's Athena. The bird, too, derives from a bird in the Marcantonio print:

36. The frog traditionally represents an attachment to material things. Ferguson, in his *Signs and Symbols in Christian Art* (London, 1961), p. 19, says specifically that the frog "is interpreted as a symbol of those who snatch at life's fleeting pleasures; hence it represents worldly things in general." Johann Gassner (*The Heart of Man* [Harrisburg, Pa., n.d.], p. 10) writes: "The toad [and it is difficult if not impossible to determine whether Manet's creature is actually a frog or a toad] represents avarice, which excites man to strive after earthly goods with insatiable desire." It is perhaps directly relevant that Baudelaire imagined the materialistic side of life symbolized in animal form. He wrote in 1856: "J'ai pensé bien souvent que les bêtes malfaisantes et dégoutantes n'étaient peut-être que la vivification de la vie matérielle, des *mauvaises pensées* de l'homme." [I have often thought that malevolent and disgusting creatures were nothing other than the vivification of material life, of man's evil thoughts.] (*La Corréspondance générale de Charles Baudelaire*, ed. Jacques Crépet [Paris, 1947], vol. 1, p. 370.) It might also be noted that the three demonic creatures at Armageddon described in the *Apocalypse* (XVI: 16) appear in the form of frogs.

The bird, in that it may soar above the earth, is a traditional symbol of the soul or spirit. Herbert Friedmann, in *The Symbolic Goldfinch*, Bollingen Series 7 (Washington, D.C., 1946), p. 7, says of birds in general that they "represent the soul as opposed to the body, the spiritual in contrast to the earthly part."

the eagle, the attribute of Zeus, which hovers in the heavens above the seated water gods below. We hardly need further proof than this judiciously selected and carefully placed pair of creature-symbols of the presence of Manet's underlying philosophical theme.

Manet's use of the flat surface and a two-dimensional reading in order to make significant references to a concealed theme may be a reflection of his interest in Japanese prints and the naïve imagery produced for mass consumption at Epinal and other centers. It also recalls some lines of verse by Théophile Gautier, with whose poetry, as we have seen, Manet was familiar:

> La vie est un plancher qui couvre
> L'abîme de l'éternité;
> Une trappe soudain s'entr'ouvre
> Sous le pécheur épouvanté;
> Le pied lui manque, il tombe, il glisse,
> Que va-t-il trouver? Le ciel bleu
> Ou l'enfer rouge? le supplice
> Ou la palme? Satan ou Dieu?[37]

> [Life is a floor that covers
> The abyss of eternity;
> A trap suddenly half opens
> Under the terrified sinner;
> He loses his footing, he falls, he slips
> What will he find? Blue sky
> Or red hell? Torture
> Or the palm? Satan or God?]

In these lines we find not only the description of the mortal caught between good and evil, but also the description of life as a surface over the profound gulf of eternity. Manet has converted a poetic image into a visual one by a radical innovation in the concept of pictorial space, and we can identify this aspect of his modernism with his desire to convey an ancient theme in the most purely pictorial way possible. Certainly the anecdote has been destroyed in favor of more painterly considerations, but these had never been isolated from the world of ideas, as Zola and more recent writers have maintained.

The interpretation given here of the wading woman as a representation of the spiritual side of man may also be traced to Gautier. In his *Constantinople*, we find the following imagery:

> A mountain lifts its hip from the water, like a nymph resting on the beach after bathing, beautiful, pure, elegant. . . .[38]

37. Théophile Gautier, *Poésies Complètes* (Paris, 1855), p. 343.

38. ". . . Une montagne sortit sa hanche de l'eau, comme une nymphe qui se repose sur le sable apres le bain, belle, pure, elegante. . . ." Théophile Gautier, *Constantinople* (Paris, 1856), p. 34.

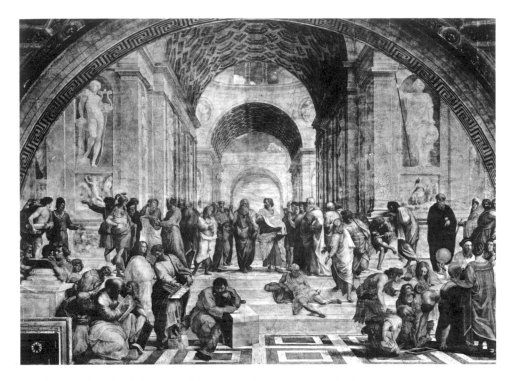

24. Raphael, *The School of Athens*, 1508–11, fresco, Vatican, Rome.

Joseph Lowin has pointed out that the figure emerging from the water purified and divine, is a frequent theme in Gautier's work,[39] and Manet's susceptibility to Gautier's imagery ("Symphonie en blanc majeur") has already been discussed.

Although the *Déjeuner sur l'herbe* began as a reinterpretation of a painting by Giorgione, Manet, as we have seen, looked to the closed, formal design of Raphael for the characters of his composition. The images that Raphael's art gave to the *Déjeuner sur l'herbe* do not, of course, represent Manet's overall theme but are assembled form-idea fragments.[40] This theme is found, however, in a monumental

39. Joseph G. Lowin, "Dreams of Stone: Disengagement and Binding in the Poetic Novels of Théophile Gautier" (Ph.D. dissertation, University of Michigan, 1969), p. 38. See also Constance Gosselin Schick, "The World of Théophile Gautier's Travel Accounts" (Ph.D. dissertation, The Pennsylvania State University, 1973), pp. 135–36.

40. In the letter quoted in note 36 above, Baudelaire also speaks of his old notion of the "forme moulée sur une idée" [form molded on an idea]. Such forms, as we learn from his notebooks, are eternal: "Toute idée est donnée d'une vie immortelle, comme une personne. Toute forme crée, même par l'homme, est immortelle." [Every idea is given an immortal life, like a person. All created forms, even those created by man are immortal.] (*O.C.*, "Mon coeur mis à nu," p. 1298.) It is quite possible that when Manet borrowed single figures or fragments from older works of art in the construction of his larger works, he held just such a view of the form in question.

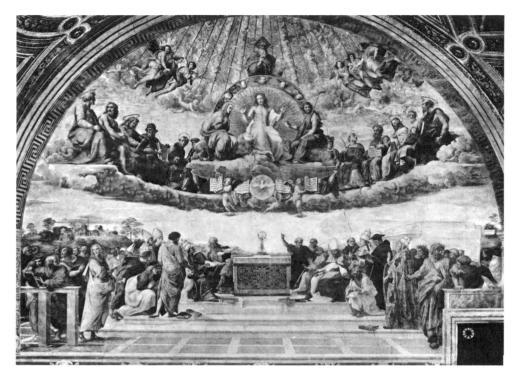

25. Raphael, *La Disputà*, 1508–11, fresco, Vatican, Rome.

work by Raphael: the Stanza della Segnatura, considered as a whole, composed of four great frescoes. These murals have the metaphysical problem of the "above" and the "below" as their central theme. The two major pictures, the *Disputà* and the *School of Athens*, in particular reveal a striving to demonstrate the unification of opposites into a single principle. Under the arc of *The School of Athens* (fig. 24) Raphael, without implying a moral judgment, represents the superior and inferior realms in the persons of Plato and Aristotle, side by side and at the center of the design. Plato points heavenward and carries a copy of the *Timaeus* vertically under his arm. Aristotle extends his hand outward, palm down, parallel to the earth, and with the other hand supports his *Ethics* in a like position against his thigh.[41] In the *Disputà* we have a celestial and an earthly realm in which two figures flank the altar, one pointing to Christ in the heavens above, the other to the monstrance

41. This aspect of Raphael's composition was, of course, similarly interpreted in Manet's time. In his *Histoire des peintres de toutes les écoles: L'Ecole ombrienne*, Charles Blanc expressed it thus: "Que de nuances délicates et pourtant faciles à saisir entre le divin Platon dont la pensée monte au cieux, et le positif Aristote dont la raison n'abandonne point la terre." [What delicate yet understandable nuances between the divine Plato whose thought rises to heaven, and the positive Aristotle, whose reason does not leave the earth.] Although this volume appeared in 1870, the piece on Raphael was available many years earlier (see note 33 above). At any rate, the Platonic-Aristotelian duality was commonplace.

on earth (fig. 25). Within the rectangular format of the *Déjeuner sur l'herbe* Manet has contrived a similar arch (not immediately obvious because it has been displaced to the right side of the composition), at the center of which is the single hand pointing both upward and outward toward the personifications of the same antithetical yet united principles of spirit and matter. Not only were these universally admired frescoes frequently reproduced, but Manet, like all other artists of his time in Paris, could view the full-scale copies of the *Disputà* and the *School of Athens* that were painted for the Ecole des Beaux-Arts in 1845 and 1851 by Raymond and Paul Balze, respectively, and that are still on view today in the great hall of the Ecole Nationale Supérieur d'Architecture.

The *Déjeuner sur l'herbe* reveals Manet's acceptance of Baudelaire's expectations of the painter of modern life, of that master who would interpret his own time in convincing and enduring fashion:

> He [the painter] must sift from fashion what is poetic in the historical, and extract the eternal from the transitory.[42]

And he has also agreed with the poet's belief:

> Modernity is the transitory, the fleeting, the contingent, that half of art whose other half is the eternal and the immutable.[43]

It is now plain that Manet, while continuing to borrow from the old masters and others, turned to painting personally experienced scenes and situations and believed, like Courbet, that for a work of art to be viable it had also to be plausible. But these scenes of modern life (and Manet did not limit himself to these, notably in the religious paintings) are chosen and arranged in such a way as to recall older works of art and, through them, eternal questions of undiminished importance for modern men. It is precisely a matter of discovering the eternal behind the "plane" of modern life.

Baudelaire's essay "Le Peintre de la vie moderne" was completed in 1860, and in it Constantin Guys is singled out as the poet's candidate for that title. Certainly there are indications that Baudelaire saw Guys's limitations, but he seemed to find no serious competition for him at the time, and Guys's character, which also endeared him to Manet, may have swayed Baudelaire in his judgment. In 1858 Manet had not yet painted enough to have convinced even Baudelaire of his full potential. The essay and Baudelaire's ideas on the subject, surely discussed between the two men, undoubtedly affected Manet's future development as a painter. Modernity and its relationship to the eternal is the basis of all his major works of the 1860s, and of many after that. When Manet proclaimed that he had no imagination, he could only have meant that one must be accurate about rendering nature, otherwise it will not yield up its secrets. In other words, the

42. "Il s'agit pour lui, de dégager de la mode ce qu'elle peut contenir de poétique dans l'historique, de tirer l'éternel du transitoire." (Baudelaire, *O.C.*, p. 1163.)

43. "La modernité, c'est le transitoire, le fugitif, le contingent, la moitié de l'art, dont l'autre moitié est l'éternel et l'immuable." (Ibid.)

timeless cannot be apprehended without first experiencing its transitory shell. Thus he railed against history painters and the entire concept of Salon allegory, a literary device misapplied and devoid of the spark of life and the power of truth. There must be a harmony between the inner and the outer aspects of an image for it to resist the ravages of time. Nature cannot be neglected, and, in this respect, Manet again agrees with Baudelaire:

> This transitory, fugitive element whose metamorphoses are so frequent, you do not have the right to scorn it or to do without it. Suppressing it, you fall inevitably into the void of an abstract and undefinable beauty.... It is absurd to substitute another costume for the indispensable costume of a period.[44]

Hence, Manet's exclamation: "There is only one true thing. To paint spontaneously what one sees."[45] But this does not mean that likeness and the first impression were his only concerns, but rather, as stated by Baudelaire, that only by painting what is actually seen and painting it with a full respect for its visual character can the artist touch and make palpable the eternal, "moral" sense of the image in the work of art.

In view of the true character of the *Déjeuner sur l'herbe*, the foregoing affinities of Manet's art with Baudelaire's ideas are obvious. There is, however, a difficulty that must be taken into account, and that is Baudelaire's avowed disapproval of that category of artist known as the "peintre-philosophe." By aligning himself with Raphael in the construction of a philosophical picture, this is exactly the position in which Manet had placed himself. In a short essay published only after the poet's death Baudelaire makes himself clear on the subject: "L'art philosophique," as it is defined by Paul Chenavard and the Germans, is a plastic art destined to replace books; it is a return to the infancy of the human race; it is a monstrosity that has, nevertheless, attracted talented artists. Baudelaire is careful to direct his attack not at the desirability of including philosophical ideas in painting, but at the rationalistic, didactic approach that ignores the innate expressive potential of the medium of painting: "... Overbeck studying beauty in the past only to better teach religion."[46] Elsewhere, however, Baudelaire makes clear that all artists are philosophers. He speaks of himself in this way and, when wishing to address Franz Liszt in as complimentary a fashion as possible, chooses the words "philosophe, poète et artiste."[47] For Baudelaire, then, if the painter is to

44. "Cet élément transitoire, fugitif, dont les métamorphoses sont si fréquentes, vous n'avez pas le droit de le mépriser ou de vous en passer. En le supprimant, vous tomber forcément dans le vide d'une beauté abstraite et indéfinissable.... Si au costume d'une époque qui s'impose nécessairement, vous en substituez un autre, vous faites un contre-sens...." (Ibid., pp. 1163–64.)

45. "Il n'y a qu'une chose de vraie. Faire du premier coup ce qu'on voit." (Proust, p. 30.)

46. "... Overbeck n'étudiant la beauté dans le passé que pour mieux enseigner la religion." Baudelaire, *O.C.*, "L'Art philosophique," p. 1100. This piece, according to Le Dantec and Pichois, was written about 1859.

47. Baudelaire, *O.C.*, "Le Thyrse," p. 285.

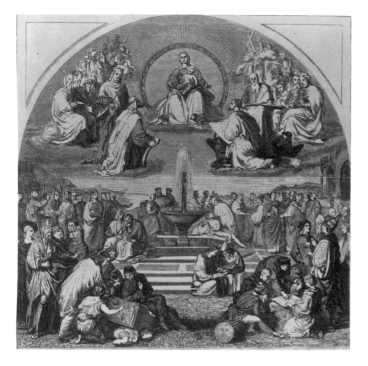

26. Johann Friedrich Overbeck, *La Triomphe de la religion*, engraving after the painting, from the *Gazette des Beaux-Arts*, vol. I (18.

be universal he must be a philosopher, yet he must give expression to this part of himself in a way that does not betray his medium. To appropriate the means of another art form is for Baudelaire a sign of decadence. In short, if the artist is not true to the totality of the constellation of his time, he will produce a work that is false. If, on the other hand, he has no sense of the "moral" and of the eternal meaning within the images that he sees and attempts to reproduce, the work will be fashionable but empty. Manet sought to avoid both pitfalls, not because he blindly believed Baudelaire that this was the case, but because he evidently felt the truth of it himself. His *oeuvre* in all its force and conviction could never have been achieved without this belief.

It is interesting that Baudelaire should have singled out Johann Friedrich Overbeck for criticism. In the first issue of the *Gazette des Beaux-Arts*, in 1859, Overbeck was the subject of a long article by the respectful, if somewhat skeptical, Léon Lagrange. The object of his concern is a painting by the then aged German artist entitled *La Triomphe de la religion* (fig. 26). The painting, reproduced in the article, is a pastiche of Raphael's two great frescoes, the *Disputà* and the *School of Athens*, only it is servile if skillful copying, without a trace of concern for modern life. At the center Overbeck has placed a fountain and explains to the writer that it provides a reflection of the Madonna's face, a reflection that artists since the beginning of Christendom have painted according to their temperaments, for

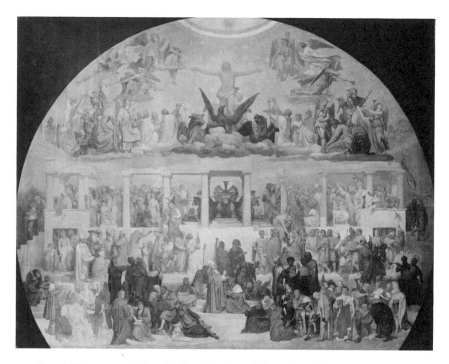

27. Paul Chenavard, *La Palingénésie sociale*, 1848, Musée des Beaux-Arts, Lyon.

which he uses the metaphor of the calm or agitated surface of the water.[48] In all probability, this work (reproduced and discussed the very year of his own essay) was the one that Baudelaire had in mind when he found fault with Overbeck's didactic approach. The French artist whom Baudelaire criticizes for a similarly didactic concept of art is Chenavard. This artist, too, in a major project, *La Palingénésie sociale* (fig. 27), also turned to Raphael's *Disputà* and *School of Athens* frescoes for inspiration. Manet's painting, also calling on Raphael and also using water in symbolic fashion, appears to be an attempt to preserve the idea of the "peintre-philosophe" without slavish quotation or literary allegory, with an awareness of its continued relevance in his own time. It was not unusual for the critics of Manet's day to hold the modern German school up as an example of lofty ideals and meaningful content. We can have no better idea of this situation than by reading the parody of this critical pose in the de Goncourts's novel of 1866,

48. Léon Lagrange, "L'Atelier d'Overbeck," *Gazette des Beaux-Arts* I (1859), pp. 321–35. Lagrange recognized Overbeck's reference to the *Disputà* and the *School of Athens*, and the painter's attempt to convey the beauty of the celestial sphere (symbolized by the Madonna) in its myriad reflections (symbolized by the fountain) in the history of Christian art on earth. The author finds the work unclear, and he concludes that Overbeck is intentionally secretive and speaks of "les voiles épais du mysticism germanique dont il a pris plaisir à l'envelopper" [the thick veils of Germanic mysticism in which he took delight in wrapping it] [the painting].

Manette Salomon. The novel's hero, Coriolis, had just exhibited two works painted with the aim of capturing the spirit of modern life. One of them, like Manet's work in this vein, was a nude. The critic, in the words of the de Goncourts, expressed his offense in the following manner:

> Why didn't he understand that it was almost blasphemous to create a nude, the divine nude, the sacred nude with the nude of a conscript? . . . We cannot help feeling distressed as we realize that it is abroad, in Germany, this land of thought, that a French painter had the unfortunate courage to exhibit such examples of the decadence of our art.[49]

The authors de Goncourt realize, of course, that the tradition of great painting is made up of the accumulation of generations of response to "modern life," and their parody-review reveals their recognition of the lack of this important element in the modern "philosophic" German school. Manet's friend Champfleury, in his novel of 1861, *La Masquérade de la vie parisienne*, compares a group of voluble but inactive French painters to "Les chefs de l'école allemande," who never lift their brushes for fear of weakening their "concept" in giving it material form.[50] Elsewhere in *Manette Salomon*, the de Goncourts speak acidly about the lifeless works of the German Cornelius and the empty "machines" at the Paris Salons. The former are too spiritual and devoid of a sense of life, the latter too coarsely materialistic. Naturally, the polarity of Ingres and Delacroix in utterly simplified form (of which the Goncourts speak) underlies the sharp awareness of the presence in painting of two fundamental, diametrically opposed aspects of human nature.[51] This awareness was directed not only to considerations of style, but to the more obvious realm of subject matter, in which the preoccupation with "modern life" played an important part. In any event, this situation could only have had the effect of making a thoughtful painter such as Manet particularly conscious of the broader philosophical problem of duality itself. His own remark that the proverbially sensual Delacroix's doctrine was "glaciale" echoes Baudelaire's calculated opposition of the painter's passionate nature and cool-headed method, and both remarks reveal the tendency to toy with the possibilities of paradoxical inversions.[52]

49. "Comment n'a-t-il pas compris qu'il y avait presque un blasphème à vouloir faire du nu, du nu divin, du nu sacré, avec le nu d'un conscrit? . . . Nous ne pouvons nous défendre d'une pénible impression, en songeant que c'est devant l'étranger, à l'exposition des grands oeuvres de L'Europe, en face de l'Allemagne, cette terre de la pensée qu'un peintre français a eu le triste courage d'exposer de pareils échantillons de la décadence de notre art." (Jules and Edmond de Goncourt, *Manette Salomon* [Paris, 1897], pp. 331–32; originally published in 1866.)

50. Champfleury (Jules Fleury-Husson), *La Masquérade de la vie parisienne* (Paris, 1861), pp. 107–8.

51. De Goncourt, *Manette Salomon*, 3, pp. 13–16. The authors speak of Ingres and Delacroix as "deux tempéraments extrêmes et absolus" [two extreme and absolute temperaments] and "ces deux hommes dont les noms étaient les deux cris de guerre de l'art" [these two men whose names represented the two battle cries of art] (p. 16).

52. See Baudelaire, *O.C.*, pp. 1118, 1124–25. The poet speaks at length of Delacroix's dual nature and attacks the simplistic view of the classic-romantic controversy. For Manet's remark, see Proust, p. 24.

Academic training in France, which the Goncourts's simulated critical review reflects, was not without the same philosophical pretensions. Here the question of spirit and matter, if not frequently the subject of pictures,[53] became the philosophical basis for the art of painting itself. A painter's manual published in 1858 distinguishes two kinds of imitation, one spiritual, the other material, further designated as "sympathetic" and "voluntary," respectively.[54] The sympathetic form is the result of a spiritual "geste intérieur" and these inner gestures ". . . harmonize with all phenomena in the finite and infinite worlds."[55] The observation might have been made by Baudelaire.

If such a painter's manual of the period provides us with an idea of the general attitudes toward the art of painting during Manet's youth, we can trace them directly to Manet's door with a perusal of the *Entretiens d'atelier*, by his teacher, Thomas Couture.[56] Couture rejects Dutch art, with few exceptions, on the grounds of what he finds to be its overriding materialism. It is too one-sided. In an aside about Balzac, Couture remarks, "This writer has separated his body and his soul,"[57] and concludes that in art "style is the spirit of man."[58] In another lesson, he insists that "there are therefore two very distinct parts in the art of painting, one spiritual, the other material."[59] When Emile Zola wrote in 1866, "If temperament did not exist, all pictures should inevitably be mere photographs,"[60] it must surely have reminded Manet of the words of his old teacher:

> What do I care about things that are perfectly imitated? No matter how
> well the painter does, he will never do as well as the mirror that reflects

53. In its second year of publication, the *Gazette des Beaux-Arts* (1860, pp. 226–37) gave considerable space to an article entitled "Victor Vibert: la gravure d'après le tableau 'le Bien et le Mal' de Victor Orsel." Were it not for the banality of the drawing (as seen in the two reproductions included in the article), we would have a work that, in theme at least, would have pleased Baudelaire. The author, Henry Trianon, writes of the work: "De ce double point de départ se déduisent deux existences contraires, et, sous la forme de huit compositions latérales, elles remontent l'une par des différent degrés du bien . . . ; l'autre par ceux du mal . . . jusqu'au tableau supérieur qui montre—dernière récompense et dernier châtiment—le Christ repoussant l'une des deux jeunes filles, et recevant l'autre dans le ciel. Au centre de la base ornée qui supporte le tableau, on voit l'ange et le démon se disputant le monde." [From this double starting point two opposing existences develop, and, in the form of eight lateral compositions, they ascend, the one by steps of good . . . ; the other by those of evil . . . right up to the image above which represents—last reward and last punishment—Christ rejecting one of the girls while receiving the other in heaven. At the center of the base that supports the image, we see an angel and a demon fighting over the world.]

54. *Encyclopédie-Roret, Peintre d'historie et sculpteur* (Paris, 1858), p. 5.

55. ". . . Se mettent à l'unisson avec tous les phénomènes qui se passent dans le monde terminé et indéterminé." (Ibid., pp. 11–13.)

56. Thomas Couture, *Entretiens d'atelier: Le Paysage* (Paris, 1869).

57. "Ce producteur a fait division de son corps et son âme." (Ibid., p. 121.)

58. "Le style est l'esprit de l'homme." (Ibid.)

59. "Il y a donc deux parts bien distincts dans ce domaine de l'art de peindre, l'une spirituelle, l'autre matérielle." (Ibid., p. 112.)

60. "Si le tempérament n'existait pas, tous les tableaux devraient être forcément de simples photographies." Zola, *O.C.*, "Le Moment artistique," p. 213. (Originally published in L'Evénement, 4 May 1866.)

the object exactly. This provides me with a spectacle that is vulgar, without wit, without passion, without love; the torch of art has not yet illuminated the picture.[61]

In further emphasis on the dangers of an imbalance of the duality of art, Couture exclaims, "Clothes have killed the man."[62] Manet manifestly sought to preserve the man within a faithfully copied suit. The interior is discovered by means of a careful study of what is presented to the eye.

We are aware of Couture's dislike for realist painting, the art of Courbet and his followers, and of his savage barb at such a persuasion in the form of a picture in which the realist is seen seated on the head of the Olympian Zeus, minutely copying the head of a pig. No doubt for Couture the realist lacked style and hence gave no evidence of possessing a soul. Manet was surely not so blind to the qualities of Courbet's art, but undoubtedly had his own reservations about it. His famous feud with Couture, it would seem, was rather more a matter of the form in which the artist's soul is to be expressed in his painting than of the question of the importance of the spiritual quality of the artist, on which the two men were evidently in agreement.

Proust has told us that Couture objected to Manet's omission of middle tones, to his abrupt passage from dark to light.[63] Yet anyone familiar with Couture's preparatory oil sketches will recall that such a contrasting way of handling values is one of their most impressive characteristics. The master may, of course, have stressed that halftones needed to be introduced in the finished work. Let us note here, too, the influence Couture had on Manet in the matter of technique. Zola had written of Manet's flat pictures:

> It has been said, in derision, that the pictures of Edouard Manet recall the popular Epinal prints and there is much truth in this derision, which is in fact a compliment; in both cases the methods are the same, the colors are applied in flat planes.[64]

In his lesson on the beauty of Titian's color, Couture taught:

> The mystery is not far, it is found in our two-penny pictures, which you probably regard with scorn, but which contain reds, greens, and other tones admirable for their strength and their beauty. But, you will say,

61. "Que me font à moi les choses parfaitement imitées? Si bien que fasse le peintre il ne fera jamais mieux que la glace qui représente exactement l'objet, cela me donne un spectacle vulgaire, sans esprit, sans passion, sans amour; l'art n'a pas encore animé l'image de son flambeau." (Couture, *Entretiens*, pp. 97–98.)

62. "L'habit a tué l'homme." (Ibid., p. 99.)

63. Proust, pp. 15–16.

64. "On a dit, par moquerie, que les toiles d'Edouard Manet rappelaient les gravures d'Epinal, et il y a beaucoup de vrai dans cette moquerie qui est un éloge; ici et là les procédés sont les mêmes, les teintes sont appliquées par plaques." (Zola, *O.C.*, pp. 258–59 [contained in *Edouard Manet*, originally published in 1867].)

this is the pure color, washed, spread on a body or on a drapery.—Yes, that's it, and that is where the secret lies.[65]

Dramatized, this technique of flat color yielded *Olympia*, which derives in part from a painting by Titian. But it had already produced the startling effects of the *Déjeuner sur l'herbe*, also inspired by a Venetian source. Of course, Zola went on to add that the Japanese print was probably of even greater importance for Manet than the *images d'Epinal*. If Couture could teach about the relationship between Titian's art and modern popular imagery, an original view that could only have impressed Manet, we may be more certain that the teacher's basic notion that the duality of the art of painting is a reflection of the duality of man made a profound impression on his pupil as well, particularly since this was Baudelaire's view exactly.[66] But can we accurately assume that Couture's influence preceded that of Baudelaire? It has been generally agreed that Manet and Baudelaire met in 1858, the year in which Manet had painted the *Buveur d'absinthe*, but Proust tells us that while he and Manet had been students in Couture's studio—that is, between 1850 and 1856—they frequently met at the restaurant Pavard for lunch with Baudelaire and Barbey d'Aurevilly.[67] The friendship, therefore, is probably older than has been supposed, and with the presence of Barbey d'Aurevilly, author of *Les Diaboliques*, we can well imagine the tenor of the conversations that took place and that nourished the imagination of Manet, then in his early twenties.

In the *Déjeuner sur l'herbe* the spirit-matter, soul-body polarity existed not only as a guiding principle during the conception and the execution of the work, but as its subject as well. Overbeck, in his *Triomphe de la religion*, tried to demonstrate the victory of the spiritual over the material portions of the art of painting, as well as the triumph of man's spiritual nature. Manet is less moralizing about the matter. He does not give us a clear suggestion of the superiority of the one or the other, but rather the simple presence of the two natures in man. It is true that the "sacred" figure is central and in the highest position, but the nude, closer to the viewer, is a powerful presence. We find the same duality a matter of concern to another German painter, more talented than Overbeck, Arnold Böcklin. In a recollection of that master, his pupil, Rudolf Schick, makes the following observation for the year 1868:

> Böcklin spoke of sacred and profane love, which are quite clearly expressed in the composition in terms of light and dark, and warm and cold.[68]

65. "Le mystère n'est pas loin, il est dans nos images à deux sous que vous considérez sans doute avec mépris, mais qui contiennent des rouges, des verts, et d'autres tons admirables de force et de beauté. Mais, direz-vous, c'est la couleur pure, levée, étendu sur un corps ou sur une draperie. —Oui, c'est cela, et c'est là qu'est le secret." (Couture, *Entretiens*, p. 74.)

66. "La dualité de l'art est une conséquence fatale de la dualité de l'homme." (Baudelaire, *O.C.*, p. 1154.)

67. Proust, p.22.

68. "Böcklin sprach von der himmlischen und irdischen Liebe, die ganz entschieden auf Hell und Dunkel, und warm und Kalt hin komponiert sei." (Rudolf Schick, *Arnold Böcklin, Erinnerungen* [Berlin, 1903], p. 159.)

Böcklin translates a notion associated with the human condition into the terms of painting. Manet, in the *Déjeuner*, depended more upon compositional devices and purposeful space distortions than upon dark-light, warm-cold oppositions to create his polarity, but his way is an equally painterly solution. Manet, of course, made great use of value contrasts in other works, and we shall have occasion to consider whether a function analogous to that expressed by Böcklin is not intended.[69]

Böcklin was not inclined to be as secretive as Manet about his subject matter. An allegorical title in his *oeuvre* is not surprising, and although Manet's original title, *Le Bain*, is perhaps more suggestive of the picture's real theme than the title it now bears, it is still far from putting us directly on the right track. Be that as it may, Manet overtly paints a scene from modern life, a scene that contains a philosophical argument transcending the time and place of the scene depicted; the wit, the resourcefulness, the game with classical sources, and the transmuted attribute of the helmet to hat—in short, the rebus directly related to experience—are decidedly French qualities. And it is in the French novel of artistic life *Manette Salomon* that we find the duality of spirit and matter, itself a timeless principle, expressed in terms of the fleeting and even comical situations of the artist's studio. The painter Anatole has brought to his studio a monkey and a pig in order to find amusement in their reactions to one another. The pig (and let us recall his having served as a symbol of materialism for Couture) finally runs off with the monkey on his back amid peals of laughter. The authors observe, however, that it was a moment in which a philosopher might have seen "the spirit mounted on the flesh and carried away by it."[70] There is no standard iconography for this polarity, and for Victor Hugo, moving his symbols up a notch, it was the monkey who represented the flesh, against an angel as the spirit. Manet used a bird and a frog, which, like the figures they help us to interpret, do not struggle for the dominant position but serve to call attention to man's condition, to the inevitable paradox of life.

While a consciousness of the theme of sacred and profane love is of use to us in discovering the philosophical basis of the *Déjeuner sur l'herbe*, it is too narrow and specific a subject to serve as an adequate guide for our understanding of Manet's more universal idea in this picture and in his *oeuvre* as a whole. Baudelaire, in his concept of the *homo duplex*, includes a wide range of polarized pairs that are all expressions of a more general concept. For example, in various places in his

69. De Mesnil ("Le Déjeuner," p. 256) has, in fact, noted the sharp contrasts in the *Déjeuner sur l'herbe* as indications of the lack of ease and harmony in the work when compared to Giorgione's *Concert Champêtre*. He singles out a telling detail: ". . . niente è più brutto, ad es., che il contrasto fra il piede bianco della giovinetta e la goffa scarpa nera del giovane che gli fa riscontro." [. . . Nothing is uglier, for example, than the contrast between the white foot of the girl and the clumsy black shoe of the young man, which are placed in opposition to each other.] Indeed, the juxtaposition is striking and results not simply from the fact that Manet has shod the foot of the male figure of the Raimondi print, but from the calculated, sole-against-sole opposition of the feet, which also represents a change from his source.

70. "L'esprit monté sur la chair et emporté par elle." De Goncourt, *Manette Salomon*, ch. 67, p. 227.

writings he cites the antitheses of action-inaction, dream-reality, spiritual-natural, masculine-feminine, intention-expression, straight-sinuous, unity-multiplicity, good-evil, and macrocosm-microcosm (the essential expression of his notion of vertical correspondences), and this hardly exhausts the inventory.[71] What is really significant for him is the fundamental principle of duality that reigns throughout creation, as Sallust saw the golden apple in the *Judgment of Paris* as the symbol of a universe made of opposites.[72] In his essay on Victor Hugo, Baudelaire asks:

> How did the single Father breed duality and finally transform himself into a countless population of numbers? Mystery![73]

If this question reminds us of Baudelaire's known familiarity with the writings of the mystics, notably with Eliphas Lévi (the Abbé Constant),[74] his use of numerous pairs of opposites, which are drawn from a variety of levels as to type and profundity, recalls the table of opposites attributed to Pythagoras and its interpretation by Aristotle as given in the *Natural Science*:

> All of them [earlier thinkers] alike refer to the same table of opposites for their basic principles, although the particular pair of opposites for which they assume priority may be wider or narrower in range. Some of them . . . start from what is logically more intelligible, others from what is more familiar to the senses; these two starting points being the universal (*katholou*) and the particular respectively, inasmuch as "logical explanation" (*logos*) deals with universal and sense perception (*aesthesis*) with the particular. Great vs. small, for instance, is a logical distinction, while dense vs. rare is a distinction of sense.

71. In addition to *Les Fleurs du Mal*, wherein such oppositions abound, see, in particular, Baudelaire's essays on Victor Hugo (*O.C.*, pp. 700–12), on Asselineau's *La Double Vie* (*O.C.*, pp. 658–62), "Richard Wagner et Tannhäuser à Paris" (*O.C.*, pp. 1208–44), and "Le Thyrse" (*O.C.*, pp. 284–85).

72. See note 11 above.

73. "Comment le Père *un* a-t-il pu engendrer la dualité et s'est-il enfin metamorphosé en une population innombrable de nombres? Mystère!" (Baudelaire, *O.C.*, p. 709.)

74. According to Eliphas Lévi: "Le binaire est le générateur de la société et de la loi; c'est aussi le nombre de la gnose. Le binaire est l'unité se multipliant d'elle-même pour créer." [The binary is the generator of society and the law; it is also the number of gnosis. The binary is unity multiplying itself in order to create.] (*Dogme et rituel de la Haute Magie* [Paris, 1967; originally published in 1855–56], p. 64.) In "Invitation au voyage" (*O.C.*, *Spleen de Paris*, p. 255) Baudelaire writes the phrase: "pour parler comme les mystiques . . ." [to speak like the mystics . . .], which in the earlier version of 1857 had been: "pour me servir du langage de ces livres qui trainent toujours sur ma table . . ." [to use the language of these books that are always lying on my table . . .] (*O.C.*, p. 1605). Swedenborg's *Du Ciel et de ses merveilles* was surely one of these books, and it is likely that Eliphas Lévi's work was another. When the poem "L'Imprévu" was published in the collection *Les Epaves* (1866), an editor's note directed the reader's attention to the *Rituel de la Haute Magie* (see *O.C.*, p. 1573).

Our general conclusion, then, is that basic principles will have the form of a pair of opposites.[75]

As Philip Wheelwright remarks in a footnote to his translation of the passage, "The point of Aristotle's remark is that these thinkers all alike rest their doctrines upon the *general conception of antithesis*, of which the Pythagorean table is an embodiment."[76]

This table includes the following antithetical pairs: (1) limited-unlimited; (2) odd-even; (3) one-many; (4) right-left; (5) male-female; (6) at rest-in motion; (7) straight-curved; (8) light-dark; (9) good-evil; (10) square-oblong.[77] While a number of these are identical with the pairs employed by Baudelaire, two of the most visual in character, light-dark and left-right, have long been associated with problematic aspects of the art of Manet, without reference, however, to the principle of duality that appears to have guided him.

The absence of any implication of a moral judgment in the *Déjeuner sur l'herbe* suggests an acceptance of the idea of the equal importance of the two female figures. In his references to the condition of duality, Baudelaire speaks of the interchangeability in his antitheses, and Manet's interest in the idea of reciprocity in this case can best be demonstrated by the principal thematic images he used as sources, the frescoes of the Stanza della Segnatura.[78] Not only do the *Disputà* and the *School of Athens* both contain references to the upper and lower realms, as we have seen, but they are placed opposite one another in a calculated Christian-pagan dualism, a monumental expression of a major Renaissance problem. We have already noted Manet's use of a Christian and a pagan figure for the designs of the two symbolic women in the *Déjeuner sur l'herbe*, as well as Baudelaire's view of this particular expression of the concept of antithesis.

75. Aristotle, *Natural Science*, I.v, trans. and ed. Philip Wheelwright (New York, 1935), p. 7.

76. Ibid., n. 2.

77. Ibid. (Also found in Aristotle's *Metaphysics*, I.v.)

78. It may be that Manet's involvement with Raphael's frescoes is to be found in still another important painting of the early 1860s: *La Musique aux Tuileries*. This picture, like many others by Manet (notably the lithograph *Le Ballon*, also of 1862), is a curious amalgam of the intuitive, apparently carefree touch and the symmetrically ordered composition. It is the latter quality (the central area marked off by trees, the wedge of sky directly above it, and the fountain at the center in the distance) that again begins to suggest Raphael. But, closer to the point, is not the gathering of poets, writers, and musicians a modern "Parnassus," with the three literary figures, Baudelaire, Gautier, and Baron Taylor [?] suggestive of a similar arrangement in that Vatican fresco? Even the seated lady in the foreground, thought to be Mme. Lejosne, in her pose and location relative to these three figures, is reminiscent of Sappho in Raphael's composition. Finally, the presence of Manet himself and the painter de Balleroy at the extreme left of the picture vividly recalls the appearance of Raphael and Perugino (or Sodoma) at the right edge of the *School of Athens*. Sandblad has suggested *(Manet*, p. 56) that this double portrait derives rather from the so-called Velasquez and Murillo in the *Petits Cavaliers* (then attributed to Velasquez), which Manet copied. This picture played an important role in Manet's development in 1862, as we shall see in the next section, and while there may be reference to it in the *Musique aux Tuileries*, the reference to Raphael, particularly in view of the other connections, seems the stronger.

In Far Eastern philosophy, this idea is contained in the ancient principle of the Yang-Yin, expressed concisely and with subtlety in the emblem of the circle bisected by a sigmoid line into black and white halves (fig. 112). These represent the masculine, active principle (Yang) and the feminine, passive one (Yin). In each of the two sectors is placed a grain of its opposite, a device that together with the interpretations provided by the sigmoid divider, stresses the interdependence and, ultimately, the fundamental unity of the scheme. It is this element of reciprocity (also stressed by Western mystics such as Swedenborg and Eliphas Lévi, who refers to the dictum contained in the Emerald Table of Hermes Trismegistus: "That which is above is like that which is below") that is so striking in Baudelaire's poetry.[79] He explains it clearly in his essay on Victor Hugo:

> Swedenborg ... had already taught us that *heaven is a very great man;* that all form, movement, number, color, scent, in the *spiritual* as in the *natural*, is significant, reciprocal, converse, *corresponding*.[80]

And in his dedication of the *Spleen de Paris* to Arsène Houssaye:

> My dear friend, I am sending you a small work about which we could not say without unfairness that it has neither head nor tail, since everything in it, on the contrary, is at the same time head and tail, alternatively and reciprocally.[81]

As well as in his journals, more mysteriously still:

> Theology.
> What is the fall?
> If it is unity become duality, it is God who has fallen.
> In other words, couldn't creation be the fall of God?[82]

In other works, as we shall see, Manet treats this aspect of the theme of duality in a variety of ingenious ways.

There is a final dual aspect to the *Déjeuner sur l'herbe*, and that is Manet's double inspiration for the work, Raphael and Giorgione. In his attempt to fuse the soft, painterly, and mysterious qualities of the Venetian school with the crisper, linear, and more discursively clear expression of the Florentine, does he not refer to the age-old dichotomy of "colore-disegno" revived in the seventeenth century in the dispute between the *Rubénistes* and *Poussinistes*, and in his own time in the Ingres-

79. See, in particular, "Hymne à la beauté," "Un Fantome," "Toute Entière," "Reversibilité," and "Chanson d'après-midi" from *Les Fleurs du Mal*, to name only a few examples.

80. "Swedenborg ... nous avait déjà enseigné que *le ciel est un très grand homme;* que tout forme, mouvement, nombre, couleur, parfum, dans le *spirituel* comme dans le *naturel*, est significatif, réciproque, converse, *correspondant*." (*O.C.*, p. 705.)

81. "Mon cher ami, je vous envoie un petit ouvrage dont on ne pourrait pas dire, sans injustice, qu'il n'a ni queue ni tête, puisque tout, au contraire, y est à la fois tête et queue, alternativement et réciproquement." (*O.C.*, p. 229.)

82. "La théologie. Qu'est-ce que la chute? Si c'est l'unité devenue dualité, c'est Dieu qui a chuté. En d'autres termes, la création ne serait-elle pas la chuté de Dieu?" (*O.C.*, p. 1283.)

Delacroix controversy, as a fundamental problem of opposing but complementary temperaments? It is a problem that, rooted specifically in the tradition of European painting, suggests a whole range of human antitheses, notably those of precise knowledge versus intuition, and thought versus feeling. In addition to Baudelaire, this formulation of the double personality is characteristic of another figure whom Manet greatly admired, Jean-Jacques Rousseau. It is evident throughout the *Confessions* (which Manet read at least twice and which he had discussed with Mallarmé)[83] and comes to the surface in a great moment of self-recognition:

> Two contraries are united in me in a way I do not understand: an ardent temperament, quick and impetuous passions, and confused and slowly emerging ideas that appear as an afterthought. It would seem that my mind and my heart do not belong to the same person.[84]

And elsewhere:

> I think that I have already pointed out that there are times when I am so unlike myself that one would take me for another man, of completely opposite character.[85]

In view of the presence of the animal symbols, the popularity and common use of the opposition of spirit and flesh,[86] and, above all, the fame of Manet's sources for the *Déjeuner sur l'herbe* in the nineteenth century, it is all the more astonishing that the work's philosophic content was apparently not understood by anyone. (If Manet's intimates Baudelaire, Astruc, and a few others knew

83. See Introduction, note 22.

84. "Deux choses presque inalliables s'unissent en moi sans que j'en puisse concevoir la manière: un tempérament très ardent, des passions vives, impétueuses, et des idées lentes a naître, embarrassées, et qui ne se présentent jamais qu'après coup. On dirait que mon coeur et mon esprit n'appartiennent pas au même individu." (Rousseau, *Les Confessions* [Paris, n.d.; ca. 1909], vol. 1, p. 113.)

85. "Je crois avoir déjà remarqué qu'il y a des temps ou je suis si peu semblable à moi-même qu'on me prendrait pour un autre homme, de caractère tout opposé." (Ibid., p. 129.)

86. The awareness of this dualism is, as we have noted, a popular one, and was even more so during the last century. It forms the basis of the teaching of Saint Paul and medieval scholasticism. In the nineteenth century, in addition to the references given in the text and foregoing notes, the famous statement in Goethe's *Faust* comes to mind: "Zwei seelen leben, ach, in meiner Brust" [Two souls coexist, alas, within my breast], as do, in the form of good and evil, Stevenson's *Dr. Jekyll and Mr. Hyde*; Balzac's study of man's dual nature, *Séraphita*; the split personality of Odette-Odile in *Swan Lake*; George Grey Barnard's success at the 1894 Champ de Mars Salon, *The Two Natures of Man*; and the famous yard-wide 1857 photograph by O. G. Rejlander, *The Two Ways of Life*. Even on the general level of duality, the creating of dramatic tensions by the use of opposites was common practice among poets. When criticizing Victor Hugo in an early essay, Baudelaire noted: "Il possède à fond et emploie froidement . . . toutes les ressources de l'antithèse. . . ." [He is in complete possession of, and uses quite coldly . . . all the possibilities of antithesis. . . .] (*O.C.*, "Le Salon de 1846," p. 889.) Evidently, Baudelaire expected more probing and original formulations of the principle of antithesis.

anything about it, they gave expression to this knowledge only in the most cryptic way, respecting the artist's own silence on the matter.) The *Concert Champêtre* was on view in the Louvre, and the universal admiration for Raphael lent considerable fame to Marcantonio's prints,[87] particularly to those based on designs by the master. When Ernest Chesneau did, in fact, recognize Raphael's composition in Manet's three foreground figures, he failed to draw any meaningful conclusions from his discovery. Even Gustave Pauli, who rediscovered the fact in 1908, was content to defend Manet's originality in spite of this incident of direct borrowing. In this respect he repeats the defense made by Bartsch, who in 1814 insisted upon Raphael's originality although he had borrowed his motif from a Roman sarcophagus.[88] If the other critics lacked Chesneau's knowledge or ability to associate images, the puzzling qualities of Manet's picture did not escape them. The stream of invective that appeared in the press is to a large extent an expression of frustration.

It seems clear that Manet expected the cultivated viewer to make the basic identifications necessary for a penetration into the moral sense of the picture and, from there, to a recognition of timeless concerns in modern life. The artist was perhaps less distressed by the abuse his painting called forth than he was dismayed by the unanimous display of ignorance of his intentions. Perhaps they were too well concealed; perhaps Manet had expected too much. When the experience was repeated in 1865 with the reception given *Olympia*, Manet questioned the validity of his method. "Obviously," he wrote to Baudelaire, "someone is wrong."[89]

87. In *Manette Salomon*, the de Goncourts describe the studio of the painter Garnotelle: "Sur les murs se détachaient des cadres dorés, des gravures de Marc-Antoine" (ch. 41, p. 151).

88. Adam Bartsch, *Le Peintre-Graveur*, vol. 14, *Oeuvres de Marc-Antoine*, (Vienna, 1813), pp. 197–98, no. 245. "This is one of the most perfect of Marcantonio's prints; he engraved it after an excellent composition by Raphael, who got the idea, according to some, from an ancient bas-relief that this painter is said to have smashed in order to be credited with the invention. We leave it to others to discuss whether Raphael could have been so crude as to destroy a beautiful monument of antiquity, and whether he ever needed to support his genius by such unworthy means."

89. "Il est évident qu'il y a quelqu'un qui se trompe." (Tabarant, *Manet et ses oeuvres*, p. 110.)

Le Vieux Musicien

In 1862 Manet had already painted a monumental canvas that has strong affinities with the far more famous *Déjeuner sur l'herbe* of the following year. *Le Vieux Musicien* (fig. 28), unmentioned by Proust, remains the least discussed of Manet's major early works and has been generally dismissed as a still immature and frankly unsuccessful work. Richardson has gone so far as to single it out as a clear example of Manet's inability to compose successfully.[90] In fact, it is hardly less successful than its more illustrious followers, the *Déjeuner* and *Olympia*, and Alan Bowness has seen in it not a poor use of academic compositional principles but a conscious search for something new.[91] Manet had never submitted the picture to the Salon, and consequently it inspired no flow of journalistic ink. When it was exhibited at Martinet's gallery in the spring of 1863 it was overshadowed by the smaller *La Musique aux Tuileries*, which was found to be outrageous. *Le Vieux Musicien*, in spite of its greater size, appears to have gone unnoticed. The painting, then, faces us today in its pure state, without a critical and anecdotal history, the way all Manet's paintings faced his contemporaries, and it is clear that we are almost as mystified by it today as was the public a century ago.

In such a situation we have both an advantage and a disadvantage compared to the viewer of 1862: on the one hand, we know a great deal more about Manet, but on the other, we no longer have the awareness of certain events of the time in which the picture was created, and the contemporary consciousness upon which the artist may have depended, at least in part, is now gone. These events, however, are not entirely lost to us, and something of the atmosphere in which *Le Vieux Musicien* came into being can be reconstructed. The clues that tell us where to begin are found in the painting itself.

One of the longer descriptions of the work is given by Manet's biographer and friend, Théodore Duret:

> *Le Vieux Musicien* of 1862 is, because of its size, the most important work of his early period. The old musician, in the center of the canvas, is the heart of the picture. He is sitting outdoors, his violin in one hand, the bow in the other, ready to play. The characters around him are waiting to hear. At the left, a little girl standing in profile, a doll in her arms . . . next two young boys, full face. Then in the background *Le Buveur d'Absinthe* appears anew. Finally, on the right, half cut by the frame, we see an oriental, with a turban and a long robe. This combination of characters is surprisingly fanciful. I do not think that Manet had any other intention, in painting this picture, than to put there various figures whom he liked and whose likeness he wanted to preserve.[92]

90. Richardson, *Manet*, pp. 13, 118. Others have also found fault with the painting. See Perruchot, *La Vie de Manet*, pp. 109–10; Hamilton, *Manet and his Critics*, p. 38; Bataille, *Manet*, p. 38; Colin, *Manet*, pp. 54–59.

91. Bowness, "A Note on Manet's Compositional Difficulties," p. 276.

92. "De l'année 1862 est le *Vieux Musicien*, l'oeuvre la plus importante, par ses dimensions,

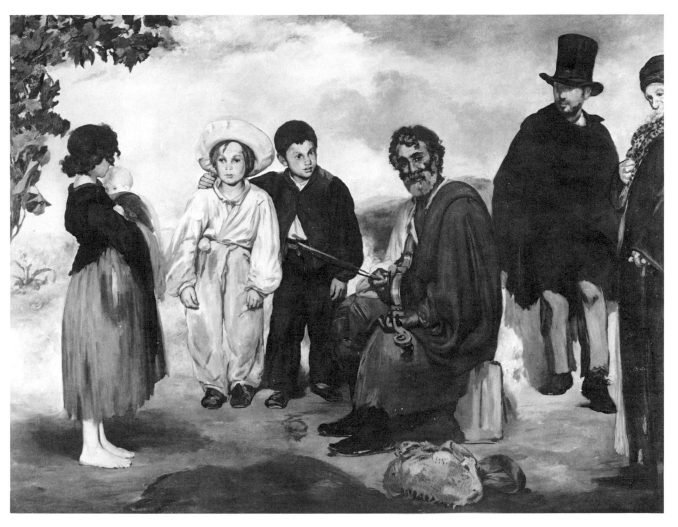

28. *Le Vieux Musicien*, 1862, National Gallery of Art, Washington, D.C., Chester Dale Collection.

In his recognition of the strangeness of the assortment of characters in the painting, and in denying knowledge of any intention on Manet's part other than the creation of a picturesque arrangement, Duret suggests that there may, indeed, have been a thematic basis for the work. Visitors to Washington's National Gallery continue to re-experience Duret's surprise before this monumental and compelling picture, and, given Manet's present stature, our inability to penetrate to the meaning of the *Vieux Musicien* can be explained only on the grounds of its intransigent resistance to this kind of investigation. Yet the character of the musician looks at the viewer squarely and benevolently, teasing the imagination and inviting him into his world. The preceding discussion of the *Déjeuner sur l'herbe* can be of help to us here. As we shall see, in this slightly earlier painting Manet had already put into practice the principles of embedding his theme within the structure of the picture and of making references to it by the use of specific and recognizable sources. Let us turn now to these sources and their role in Manet's highly organized, if unorthodox, composition.

It is certainly Manet's composition that is responsible for the initial feeling of strangeness that the viewer experiences before this painting: six monumental figures with no psychological rapport with one another are strung across the canvas. They avoid each other's glances, as well as that of the viewer, with the single exception of the violinist, (to the right of center, and not in the middle as Duret claims), who looks at us frankly. They are all Bohemian types set into an ambiguous landscape, but they utterly lack the charm and genre quality normally associated with such figures. Instead, Manet's impersonal approach to the individuals depicted creates an iconic, symbolic impression. Each figure, as well as the ensemble, is larger than life in terms of the impact produced.

If the characters fail to unite into an agreeable social gathering, they are, nevertheless, all in contact with one another when the picture is read two-dimensionally: the violinist's cloak and that of the figure behind him are tangent arcs, and the same kind of contact is made between the adolescent boy in white and the girl holding the infant at the left. This fact plus the isocephalic arrangement of the four figures to our left (including the musician) stress the flatness of the picture and lead to the further observation that Manet has connected several of the figures to one another as well as to the landscape by means of an irregularly curving line, which, for greatest clarity, we may begin to follow at the right edge of the com-

de sa période des débuts. Le vieux musicien, au centre de la toile, sert de raison première à l'existence de l'ensemble. Il est assis en plein air, son violon d'une main, l'archet de l'autre, prêt à jouer. Les personnages autour attendent pour l'écouter. D'abord, à gauche, une petite fille debout, et de profil, un poupon dans ses bras . . . à côté sont placés deux jeunes garçons, de face. Puis, dans le fond, apparait repris *Le Buveur d'absinthe*. Enfin, à droite, à moitie coupé par le cadre, se voit un oriental, avec turban et longue robe. La réunion de ces personnages surprend d'abord par sa fantaisie. Je ne sache pas que Manet ait eu d'autre intention, en peignant ce tableau, que d'y mettre des êtres divers, qui lui plaisaient et dont il voulait conserver l'image." (Théodore Duret, *L'Histoire d'Edouard Manet et de son oeuvre* [Paris, 1902], p. 23.)

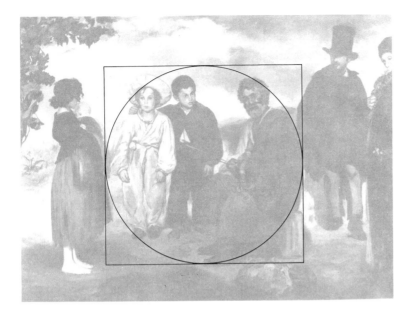

29. Diagram of fig. 28.

position. Here, the diagonal line that marks the bottom of the sleeve of the aged figure is contiguous with an arching line across the cloak of the figure adjacent to him. This line then continues along the horizon behind the head of the violinist. It disappears behind the two boys to reemerge between the boy in white and the girl holding the infant, descending along the oblique edge of her tunic to terminate in the landscape once again as an edge upon which the little plant beneath the grapevine is placed. It will now be noticed that this line, which ties the figures at the left to those at the right, is interrupted by the trio composed of the old musician and the two boys, who are, nevertheless, integrated into the ensemble in other ways. The next discovery to be made, then, is that this group of three figures falls within a circle (or a square—it can be read both ways) placed at the exact center of the design (fig. 29). It is already obvious at this point that the composition, whatever else might be said of it, is neither casual nor without some specific intention. The spatial ambiguities created by the fusion of figures with the distant background and the friezelike arrangement foreshadows the similar situation of the *Déjeuner sur l'herbe*, wherein the scale of the wading figure and the arc within which the four figures are placed produce an equivalent, intentional, spatial confusion.

We have, then, a contiguous row of figures with a nucleus given visual emphasis by means of geometric manipulation, and we are led, quite naturally, to inquire as to the significance of this central group. Manet provides the key in his references to two well-known older works of art upon which two of the three figures were based. Alain de Leiris, in an important article, has recognized the quality of *Le*

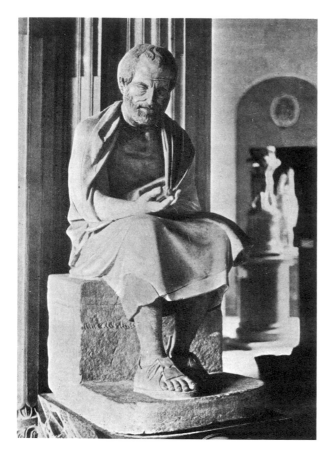

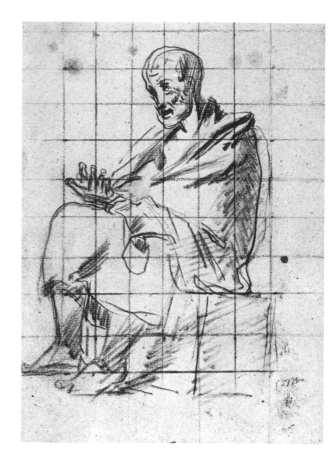

30. *Seated Philosopher* (Chrysippos), before the head was exchanged, ancient copy of Greek marble of the third century B.C., Musée du Louvre, Paris.

31. *Seated Philosopher*, ca. 1860, sanguine and penc Musée du Louvre, Paris.

Vieux Musicien and has characterized it as a manifesto. He has also demonstrated that the figure of the old musician was modeled on the Hellenistic statue of a philosopher in the Louvre, now identified as Chrysippos (fig. 30).[93] Although the violinist differs in a number of particulars from its source, a preparatory drawing by Manet, now in the Cabinet des Dessins, is clearly a careful copy of the Louvre statue (fig. 31). The most obvious change that has occurred in the adaptation of the drawing to the needs of this multifigure composition is the addition of the violin. Assuming that Manet's interest in the ancient piece was prompted by his

93. Alain de Leiris, "Manet, Guéroult and Chrysippos," *Art Bulletin* 46 (1964), pp. 401–4.

search for a philosopher type, the addition of the violin serves the double purpose of avoiding the unlikely presence here of an easily recognized character from another time and place and of creating an itinerant artist, consistent with this Bohemian nineteenth-century setting, without loss of the philosopher's role played by the character. In his book of 1858, *Ce qu'on voit dans les rues de Paris*, Victor Fournel informs us of the popular conception of such a type: "The itinerant artist is a philosopher: he knows thoroughly the vanity of the glories of this world,"[94] and both Tabarant and Sandblad have sensed something of this intention when, without a knowledge of its sources, they liken the violinist to a Homeric hero.[95]

Since the most apparent transformation of the Greek philosopher into his Bohemian counterpart centers on the introduction of the violin, we might expect to discover some evidence of this in Manet's treatment of the hands in his drawing after the prototype. Indeed, the right hand of Chrysippos is extended in the gesture of the "*digitis computans*" and Manet has concentrated his attention upon it. In the drawing, this hand is darker and more belabored than any other portion of the figure. And, what is not discernible in a black and white reproduction, this hand is drawn in pencil, while the remainder of the figure is executed in paler sanguine. The fingers, extended in an expression of counting, appear to make a double indication, and a new look at the violinist at this point reveals that the bow, which replaces the two pointing fingers, is itself a pointer with which the artist-philosopher directs our attention to the two boys, the shadow of its tip framed within the triangle formed at the waist of the boy on the right. The similar activity of the dandy-philosopher, whose gesture is at the same time before our eyes yet masked in the *Déjeuner sur l'herbe*, comes immediately to mind, and we recognize that the theme of that painting, as well as Manet's techniques for its presentation, had already been broached in *Le Vieux Musicien*.

The two boys are opposites in several calculated ways: one is swarthy, the other fair; one wears dark clothing, the other light; one looks slightly to the right, the other toward the left. Yet the dark child has thrown his arm over the other's shoulder and they are of the same age and height. Consequently, they are to be considered as a single unit made up of opposing characteristics, and together they form the object of the violinist's pointing bow. The philosopher and the phenomenon to which he calls our attention comprise the central squared circle, itself a geometric allusion to the fusion of opposites, of the painting. The circle and the square also inevitably recall the christian symbols of heaven (the eternal) and earth (the transitory) respectively.

The fair boy, posed by Léon Koella-Leenhoff—in all probability Manet's own son[96]—is a clear reference to Watteau's *Gilles* (fig. 32). The similarity has long

94. "L'artiste ambulant est philosophe: il connait à fond la vanité des gloires du monde." (Victor Fournel, *Ce qu'on voit dans les rues de Paris* [Paris, 1858], p. 10. Cited in G. C. Feller, "A Study of the Sources for Manet's 'Old Musician'" [M.A. thesis, Columbia University, 1966], p. 38, and by Reff, "'Manet's Sources,'" p. 43.)

95. De Leiris has reminded us of these observations ("Manet, Guéroult and Chrysippos," p. 402, n. 11).

96. Léon Leenhoff was the son of Suzanne Leenhoff, whom Manet did not marry until

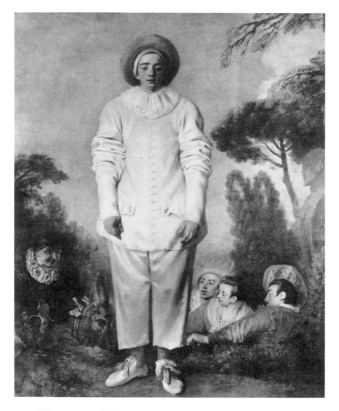

32. Watteau, *Gilles*, 1721, Musée du Louvre, Paris.

been recognized,[97] but obvious as the reference is, it has never received a convincing interpretation. The Chrysippos statue was a well-known and widely admired piece in Manet's time. Not only did it occupy a prominent place in the Salle des Caryatides in the Louvre, but a copy of it was placed (and still remains) in the courtyard of the quai entrance to the Ecole des Beaux-Arts. Watteau's *Gilles*, then in the La Caze collection, was equally well known, if not more so. In 1860 it was on view at Louis Martinet's gallery on the Boulevard des Italiens, where Manet was soon to exhibit his own work. The critic Willem Bürger (a pseudonym for Théophile Thoré) qualified the work as a masterpiece in his review of the exhibition in the *Gazette des Beaux-Arts*, and a reproduction of it was

1863, after his father's death. Before the world, Manet passed as Léon's godfather, but his paternity is strongly suspected. For the most complete discussion of this mysterious relationship, see Tabarant, *Manet et ses oeuvres*, pp. 479–85.

97. See Florisoone, *Manet*, p. xvii; Bataille, *Manet*, p. 38; Fried, "Manet's Sources," p. 32, among others.

included in his long article.[98] But *Gilles* was also mentioned frequently in those days in connection with a historic event, Baron Haussmann's renovation of Paris, which in 1862, the year in which *Le Vieux Musicien* was painted, rendered Gilles's timeless prototype, Pierrot, homeless. On the fourteenth of July wrecking crews began the demolition of the Théâtre des Funambules as part of the overall destruction of the colorful Boulevard du Temple, better known as the Boulevard du Crime.[99] Manet in 1862 could hardly have included such an obvious reference to the most famous Pierrot in the history of art without an expectation that the viewer would be reminded of the Funambules and the world of the commedia dell'arte that it housed. Even at this distance in time, without a knowledge of the topical event to which Manet's image is surely a reference, the viewer may readily suspect that Gilles is present here as a reminder of Pierrot's world and what it meant to Manet and his circle. Let us recall that in the same year Manet had included a Polichinelle in a design that he had intended to use as a frontispiece for a portfolio of eight of his etchings (fig. 102).

It was during the 1830s, with the appearance of the great mime Gaspard Deburau in the role of Pierrot, that writers and artists began to think of the productions at the Funambules as high art and of its characters as great human symbols. Over the years the belief spread that the pantomime theater with its traditional commedia dell'arte characters symbolized life itself, with a mixture of the comic and the tragic, without pedantry, in a form admirably designed to reach the general public.[100] In 1842 Théophile Gautier, impressed by an unusual play entitled *Marchand d'habits*, wrote:

> Isn't this a strange drama, a blend of laughter and terror? Don't the ghost of Banquo and the ghost in Hamlet have a strange connection with the appearance of the clothes salesman, and isn't it remarkable to find Shakespeare at the Funambules? This parade contains a myth that is very deep, very complete and very moral, that would only need to be expressed in Sanscrit, to elicit a flow of comments. Pierrot, who walks in the street with his white jacket, his white pants, his powdered face, preoccupied with vague desires, isn't he the symbol of the human soul, still innocent and white, tormented with infinite aspirations toward the beyond?[101]

98. W. Bürger (Théophile Thoré), "Exposition de tableaux de l'école française," *Gazette des Beaux-Arts* 7 (1860), p. 260.

99. Louis Péricaud, *Le Théâtre des Funambules: ses mimes, ses acteurs, et ses pantomimes depuis sa fondation jusqu'à sa démolition* (Paris, 1897), p. 4.

100. See Jules Janin, *Deburau, histoire du théâtre à quatre sous* (Paris, 1832); Charles Nodier, "Polichinelle," in *Contes de la veillée* (Paris, n.d.), pp. 80–89 (originally published in 1831). See also notes 101–108 below.

101. "Ne voila-t-il pas un étrange drame, mêlé de rire et de terreur? Le spectre de Banco et l'ombre d'Hamlet n'ont-il pas de singulier rapports avec l'apparition du marchand d'habits, et n'est-ce pas quelque chose de remarquable que de trouver Shakespeare aux Funambules? Cette parade renferme un mythe très profond, très complet et d'une haute moralité, qui ne demanderait que d'être formulé en Sanscrit, pour faire éclore des nuées de commentaires.

In 1846, Champfleury, who was later to become Manet's friend and collaborator, was inspired to provide the Funambules with a novel idea for a pantomime. He named it *Pierrot, valet de la Mort* and in his *Souvenirs des Funambules* informs us that the idea for the work had been suggested to him by a brochure entitled *De la Nature hyperphysique de l'homme* by Wallon, which he had come upon accidentally.[102] Wallon's notion that man will find a "conscious immortality," the only kind worthy of him, through an understanding of the concept of the word having become flesh is described by Champfleury as an "illuminism worthy of Swedenborg." Despite the philosophical nature of his pantomime, Champfleury disclaims any intention of making the play into a schoolmasterly lesson in metaphysics, an approach he sees as completely alien to the popular character of the Funambules. Nevertheless, he expresses the hope that the idea will make itself felt through the work of art, the structure of which it determined.[103] What was apparent to anyone who saw the production was that Pierrot is indestructible and, after having been pronounced dead, returns to life, following an amusing scene with the devil. Gérard de Nerval, in reviewing the play, perceived it as an attempt to restore pantomime to the high symbolic level it had once had and flatly stated that "modern philosophy has not formulated anything that is as clear as this pantomime in seven scenes."[104]

Encouraged by this success, Champfleury created a second pantomime, *Pierrot Pendu*, which was staged a month later. It was in response to this work that Gautier expressed his view of the silent comedy as a microcosm:

> The crowd has lost the meaning of these high symbols, of these profound mysteries that stimulate the poet and the philosopher; it doesn't have a mind subtle enough to follow and understand this living dream, this trip through events and things, this perpetual agitation, this aimless turbulence that describes life so well.
>
> Pantomime is the true human comedy: and although it doesn't use two thousand characters like Balzac's, it is no less complete. It does everything with four or five types.... Isn't this a complete microcosm that expresses in itself all the evolutions of thought....
>
> All of humanity lives and breathes in half a dozen names.[105]

Pierrot, qui se promène dans la rue avec sa casaque blanche, son pantalon blanc, son visage enfariné, préoccupé de vagues désirs, n'est-ce pas la symbolization de l'âme humaine encore innocente et blanche, tourmenté d'aspirations infinies vers les régions supérieurs?" (T. Gautier, in *La Revue de Paris*, 4 September 1842; partly quoted as a prologue to Sacha Guitry's play *Debureau* [Paris, 1918], p. 19.)

102. Champfleury, *Souvenirs des Funambules* (Paris, 1859), p. 8.

103. Francis Haskell, in a discussion of the Funambules, has referred to Champfleury as "the Marsilio Ficino of the Commedia dell'Arte." ("The Sad Clown: Some Notes on a Nineteenth Century Myth," *French Nineteenth Century Painting and Literature* [New York, 1972], pp. 2–16. The reference is on p. 11.)

104. "Au reste, la philosophie moderne n'a rien formulé de plus clair que cette pantomime en sept tableaux." (De Nerval, cited in Péricaud, *Le Théâtre des Funambules*, p. 299.)

105. "La foule a perdu le sens de ces hauts symboles, de ces mystères profonds qui rendent

Gaspard Deburau died in 1846, the year of Champfleury's two plays, and Jules Janin paid him homage by recognizing his essentially modern incarnation of Pierrot:

> He has truly created a new kind of clown.... An actor without passion, without words and almost without a face, he says everything, expresses everything, makes fun of everything.[106]

And in his *Salon of 1846*, Baudelaire spoke of Deburau as

> ...the true Pierrot of today, the Pierrot of modern history, who must be included in all sideshow paintings.[107]

New as Deburau's character was, Janin's description suggests its affinity with Watteau's *Gilles* and Manet's derivation of it, as well as the dispassionate and symbolic character of all of Manet's monumental figures. Charles Deburau continued to keep Pierrot alive at the Funambules in the tradition established by his illustrious father, and when the theater was wrecked in 1862 Albert Glatigny, in reviewing the last production, *Les Mémoires de Pierrot*, explicitly asserted the relationship of the character to *Gilles*:

> There is no doubt about it. Deburau infuses him with serene gaiety, despised elegance, everything that constitutes great art. His smile contains inexpressible melancholies; it is the smile of Wateau's [*sic*] Gilles, a smile tender and gentle, ironical and capricious.[108]

The description of *Le Vieux Musicien* in this discussion contains references to the "characters" in the picture as a consequence of the "staged" quality of the composition. Georges Bataille had the same impression when he described the figures as sitting or standing haphazardly, "much as actors on stage taken unawares

rêveurs le poète et le philosophe; elle n'a plus l'esprit assez subtil pour suivre et comprendre ce rêve éveillé, ce voyage à travers les événements et les choses, cette agitation perpetuelle, cette turbulence sans but qui peint si bien la vie.

"La pantomime est la vraie comédie humaine; et bien qu'elle n'emploie pas deux milles personnages, comme celle de M. de Balzac, elle n'en est pas moins complète. Avec quatre ou cinq types, elle suffit à tout.... Ne voila-t-il pas ... un microcosme complet et qui suffit a toutes les évolutions de la pensée....

"L'humanité entière palpite sous une demi-douzaine de noms." (Gautier, cited in Champfleury, *Souvenirs*, pp. 62–63.)

106. "Il a véritablement crée un nouveau genre de paillasse.... Acteur sans passion, sans parole et presque sans visage, il dit tout, exprime toute, se moque de tout...." (Janin, cited in Péricaud, *Le Théâtre des Funambules*, p. 38.)

107. "... Le vrai pierrot actuel, le pierrot de l'histoire moderne,... qui doit avoir sa place dans tous les tableaux de parade." (Baudelaire, *O.C.*, p. 909.)

108. "Il n'y a pas à dire. Deburau incarne en lui la sereine gaité, l'élégance méprisée, tout ce qui constitue le grand art. Son sourire a d'inexprimables mélancolies; c'est le sourire du Gilles de Wateau [*sic*], un sourire tendre et doux, ironique et capricieux." (Albert Glatigny, Mémoires de Pierrot," *Revue et gazette des théâtres*, 19 June 1862. Cited in Péricaud, *Le Théâtre des Funambules*, p. 294.)

as they wait for the curtain to go up."[109] The presence of the *Gilles* among the cast of characters makes the reference to the theater unmistakable, and we may further conclude that the reference is specifically to the pantomime at the Théâtre des Funambules, its silent expressions of life itself, in which "all of humanity lives and breathes in half a dozen names."

Manet's painting, then, represents the "stage of life," its symbolic characters linked, also symbolically, through the painter's artifice rather than by means of an overly particularized anecdote. The gamin Gilles is the specific reference that supports a general impression. But let us recall that this figure in Manet's composition constitutes one half of a duality, which is at the center of the stage and, we may therefore suppose, has still another role in the work besides that of signpost to the Funambules in general. Heightened by the interpretations of the Deburaus, Pierrot was strongly identified with pallor and innocence. The poetical imagination, quite naturally, soon created his counterpart, and the profundity of this juxtaposition was immediately perceived by Gautier in connection with Champfleury's second play, *Pierrot Pendu*:

> To introduce himself to Colombine, Pierrot, always a little shy toward the fair sex, uses the most dark and mysterious means, chimney sweepers' means—a profound symbol—since to become a criminal, he sullies with soot the immaculate whiteness of his clothes: from white he becomes black....[110]

Although this play had been staged when Manet was a schoolboy, he would have been aware of it through his friendship with Champfleury and would certainly have read the latter's *Souvenirs des Funambules*, which was published in 1859. But, more important, the new view of the pantomime that was born in the 1830s had become traditional thirty years later, as had some of its specific inventions, such as the "Pierrot blanc" and the "Pierrot noir." One of the later productions at the theater, entitled *Le Père Funambules*, included a song rendered by the character "Progrès," in which the development of the pantomime is recounted. One passage (sung to the air of "Rose et Marguerite") gives us the following information:

> Petits enfants, Pierrot fit votre joie,
> En amusant aussi les grands enfants.
> N'oublions pas *Noir et Blanc*, genre étrange,
> Né de l'Egypte, il rembrunit les traits.[111]

109. Bataille, *Manet*, p. 38. More recently, Fried, "Manet's Sources," pp. 29–40.

110. "Pour pénétrer auprès de Colombine, Pierrot, toujours un peu timide à l'endroit du beau sexe, se sert des moyens les plus ténébreux, des moyens de ramoneur—profond symbole—car pour arriver au crime il souille de suie la blancheur immaculée de ses vêtements: de blanc il devient noir...." (Gautier, cited in Champfleury, *Souvenirs*, p. 68.)

111. Péricaud, *Le Théâtre des Funambules*, p. 485.

[Little children, Pierrot delighted you,
While also amusing the grown children.
Let us not forget *Black and White*, strange genre,
Born in Egypt, it darkens the features.]

The first two of the twenty-two tableaux of the final performance, *Les Mémoires de Pierrot*, given on 17 May 1862, began with "Pierrot en costume de ville, noir" and "Le Pierrot traditionnel, blanc," and tableau sixteen bore the description, "Pierrot Wateau [*sic*]."[112] The notion of the double Pierrot and his moral dichotomy had become firmly entrenched; as late as 1889 Paul Hugounet, musing on the future of the pantomime asked,

Will Pierrot be white, will he be black?
Belly or brain?[113]

This is the dualism that, with the philosopher who calls it to our attention, occupies the central circle of Manet's composition. It has already been noted that the two boys, while integrated into the friezelike arrangement, are not woven into the curving line that unites the discretely placed individual figures. They stand before it, in a sense, a distinction consistent with their being singled out by the violinist's bow. Added to the foregoing observations relative to the choice and placement of figures is the fact that they grow increasingly older as we read the picture from left to right. The series begins with infancy, in the image of the babe in arms. It continues with a representation of childhood, symbolized by the two boys, who are followed by the mature cloaked figure, and terminates with the aged man in the turban at the extreme right. Manet has presented us with a life cycle, reminiscent of the subject of the "degrés d'ages" [the stages of life] so often pictured in the popular prints published at Epinal and other centers (fig. 33), but he has reduced the steps from the usual ten, perhaps with a consciousness of the system of the four ages of man. The personifications of these ages curve around the figure of the philosopher, who points out man's essentially dualistic nature. This idea is suggested to the viewer in the reference to popular prints and the timeless themes that the pantomime treated in popular form. An American print by Currier entitled *The Life and Age of Woman* (fig. 34) is also based upon the ten-step progression toward age one hundred and begins with a babe in arms as does *Le Vieux Musicien*. Furthermore, it includes, over the left side of the composition, a fruit-laden apple tree, while a weeping willow crowns the last stages of life. At the left of *Le Vieux Musicien* Manet has placed a grapevine, and it is possible that the little plant below it is its symbolic opposite, a dry thistle.[114]

In addition to the general popularity of the Funambules and the particular attention of which it was the subject in 1862, the year of its destruction, the com-

112. Ibid., p. 493.

113. "Pierrot sera-t-il blanc, sera-t-il noir?/Ventre ou cerveau?" (Paul Hugounet, *Mimes et Pierrots* [Paris, 1889], p. 206.)

114. The identification of this plant as a thistle was suggested to me by Paul Isaacson.

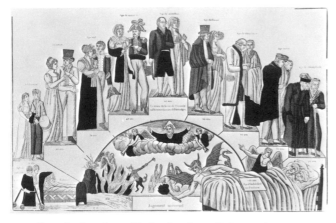

33. *Degrés des Ages*, Epinal print of the early
nineteenth century.

34. Nathaniel Currier, *The Life and Age of Woman*,
1850, lithograph.

media characters had begun to appear before the public in the form of puppets the preceding year. At that time Duranty, the art critic and friend of Manet and Baudelaire, had received the necessary royal permission to establish a permanent puppet theater in the Tuileries gardens. Duranty insisted upon the moral importance of his theater and claimed that his amusing puppet plays had more to teach the young than all the writings of the educator Berquin.[115] When the theater opened, the tone of Victor Luciennes's review made it clear that this popular entertainment embodied a profound and traditional symbolism. The main character here was not Pierrot but Polichinelle, and of him Luciennes wrote:

> They say you are a bohemian: alas! It is true . . . but cheer up: Homer also was a bohemian. . . . You know how to amuse everybody: men, women, children, those who are departing and those who begin. . . . Sublime artist, you say to those who surround you: Let the little children come unto me.[116]

The ready identification of Polichinelle with Homer and Christ is an indication of how widespread and deep the association of the commedia with profound philosophic significance had become. Such identifications had also been made for the star of the Funambules, Pierrot. In their novel *Manette Salomon* the de

115. Edmond Duranty, *Théâtre des marionnettes du Jardin des Tuileries* (Paris, 1862), p. 387. Duranty calls his book a comic monument, encompassing "le mystère et la réalité."

116. "Ils disent que tu es un bohème: hélas! Ceci est vrai, . . . mais console-toi: Homère aussi était un bohème. . . . Tu sais amuser tout le monde: hommes, femmes, enfants, ceux qui s'en vont et ceux qui commencent. . . . Artiste sublime, tu dis à ceux qui t'entourent: Laissez venir à moi les petits enfants." Victor Luciennes, "Le Théâtre de Polichinelle aux Tuileries," *L'Artiste* (15 October 1861), p. 185.

Goncourts describe how the painter Anatole, unable to create a satisfactory image of Christ, converts the figure into a Pierrot, "qui avait un Christ comme dessous."[117] Another indication of these concepts in connection with the painted commedia is to be found in a picture by Jean Louis Hamon exhibited in 1855, which was described by William Rossetti as "*The Comedy of Human Life*, where Diogenes, Dante, Homer, antique warriors, little children, and modern portières hover about a Punch and Judy show. . . ."[118] *Le Vieux Musicien* is also a "comedy of human life," but it is life dominated by the idea of the *homo duplex*.

As we have seen, both the *Gilles* and the Hellenistic philosopher were well known when *Le Vieux Musicien* was painted and their identification by the viewer was an important aid in arriving at a correct interpretation of the painting. It remains for us to inquire, therefore, who this philosopher is, or, rather, who Manet and his public believed him to be. Although he is now identified as Chrysippos, this identification was made only in 1890. Before that, the statue bore another head (now identified as a head of Aristotle) and was labeled "Poseidonios."[119] Most current knowledge of this late Stoic philosopher is the result of Reinhardt's researches, published in 1921,[120] but the fact that the identification of the statue was made long before that indicates that some salient feature identified with the philosopher was found to be present in the Louvre figure. Edouard Zeller, in his monumental work, *Die Philosophie der Griechen*, published originally between 1844 and 1852,[121] speaks of Poseidonios's insistence on an "ethical dualism," on our learning to distinguish the godlike or good from the animal or evil.[122] Zeller also calls attention to Plutarch's observation that Poseidonios divided all human actions and conditions into "those of the body and those of the spirit; those of the spirit influenced by the body, those of the body influenced by the spirit."[123]

117. De Goncourt, *Manette Salomon*, p. 97. Haskell has also called attention to this incident in the novel. ("The Sad Clown," pp. 10–11, and note 16.)

118. W. M. Rossetti, *Fine Art: Chiefly Contemporary* (London and Cambridge, 1867), p. 115

119. When the Aristotle head was removed, a cast of a head of Chrysippos in the British Museum replaced it. The true identity of the statue was first proposed in 1890 (see Marguerite Bieber, *Sculpture of the Hellenistic Age* [New York, 1961], p. 69, n. 62, figs. 238–40, 242; and Gisela Richter, *The Portraits of the Greeks* [London, 1965], vol. 2, p. 193), but the Poseidonios identification persisted. Baedeker and Louvre guidebooks continued to refer to the piece as Poseidonios into the 1920s. G. Geffroy's *La Sculpture au Louvre* (Paris, ca. 1920), p. 77, lists the piece as a Poseidonios.

120. K. Reinhardt, Poseidonios (Munich, 1921).

121. Edouard Zeller, *Die Philosophie der Griechen*, was originally published in Tübingen. A second edition appeared between 1856 and 1858, and two more editions were published during the 1870s. A French edition, *Philosophie des Grecs*, appeared between 1877 and 1884, and an English edition of the volume, *Stoics, Epicureans and Skeptics*, which contains the information on Poseidonios, appeared in 1870 and again in 1881. I have consulted a later German edition (see n. 122 below). It is also interesting that Michelet begins his monumental *Histoire de France* with a reference to the fact that the earliest description of the Gauls by Strabo was based on the observations of Poseidonios (vol. I., Paris, 1835).

122. Ibid., vol. 3, pt. 1 (Leipzig, 1923), pp. 604–5.

123. ψυχικά, σωματικά, σωματικὰ περὶ ψυχήν and ψυχικὰ περὶ σῶμα. Ibid., p. 604, n. 1.

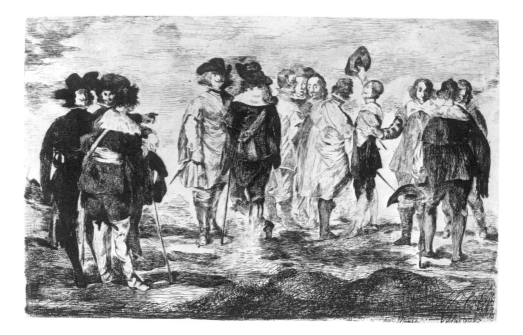

35. *Les Petits Cavaliers*, 1860, etching (third state), New York Public Library, Astor, Lenox, and Tilden Foundations.

Not only is this dualistic philosophy consistent with the gesture of the musician-philosopher in Manet's painting, but it even involves the notion of reversibility emphasized by Baudelaire, which was discussed in the preceding chapter. Although it is my contention that Manet read a great deal more than has been believed, we need not assume that he was familiar with the writings of Zeller, nor even with those of Plutarch, although this would be more likely. We need only imagine that, having found a suitable philosopher figure with the properly suggestive gesture, Manet made some inquiries about the personality and ideas of the ancient seated sage and found the information ideally suited to his purpose.

But there are still more pictorial sources used in *Le Vieux Musicien*, and given the fact that Manet relied on two for the overall composition of *Le Déjeuner sur l'herbe*, let us turn our attention now to the works that underlie the design of the earlier painting.

A work that is known to have held particular interest for Manet toward 1860 is the seventeenth-century Spanish painting in the Louvre *Les Petits Cavaliers*. At that time the picture was attributed to Velasquez and bore the title *Une Réunion d'artistes*. Since Manet copied the painting in watercolor, in oil, and as an etching (fig. 35), it would seem unlikely had such an involvement not led Manet to use the picture in the construction of an original work. Sandblad has, in fact, recognized

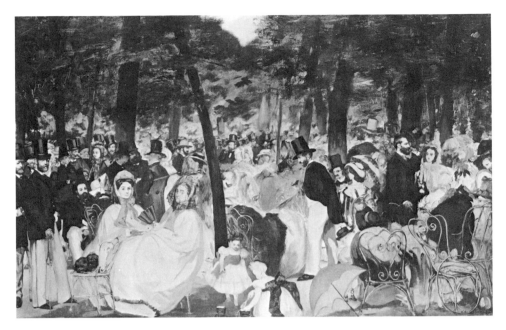

36. *La Musique aux Tuileries*, 1862, National Gallery, London.

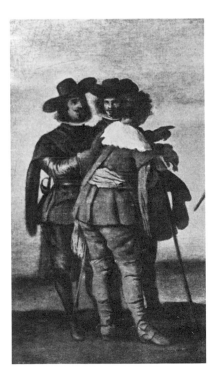

37. Detail of *Les Petits Cavaliers*, Spanish school, seventeenth century, Musée du Louvre, Paris.

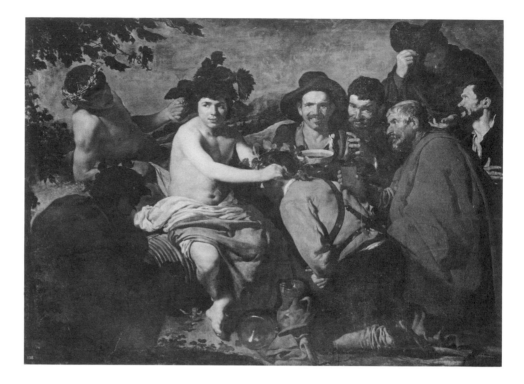

38. Velasquez, *Los Borrachos*, 1629, Prado, Madrid.

its relationship to *La Musique aux Tuileries* (fig. 36)[124] but, I believe, its role in *Le Vieux Musicien*, which Manet had exhibited with *La Musique aux Tuileries* at Martinet's in 1863, is greater. We find in *Les Petits Cavaliers* the friezelike arrangement, the division of the composition into three figure groups, and the rectangular open space in the foreground, which contains an almost identical undulating shadow. But, above all, we discover the pointing gestures that occur at both sides of the picture: in the figure at the right who, like Manet's violinist, points toward the center with a baton, while at the left the hands of two figures (believed, in the last century, to represent Velasquez and Murillo) overlap, so that one hand points toward the center group, the other downward (fig. 37) in a calculated juxtaposition reminiscent of the crossed gestures of Hera and Hermes in Marcantonio's *Judgment of Paris* (fig. 5). It also recalls the double gesture in Raphael's fresco that will find expression in *Le Déjeuner sur l'herbe*, while these frescoes (notably *The School of Athens* and *Parnassus*) are related, as we have seen (note 78), to *La Musique aux Tuileries*. The organic thematic-stylistic connections among an important group of early paintings begins to emerge, as does the basis of Manet's choice of specific old master works.

124. Sandblad, *Manet*, pp. 37–41.

39. Antoine Le Nain, *Le Vieux Joueur de flageolet (The Village Piper)*, 1644,
 The Detroit Institute of Arts.

To give his viewer directives without resorting either to vulgar anecdote or standard allegorical devices, Manet was attracted to the expedient of the dumb play of hands, which had, however, to be integrated into the overall pictorial fabric. It is natural to conclude that the pantomime theater served as inspiration here, not only in the matter of themes, but in the very technique of their artful silent communication.

The semi-concealed gestures, the distribution of figures across an ambiguous plain against an expanse of open sky, the design integration of the separate groups and the appearance in both works of the almost identical shadow configuration establish *Les Petits Cavaliers* as a basic source in the conception of *Le Vieux Musicien*, itself a crucial step toward the elaboration of *Le Déjeuner sur l'herbe* and a powerful achievement in its own right.

Velasquez's painting *Los Borrachos* (fig. 38) has long been regarded as a basic source image, but a comparison of this work with the *Vieux Musicien* is inconclusive. Although many elements of Manet's composition, such as the musician himself, the cloaked figure (a reprise of Manet's own, earlier *Buveur d'absinthe*), the closely linked pair of boys, and the grapevine at the left, remind us sharply of *Los Borrachos*, we are far from the kind of direct relationship that we find between

Le Déjeuner sur l'herbe and Raphael's *Judgment of Paris*. The kinship between *Le Vieux Musicien* and the picture by Velasquez is rather of the order of that of the *Déjeuner* to Giorgione's *Concert Champêtre*, and not even quite as strong as that. More conclusive evidence of Manet's admiration for the *Borrachos* is its appearance in the form of a print in Manet's *Portrait of Emile Zola*, painted six years later.

It has recently been discovered that the essential compositional as well as subject source for *Le Vieux Musicien* was *Le Vieux Joueur de flageolet* (fig. 39), a painting attributed to Antoine Le Nain.[125] In this work, as well as in the paintings by the brothers Le Nain in general, we find not only the monumental treatment of figures who, although combined in groups, inhabit separate worlds, but also the consistent choice of peasants, beggars, artisans, and itinerant artists as subjects. These characters, furthermore, are given a natural dignity completely devoid of false sentiment. "They do not moan; they are simple, tough and proud,"[126] and this could also be said of Manet's figures, especially of some in *Le Vieux Musicien*.

It was Paul Jamot who in 1932 saw the relationship between Manet and the Le Nains in spirit and in technique:

> It is rather odd that the same phenomenon of a Spanish affinity that is not explained by direct influences took place in the history of painting in our country at an interval of more than two centuries, and that it is found in artists who are considered representative types of the French mind and taste: Louis Le Nain and Edouard Manet.[127]

Jamot's recognition of the presence of Velasquez in the art of both Manet and the Le Nains prevented him from discerning further the direct influence of the Le Nains on Manet, who left no doubt about his interest in the French tradition when he remarked to Antonin Proust:

> There is no doubt about it, we have in France a core of honesty that always leads us back to truth, in spite of the feats of the acrobats. Look at the Le Nains, Watteau, Chardin, David himself. What a feeling for truth.[128]

125. Feller, "Study of Sources," pp. 22–23; also Reff, "'Manet's Sources,'" p. 43.

126. "Ils ne gémissent point; ils sont simples, rudes et fiers." (Blanc, *L'Histoire des peintres: L'Ecole française*, chapter on the Le Nains.) (The pagination of these volumes is not continuous; since the separate sections had appeared earlier, each one has its own pagination.) In this quotation, Blanc was referring specifically to the figures in Manet's source, *Le Vieux Joueur de fifre*.

127. "Il est assez curieux que le même phénomène d'une affinité espagnole qui ne s'explique pas par des influences directes se soit produit dans l'histoire de la peinture de notre pays à plus de deux siècles d'interval, et cela chez des artistes qui peuvent passer pour des types excellemment représentatifs de l'esprit et du goût français: Louis LeNain et Edouard Manet." (Jamot-Wildenstein-Bataille, *Manet* [Paris, 1932], vol. 1, p. 22.)

128. "Il n'y a pas à dire, nous avons en France un fonds de probité qui nous ramène toujours à la vérité, malgré les tours de force des acrobates. Regardez les Lenain, les Watteau, les Chardin, David lui-même. Quel sens du vrai." (Proust, p. 44.)

Manet, by beginning his listing with the Le Nains, was surely following his own very secure feelings in such matters. Nevertheless he was also echoing the sentiments of his friend, Champfleury, for it is to Champfleury that we owe the first modern studies of these seventeenth-century artists. In his writings on the subject, which span the period 1850 to 1865,[129] the champion of realism professed an admiration even for those qualities in the art of the Le Nains that were generally viewed as shortcomings: their faulty sense of scale, the awkwardness of the poses, the lack of direct communication between figures, and the unconventional, even bizarre, compositions:

> I even confess my weakness for their awkwardness.... It makes little difference that a figure is not in its right plane and that the back of the room seems a quarter of a mile away. It is so in almost all of the Le Nains's pictures. This awkwardness is their signature.... The Le Nains's way of composing is anti-academic; it escapes the simplest laws, they don't care to group their characters. It is obviously one of the things that attract the eye to a Le Nain painting, placed among great masters who are superior to them. Their quest for reality has even resulted in this awkwardness of placing isolated figures in the middle of the canvas; thus they are the fathers of modern experiments and their reputation can only grow.[130]

Let us compare these remarks with a recent criticism of Manet's work:

> Manet's sense of design was faulty. The result is that a number of his figure compositions—especially those like *Le Vieux Musicien*—disintegrate. Worse, the spatial illusion is flawed, at times irreparably, by a further habitual weakness ... a fallible sense of scale. ...[131]

We have seen in the *Déjeuner sur l'herbe* the kind of sophisticated purpose such distortions served, and there can be no doubt that Manet saw possibilities in the naïve features of the Le Nains's work undreamed of by Champfleury, for the writer does not deny on the one hand that weaknesses are present, but on the other he sees them as attempts at realism, leaving the two viewpoints unreconciled.

129. These writings by Champfleury include *Essai sur la vie et l'oeuvre des Le Nain, peintres Laonnais* (Laon, 1850); "Nouvelles Recherches sur la vie et l'oeuvre des frères Le Nain," *Gazette des Beaux-Arts* 8 (1860), pp. 173–85, 266–77, 321–32; *Les Peintres de la réalité sous Louis XIII, Les frères Le Nain* (Paris, 1862); "Catalogue des tableaux des Le Nain," *Revue universelle des arts* 14 (1861–62); *Documents positifs sur la vie des frères Le Nain* (Paris, 1865).

130. "J'avoue même ma faiblesse pour leur maladresses ... il m'importe médiocrement qu'une figure ne soit pas à son plan et qu'au fond d'une chambre elle paraisse éloignée d'un quart de lieue. Il arrive ainsi dans presque tous les tableaux des Le Nain. Cette maladresse est leur signature.... Leur façon de composer est anti-académique; elle échappe aux plus simples lois, ils ne s'inquiètent pas de grouper leurs personnages. C'est évidemment une des causes qui attirent le regard vers un tableau de Le Nain, placé au milieu de grands maîtres qui leur sont supérieur. Ils ont cherché la réalité jusque dans cette inhabilité à placer des figures isolées au milieu de la toile; par là ils sont les pères des tentatives actuelles, et leur réputation ne peut que s'accroître." (Champfleury, "Nouvelles recherches," p. 180.)

131. Richardson, *Manet*, p. 13.

40. Louis Le Nain, *La Halte du cavalier*, ca. 1640, Victoria and Albert Museum, London.

Be that as it may, we cannot fail to recognize in Champfleury's description of the anti-academic compositions spatial inconsistencies, oddly grouped figures, and the attraction exercised by these qualities, features that apply remarkably well to the art of Manet.

Another Le Nain painting bears a particularly strong resemblance to *Le Vieux Musicien*, and that is *La Halte du cavalier* (fig. 40), believed to have been done by Antoine's brother, Louis. In 1933, a year after Jamot had observed the relationship between Manet and Louis Le Nain, Paul Fierens discovered the specific similarities between *La Halte du cavalier* and *Le Vieux Musicien*:

> If *La Halte du cavalier*, with its big sky and its bare plains, a decor that has nothing decorative about it, presents a frieze of peasants who, each for himself and each according to his mood, live, meditate, or smile, and look at the spectator; if it is true again that this work lacks the formal exterior unity a skillful painter achieves . . . still the truth of the characters

as well as the strength and personality of each figure, taken by itself, reminds one of the masterpiece of Manet, *Le Vieux Musicien*, that challenge to the ordinary laws of composition, this picture without subject whose characters seem to say to us: We are here. What more do you want?[132]

Fierens not only has the distinction of having discovered the similarities between the two paintings, but he is the first critic to have seen the strange composition of *Le Vieux Musicien* as intentional and the only one who has qualified the picture as a masterpiece. Nevertheless, he finally attributes the relationship, as does Jamot,[133] to their common dependence on Velasquez and labels it "fortuitous," the result of the demands of the art of painting alone.

Although we cannot prove that Manet ever saw *La Halte du cavalier* (and it has never been engraved), in view of Champfleury's love for these painters from Laon (his own city of origin) and the catalogue of their works that he established, we cannot accept these similarities as purely fortuitous. Manet may have seen the relationship of the Le Nains's painting to *Los Borrachos* (a relationship that may, indeed, be fortuitous), but in this case he worked more directly from the French picture, or so it would seem. One version of *La Halte du cavalier* is in the Victoria and Albert Museum, a gift of Dr. Ionides, who had acquired it at a Christie's sale in 1884. Another appears always to have remained in France, for a painting that fits its description was included in the Francillon sale of 1828,[134] while in 1907 it was described and reproduced in the Parisian catalogue of the dealer Charles Sedelmayer.[135]

We need pursue this line of inquiry no further, however, since, close as the *Halte du cavalier* is to *Le Vieux Musicien*, *Le Vieux Joueur de flageolet* is closer to it. Here we find once again the cloaked, seated figure, but now aged and with curly hair, like Manet's musician, and holding a musical instrument. The two boys are present again, and here their poses are still closer to those of Manet's pair. At the right, in the position of the milkmaid (although reversed) is a young girl, closer in type to the corresponding figure in Manet's painting and turned

132. "Si *La Halte du cavalier*, avec son grand ciel et ses plaines nues, décor qui n'a rien de décoratif, offre un frise de paysans qui, chacun pour soi et chacun selon son humeur, vivent, méditent ou sourient, et regardent le spectateur; s'il est vrai que cette oeuvre, encore une fois, manque de l'unité formelle, extérieure, qu'un peintre habile obtient.... La bonne foi de l'énumération, en même temps que la force et le caractère de chaque figure isolément pris, nous évoque l'un des chef d'oeuvres de Manet, *Le Vieux Musicien*, ce défi aux lois ordinaires de la composition, ce tableau sans sujet dont les personnages semblent nous dire: Nous sommes là. Que vous faut-il de plus?" (Paul Fierens, *Les Le Nain* [Paris, 1933], p. 29.)

133. See note 127 above.

134. Champfleury, *Catalogue des tableaux des Le Nain*, pt. 2, p. 104.

135. *Catalogue des tableaux composant la collection Ch. Sedelmayer, I*ère *vente* (Paris, 1907), no. 222. An interesting, if marginal, piece of evidence can be brought to bear concerning Manet's dependence on this Le Nain painting. Picasso's *Famille de Saltimbanques*, painted in 1905, has generally been related to Manet's *Vieux Musicien*. It seems likely that Picasso either recognized the similarity between the paintings by Le Nain and Manet or between the Le Nain and his own, for one version of *La Halte du cavalier* was in his own private collection (Fierens, *Les Le Nain*, p. 29).

slightly toward the profile view. Behind the piper is a figure higher than the others and cut by the picture frame like the marginal character, traditionally called a Turk,[136] in Manet's painting. The boy who looks intently at the piper has been omitted, perhaps because of Manet's habitual avoidance of direct confrontations, as well as because of its superfluity. Manet has, however, maintained Le Nain's total number of six characters by including the *Buveur d'absinthe*. Although *Le Vieux Joueur de flageolet*, unlike *La Halte du cavalier*, does not have a specifically outdoor setting, the location remains ambiguous, a device that Manet himself turned to effective use in a number of later works, which are set against a neutral ground. Possibly the most interesting relationship between the Le Nain painting and *Le Vieux Musicien* is a geometric one, for not only is the frieze design present in both, but the curvature of Le Nain's piper and that of the boy furthest to the right suggest the circle into which Manet inscribed his equivalent figures.

Le Vieux Joueur de flageolet remained in England during Manet's lifetime, which reduces, if it does not eliminate, the possibility of his having seen it in the original. It was, however, engraved four times. The two earliest engravings, for stylistic reasons, could not have served as Manet's models.[137] The third engraving, *Le Vieillard complaisant*, is listed among Champfleury's collection of prints and drawings.[138] It was either this print or a fourth reproduced in Charles Blanc's first volume of *L'Histoire des peintres de toutes les écoles*, which appeared in 1860, that served Manet as a source. In his chapter on the Le Nains, Blanc wrote:

> Their painting is prose, but a firm and clean prose. They represented the lower classes, in their robust way of life, without beautifying it, without distorting it either . . . maybe even by adding to it a certain calm dignity. If I am not mistaken, the Le Nains's peasants, smiths, laborers, and poor people appear before us again one hundred years later having arrived at an honest comfort, refined and clad as bourgeois in the paintings of Jean-Baptiste-Siméon Chardin.[139]

136. Duret had described the figure as an "oriental" in 1902 (see note 92 above) and the tradition of the "Turk" has no doubt been fostered by an anonymous cartoon of the *Vieux Musicien* that emphasizes the Turkish aspects of the figure. It is discussed by E. Moreau-Nélaton in his *Manet raconté par lui-même* (Paris, 1926), vol. 1, p. 47, with the cartoon on the opposite page.

137. These appear in: W. Ottley, *Engravings of the Marquis of Stafford's Collection of Pictures* (London, 1818), no. 46, and *A Catalogue of the Collection of the Most Noble Marquis of Stafford at Cleveland House* (London, vol. 2, 1825), no. 155. There is more space on either side of the figure group than in later engravings, and, in the 1825 piece, the "Gilles" is given in an uncharacteristic *contrapposto*.

138. *Les Estampes de Champfleury* (sales catalogue, Paris, 26–28 January 1891), p. 48, no. 243. The print is entitled *Le Vieillard complaisant*.

139. "Ils ont fait de la prose, mais une prose ferme et claire. Ils ont représenté le peuple dans sa robuste allure, sans l'embellir, sans l'enlaidir non plus . . . peut-être même en y ajoutant une certaine dignité calme. Si je ne me trompe, les paysans de Le Nain, ses forgerons, ses travailleurs, ses pauvres, nous les trouverons cent ans plus tard, parvenus à une honnête aisance, vêtus en bourgeois et raffinés, dans les tableaux de Jean-Baptiste Siméon Chardin."

The heritage to which Charles Blanc refers is precisely that aspect of the French tradition that Manet appreciated when he remarked upon the wealth of French painting dedicated to "le vrai." His listing of artists also includes the Le Nains and Chardin. It was natural for him to add his own name to the list, as the "realist" of the 1860s.

The identification of the Le Nains as an early source for Manet's art has more than historiographic importance. We discover that at least as early as 1862 Manet sought a grandeur of theme expressed through humble subject matter; and he found echoed in the descriptions of Champfleury and Blanc his own reactions to the ability of the Le Nains to communicate their charm, force, and sense of truth in so arresting and original a manner. The great difference between the works of the Le Nains and that of Manet is that it is easier to accept the description of the Le Nains's characters as simply posing for their portraits than it is to believe this of the figures in Manet's work. Both Manet and the Le Nains were more interested in the state of being than of doing, but Manet's figures have greater insistence, are less good humored, and impress us as more willful and subtle in their assigned roles. Manet began with the starkness and the awkwardness of the Le Nains, only to make use of these qualities in the construction of a picture that is patently more symbolic and philosophic. If genre and Salon allegory would no longer do for Manet, a clue to the right direction lay in the unexpected and unaccustomed grouping of the figures.

Furthermore, Manet, given the direction toward flattening that his work was taking, could only have admired the inventive and attractive surface patterns at the expense of convincing space in the art of the Le Nains.

Singularly important is Champfleury's observation in regard to the Le Nains's ability to capture and hold the viewer's attention. Manet's work demands long contemplation, if we expect the idea behind the picture to reveal itself; for this idea is contained within the relationship between the structure and the source references of *Le Vieux Musicien*.

With the Le Nains established as the most important old masters behind the composition of *Le Vieux Musicien*, we are led securely back to the relationship between Manet and Champfleury. The writer had cherished the kinship between the sober art of the Le Nains and Courbet's *L'Après-diner à Ornans*, painted shortly before Champfleury's first publication on the masters of Laon. Courbet, in Champfleury's view, no longer possessed this quality in 1860, while Manet not only captured the striking character of the Le Nain images but adopted their

The effect of Manet's painting is precisely the effect of the Le Nain as it is further described by Blanc: "La scène, qui paraissait indifférente quand on l'avait vue des les champs ou au detour d'une rue, vous arrête à coup sûr, des qu'on la rencontre en un tableau de LeNain." [The scene, which seemed ordinary when observed in the fields or on a street corner will stop you in your tracks when found in a painting by Le Nain.] (*L'Histoire des peintres: L'Ecole française*, vol. 1.)

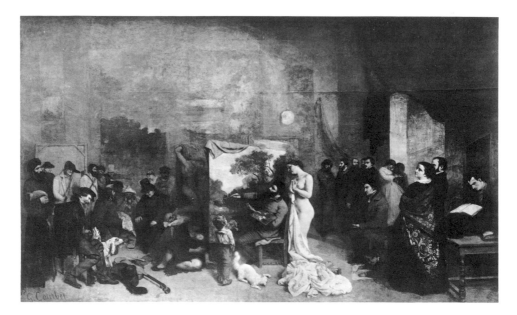

41. Courbet, *L'Atelier du peintre*, 1855, Musée du Louvre, Paris.

theme and composition.[140] But given Manet's association with Champfleury at this time and the latter's disenchantment with Courbet, we are prone to attribute some importance to the curious relationship that exists between *Le Vieux Musicien* and a major painting by Courbet, *L'Atelier du peintre* (fig. 41), which had been exhibited in 1855.

Courbet and Manet shared, for a time, the label of "realist," and Manet was regarded by many as Courbet's legitimate heir. It is curious, therefore, that so little information relevant to their relationship has reached us. There is, in fact, no clear evidence that they even knew each other, although this is highly unlikely.[141] On one occasion, Courbet refused to visit a Manet exhibition and sent his sister in his place, with these words:

> I would not like to meet this fellow who is likeable, hard-working, who is trying to succeed. I would have to tell him that I don't understand anything about his painting, and I do not want to be unpleasant to him.[142]

140. For a discussion of Champfleury's changing attitudes see Meyer Schapiro, "Courbet and Popular Imagery," *Journal of the Warburg and Courtauld Institutes* 4 (1940–41), pp. 186–88.

141. Manet made a portrait of Courbet in an ink wash technique, but, lively as it is, it was made after a photograph. See Alain de Leiris, *The Drawings of Edouard Manet* (Berkeley and Los Angeles, 1969), p. 29.

142. "Moi, je n'aimerais pas rencontrer ce garçon, qui est sympathique, travailleur, qui tâche d'arriver. Je serais obligé de lui dire que je ne comprends rien à sa peinture, et je ne veut pas lui être désagréable." (G. Riat, *Gustave Courbet* [Paris, 1906], p. 146.)

Rewald feels that there is reason to associate this statement with Manet's private exhibition of 1867, when Courbet also held one nearby.[143] It is strange to think of the two artists, linked in so many ways, with adjacent private pavilions necessitated by the hostility shown to both on the occasion of the Paris World's Fair of 1867, resolutely avoiding one another. But if Courbet rejected Manet's art entirely, Manet's positive judgment of one painting by Courbet is recorded. Proust recalls Manet's enthusiasm for the *Enterrement à Ornans*:

> Yes, *L'Enterrement* is very good. One cannot say often enough that it is very good, because it is better than anything.[144]

We cannot be surprised at such admiration for this sober, unsentimental work, but we detect Manet's view of Courbet as a primitive not only in his legendary "bonhomie" toward the peasant and in his crude manners, but in the growth of a new pictorial concept, when he adds:

> But, between us, it is not right yet. It is too dark.[145]

This view of Courbet is similar to the one intimated by Champfleury, that the painter had prepared the way for another, a new Velasquez.[146] Champfleury never championed Manet in print as he had Courbet, but he became his friend, had planned to accompany him to Spain in 1865 (they did not, finally, make the trip together), and collaborated with him on a book, *Les Chats*, in 1869. During the early 1860s both men were friendly with Baudelaire, who received them for luncheon in his apartment.[147] After 1855, the year of *L'Atelier*, Champfleury complained increasingly about Courbet as man and artist. In 1856 he wrote to the poet Max Buchon:

> Since his exhibition, he has done nothing but haunt the cafés, preach. . . .
> I deplore his lack of common sense.[148]

And in another letter, the following year, he wrote:

> The comedy of realism irritates me. I have arrived at the position of

143. John Rewald, *The History of Impressionism*, rev. ed. (New York, 1961), p. 172 and p. 194, n. 39.

144. "Oui, c'est très bien, *L'Enterrement*. On ne saurait dire assez que c'est très bien, parce que c'est mieux que tout." (Proust, p. 30.)

145. "Mais entre nous, ce n'est pas encore, ça. C'est trop noir." (Ibid.)

146. Champfleury, *Grandes Figures d'hier et d'aujourd'hui* (Paris, 1861), p. 252. Champfleury's words are cited in English by Rewald, *History of Impressionism*, pp. 50–51.

147. Baudelaire, *Correspondance*, vol. 4, p. 152. In a letter dated 14 March 1863, Baudelaire mentions that Manet is expected at his apartment the following day. In another letter (ibid., pp. 147–48), dated 4 March, he invites Champfleury for luncheon on the eighth.

148. "Depuis son exposition il n'a rien fait que courir les cafés, prêcher. . . . Je déplore son manque de bon sens." (Léonce Bénédite, *Courbet* [Paris, n.d.], pp. 53–54.)

Courbet: I am like a cat who escapes, dragging by his tail the pan of realism that some scamps have tied to it.[149]

Meyer Schapiro has explained how Champfleury had become suspicious of the positivist notion of social progress, and how he turned his attention to such symbolic figures as "le bonhomme misère" and the Wandering Jew as "vehicles of timeless, simple truth."[150] The universal meaning of the realist subject, then, of which Champfleury had always been aware (as we have seen in his pantomimes of the 1840s), became, with maturity, the principal consideration. *L'Enterrement* of 1850, in its simple, monumental power, had fulfilled Champfleury's requirements. In 1851, with Courbet in mind, Champfleury had written "skilled art acquires the same accent as naïve art,"[151] and, whereas this characterized *L'Enterrement* well, it did not seem to the writer that it could still be applied to *L'Atelier* and the later works, with the exception of the landscapes. It is interesting that while Courbet was a "naïf" in personality, his art was increasingly "savant." Exactly the opposite is true of Manet, whose taste and manners were highly sophisticated, whereas his art struck many as unskilled. The reversal of these traits corresponded fully to Champfleury's conscious new position.

Baudelaire, too, had early been drawn to Courbet and had visited his studio, but he resisted succumbing to realist slogans and turned against the movement more forcefully than had Champfleury. In 1855 he had attacked the idea of progress and, in his writings on Delacroix, had termed realism vague and obscure and its followers vulgar and myopic.[152] His friendship with Manet flourished after 1860, and, in his only article on the painter, he praised his sensitivity and imagination, without which "all the best faculties are only servants without a master."[153]

Affinities between *L'Atelier* and *Le Vieux Musicien* have been observed several times, but a serious comparison of the two works on the combined stylistic and iconographic levels has not been undertaken.[154]

Courbet provided Champfleury with a full key to his picture in a long letter written in 1855. Although not every detail of the description corresponds to the finished painting, the portions that follow contain only specifications that the artist retained:

149. "La comédie du réalisme m'irrite—j'en suis juste à la position de Courbet comme un chat qui se sauve, trainant à sa queue la casserole du réalisme que des polissons y ont attaché." (Ibid.)

150. Schapiro, "Courbet and Popular Imagery," p. 187.

151. "L'art savant trouve le même accent que l'art naïf." (Champfleury, *Grandes Figures*, p. 244. Cited by Schapiro "Courbet," p. 165.)

152. Baudelaire, *O.C.*, pp. 958–59, 1119.

153. "... toutes les meilleurs facultés ne sont que des serviteurs sans maître." (Ibid., p. 1146.)

154. See Robert Rey, *Manet*, trans. E.B. Shaw (Paris, 1938), p. 11; Richardson, *Manet*, p. 11; Bowness, "A Note on Manet's Compositional Difficulties," p. 276 (who believes that *Le Vieux Musicien* and *La Musique aux Tuileries* together refer to *L'Atelier*); E. Bazire, *Manet* (Paris, 1884), p. 15.

The scene takes place in my studio in Paris. The painting is divided into two parts. I am in the middle, painting. On the right all the shareholders, that is, the friends, the active ones, lovers of art. ... On the left, the other world of daily life, the lower classes, poverty ... people who live on death. In the background ... hang the pictures. ... At the edge of the canvas is a Jew I saw in England ... he had an ivory face, a long beard, a turban, and a long black robe that trailed on the ground ... Second part: then comes the canvas on my easel and me painting ... behind my chair is a nude model; she leans on the back of my chair, watching me painting for a moment; after this woman comes Promoyet with his violin under his arm ... people who want to judge will have their work cut out for them. They'll manage as best they can.[155]

This letter was known to Baudelaire, who planned a review of the painting with the title "Si réalisme il y a," a phrase taken from Courbet's text.[156] Houssaye, who identified the figures in his published review, also must have been familiar with Courbet's description.[157] In fact René Huyghe says of the letter, "Certainly in 1855 it went the rounds of the studios and of his friends' homes. ..."[158] Manet, then, was surely aware of Courbet's intentions in regard to *L'Atelier*, if not in 1855 then certainly by 1862 when he painted *Le Vieux Musicien*, for the famous letter suggests that Manet's idea for his monumental work may have originated with it. The full title of Courbet's painting was *L'Atelier du peintre: allégorie réelle déterminant une phase de sept années de ma vie artistique*. The title was generally laughed at, and Champfleury had written, "An allegory cannot be real, any more than a reality can become allegorical."[159] Perhaps to Manet the contradiction appeared to be superficially treated by Courbet and was not an absurdity in itself, for his *Vieux Musicien* is not only precisely what Courbet claimed his work to be—a clear, realistic view of life, heightened to the level of allegory—but a statement about life's dual nature, as suggested by Courbet's division of his

155. "La scène se passe dans mon atelier à Paris. Le tableau est divisé en deux parties. Je suis au milieu, peignant—à droite [sont] tous les actionnaires, c'est à dire les amis, les travailleurs, les amateurs du monde de l'art ... à gauche l'autre monde de la vie triviale, le peuple, la misère ... les gens qui vivent de la mort. Dans le fond ... sont pendus les tableaux.... Au bord de la toile se trouve un Juif que j'ai vu en Angleterre.... Il avait une figure d'ivoire, une longue barbe, un turban, puis une longue robe qui trainait à terre.... Seconde partie: puis vient la toile sur mon chevalet, et moi peignant.... Derrière ma chaise est un modele de femme nue; elle est appuyée sur le dossier de ma chaise, me regardant peindre un instant; à la suite de cette femme vient Promoyet avec son violon sous le bras ... les gens qui veulent juger auront de l'entourage. Ils s'en tireront comme ils pourront." (The letter is given in its entirety in René Huyghe, Germain Bazin, and Hélène Adhémar, *Courbet, L'Atelier du peintre, Allégorie réele, 1855* [Paris, 1944], pp. 23–24.)

156. Ibid.

157. Ibid.

158. "Elle a certainement en 1855, circulé dans les ateliers et chez les amis...." (Ibid., p. 23.)

159. "Une allégorie ne saurait être réelle, pas plus qu'une réalité ne peut devenir allégorique." (Ibid., p. 25, citing from *L'Artiste* 2 [1855], pp. 3–4.)

canvas into two opposing halves. If Courbet's work is concerned with a period of seven years of his own life, Manet, with fewer characters, is less personal, more universal. We can only find it natural that Manet, who professed a distaste for history painting and its pomp, sought to condense his group pictures to as few figures as possible. In *Le Vieux Musicien*, he limited himself to the "half-dozen names" that Gautier claimed to be an adequate symbol of all the situations of life; with reference to *L'Enterrement*, a painting that he admired, Manet is reported to also have remarked:

> If only this ox Courbet heard you! What *he* calls real.... Look, in his *Enterrement d'Ornans*, he managed to bury everybody: priests, gravediggers, undertakers, members of the family, even the horizon, which is ten feet underground.[160]

And as late as 1861 Champfleury had written with specific reference to *L'Atelier*:

> Even Courbet managed to go completely astray as in *L'Intérieur de l'atelier*, which is not one picture, but ten pictures.[161]

In both *Le Vieux Musicien* and *L'Atelier* there is the central, controlling figure of the artist seated between the positive and the gloomy sides of the composition (Courbet had spoken of "les actionnaires" and "ceux qui vivent de la mort"); Manet has placed only children on one side, and the mysterious "buveur d'absinthe" and the aged, bearded figure on the other. Even the sky becomes overcast above the dark figures, in the manner of a *paysage moralisé*. The violinist in Manet's painting sits with his back turned toward the figures of darkness, while the *buveur* looks over his shoulder, as Courbet described the activity of the nude model behind his chair. The *buveur*, originally conceived in 1858–59 (fig. 99), in this painting must be seen as a multiple symbol. He is, at once, the painter's model, his view of "real life," the subject of one of his older paintings (Courbet had described the presence of his older works on the wall of his studio), and a part of the painter's past.

The first figure described by Courbet in his letter is the Jew he had seen in London, who is situated "au bord de la toile." If we look at the right edge of *Le Vieux Musicien* (for Manet had reversed the positions of Courbet's "life" and "death" groups), we find the old, bearded man, who has generally been described as a Turk. In view of the other analogies with Courbet's picture, we may indeed ask whether this "Turk" is not rather a Jew. Both figures wear turbans, both wear beards and long robes, both are placed at the pictures' edges, and both are included in the tragic groups. We should also take into account the fact that in

160. "Si ce boeuf de Courbet vous entendait; lui, ce qu'il appelle être réel.... Tenez, dans son *Enterrement d'Ornans*, il a trouvé le moyen d'enfouir tout le monde: prêtres, fossoyeurs, croquemorts, l'horizon même est à dix pieds sous terre." (Ambroise Vollard, *Souvenirs d'un marchand de tableaux* [Paris, 1937], p. 173.)

161. "Il est arrivé même à Courbet de s'égarer tout à fait, comme dans *L'Interieur de l'atelier*, qui n'est pas un tableau, mais dix tableaux." (Champfleury, *Grandes Figures*, p. 258.)

42. *Le Juif errant*, French popular print of the
eighteenth century, from the frontispiece
of Champfleury's *Imagerie Populaire*, 1869.

an address book that Manet had kept at this time, there is an entry that reads,
"Guéroult, vieux Juif à barbe blanche" ["Guéroult, old Jew with white beard"].
Tabarant, who published this information, assumed that this was a reference to
the model who had posed for the figure of the violinist.[162] This conclusion has
never been questioned, but it seems more likely that if Guéroult had posed at all,
it was rather for the marginal "Turk," whose long white beard fits Manet's de-
scription far better than does the shorter gray one of the musician-philosopher.

This aged and tragic figure, who terminates Manet's frieze of life, is made to
stand forward, closer to the picture plane, like the little girl holding the infant,
and is turned inward, facing in her direction. The effect of this bracketing of the
continuum by its beginning and terminal elements is to suggest the cyclical
character of life. The same facing inward and toward each other by the marginal
figures occurs in the Currier print (fig. 34). This note of immortality lends support
to a specific identification of this venerable figure, already suggested by his stick,
his turban, the position of his hands, and his general mien, as Ahasuerus, the
Wandering Jew or eternal man who, according to ancient legend, had been present
at Christ's Passion and still walked the earth.[163] The identification is further

162. Tabarant, *Manet et ses oeuvres*, p. 47.
163. In her article "Popular Imagery and the Work of Edouard Manet" (*French Nineteenth
Century Painting and Literature* [New York, 1972], pp. 133–63) Anne Hanson has made this
identification without reference to the meaning of the painting (pp. 144–45). In the context
of her investigation of popular prints, the identity of the figure is, apparently, obvious. It is
encouraging to see that all roads lead home. In the same article, a figure in a painting by
Henri-Guillaume Schlésinger, *L'Enfant volé* (a scene of gypsy life related to Manet's "bo-
hemiens"), is convincingly presented as a source for the little girl holding the baby in *Le
Vieux Musicien* (p. 146 and note 51, with illustration on p. 141).

43. Rembrandt, *The Mocking of Christ* (detail),
 1655, etching (fourth state).

strengthened by the fact that Champfleury, whose role in the genesis of *Le Vieux Musicien* has been seen to be capital, had been deeply involved in a study of the legend of the Wandering Jew since about 1850 and would publish the results in 1869 in his *L'Histoire de l'imagerie populaire*.[164] In fact Champfleury, one of the leading authorities on the subject,[165] points out in that work that the Wandering Jew was by far the most popular theme of popular imagery and appears in prints produced at Paris, Epinal, Metz, and Nancy (fig. 42).

Meyer Schapiro has shown that a strong relationship exists between Courbet's *L'Enterrement* and popular prints illustrating "les degrés d'âge,"[166] a subject that has its part in *Le Vieux Musicien*. In addition to the presence, in an analogous location, of an aged Jew in Courbet's *L'Atelier*, we now know that he, too, had been interested in the theme of the Wandering Jew and had portrayed himself in that role in 1854 in his painting *Le Rencontre*, better known as *Bonjour, Monsieur Courbet*.[167] While *Le Vieux Musicien* also recalls the flatness and naïveté of popular prints, the figure of Ahasuerus is not based formally on any of these. He recalls, rather, the aged Jew placed at the left margin of Rembrandt's print *The Mocking of Christ* (fig. 43), where he is also seen in profile, cut by the picture frame, with

164. Champfleury, *L'Histoire de l'imagerie populaire* (Paris, 1869), pp. 1–104. An image of the Wandering Jew was used as a frontispiece.

165. Linda Nochlin, "Gustave Courbet's *Meeting*: a Portrait of the Artist as a Wandering Jew," *Art Bulletin* 49 (1967), p. 214.

166. Schapiro, "Courbet and Popular Imagery," p. 167.

167. Nochlin, "Courbet's Meeting," pp. 209–22.

one hand on his stick and the other, with clenched fingers, brought up to his breast. Since, according to the legend, Ahasuerus had been present at Christ's Passion, we can understand Manet's having taken recourse to this figure. He has only changed the direction of his glance to accommodate him to his new situation, where the spectacle is absent. The downward gaze also serves to accentuate the tragic and timeless character of the specific symbolic figure he had in mind.

Finally, we should consider the appropriateness of the presence of Ahasuerus in a scene that alludes clearly to the world of the commedia dell'arte. Since Manet's reference is not so much to the specific characters of the pantomime but to its philosophic import, the figure would present no real problem in this company. However, let us remember the popularity of the Wandering Jew through the medium of prints, broadsides, and the widely read novel by Eugène Süe published in 1845. It is not surprising, in view of such popularity, that in 1849 a mime play entitled *Le Juif Errant*, in which Ahasuerus was joined by Pierrot and his friends, entered the repertoire of the Théâtre des Funambules.[168]

According to the legend, as recounted by Champfleury, Ahasuerus, upon reaching the age of one hundred, would be stricken by a severe illness and as he was on the brink of death would be restored to youth once again. This pattern was repeated over and over again through eternity. In the representations of the "stages of life," the tenth and last stage was age one hundred, at which point an angel and a devil lay in wait for the traveler who had come to the end of the road of life. Manet has turned the figure inward, as we have already indicated, to suggest the rebirth of the cycle.

In our discussion of the composition, we observed that the sleeve edge of this marginal figure, whom we may now call Ahasuerus, is contiguous with the descending curve drawn across the cloak of the adjacent figure, the reprise of the *Buveur d'absinthe*. The model for the original *Buveur* had been a ragpicker by the name of Colardet, whom Manet had seen at the Louvre.[169] In that painting Manet had included an overturned bottle at the figure's feet, the only attribute that specifically justified the title of the painting. In *Le Vieux Musicien* this prop has been removed, and in addition to the several roles played by this character enumerated earlier, we have every reason to identify him here in the life-role of the model, that of a ragpicker, readily recognized as such by the Parisian public of Manet's time. These "chiffonniers" had come to be considered in a romantic light, and Fournel tells as that they were generally thought of as fallen angels,[170] an association consistent with the descending line of which this figure is a salient part and with his juxtaposition with Ahasuerus. It is even probable that Manet had this identification in mind in painting the original *Buveur*, with its melancholy air and the sides of the cloak that curve downward like the dark wings of a bat, and hoped to remind the viewer of this association through the expedient of the more prosaic, but accessible reference to the man "fallen" as a result of his vice.

168. Péricaud, *Le Théâtre des Funambules*, p. 347.

169. Moreau-Nélaton, *Manet raconté par lui-même*, vol. 1, pp. 25–26.

170. Fournel, *Ce qu'on voit*, pp. 344–45.

The two sides of the painting, then, despite their being part of the continuum of the "stages of life," are placed into sharp opposition to each other, a paradox succinctly expressed in the "two Pierrots," or *homo duplex* idea, pointed out by the philosopher. The benevolence and wisdom of the repentant Ahasuerus, placed after the fallen man, returns the viewer to a renewal of life.

In the *Déjeuner sur l'herbe* the figure of the dandy as philosopher was posed by Manet's brother and may, of course, be interpreted as symbolizing the artist, since it is his gesture that indicates the theme to the viewer. The philosopher in *Le Vieux Musicien*, who makes a similar silent observation, represents Manet himself with even greater certainty, in view of the fact that he occupies a position analogous to that of Courbet's self-portrait in *L'Atelier*.[171] Manet's more universal and timeless theme no doubt prompted the change in locale from the artist's studio to an ambiguous outdoor setting, less restrictive in its associations. (Here he may have taken his lead from Velasquez, to whose setting he transferred the indoor composition of Le Nain.) Just as the artist has been represented generically, and is not presently engaged in the practice of his art, so his setting is "the world" and his subject "life." Nevertheless, the reference to the theater suggests the Shakespearean notion of the world serving as a stage and recalls Gautier's remark that Shakespeare was perfectly at home at the Funambules.

By means of a carefully arranged set of poses and formal relationships, through references made to familiar concepts by means of allusions to well-known works of art and, finally, through the use of living models and a spontaneous, fresh technique, Manet communicates a complex and profound idea without violating his concept of the expressive means peculiar to painting. In his fidelity to his medium he has, like the characters of that other silent art, the pantomime, avoided becoming either ridiculous or banal.

171. In addition to the symbolic identification of himself with the philosopher-artist, there is an actual resemblance between the musician and Manet. Beneath the disguise of venerable age, we discover the curly hair, the fallen forelock, the curve of the nose, and set of the mouth of Nadar's famous photograph. Even the head of Aristotle, which adorned the Louvre statue in Manet's time, is not without a resemblance to the artist.

Olympia

For Manet's painting *Lola de Valence* of 1862 Baudelaire wrote the following quatrain:

> Entre tant de beautés que partout on peur voir
> Je comprends bien, amis, que le désir balance,
> Mais on voit scintiller dans Lola de Valence
> Le charme inattendu d'un bijou rose et noir.[172]

> [Among so many beauties everywhere visible
> I understand, my friends, that desire is hesitant to choose,
> But we see in Lola de Valence
> The unexpected charm of a rose and black jewel.]

The poet cites the colors rose and black, not really the dominant ones of the painting, as its "charme inattendu" and associates them with the multiple splendors among which he finds it difficult to choose. Although these four lines are seemingly straightforward, they actually inspire a number of questions. In speaking of "Lola de Valence," does the poet refer to the woman or the painting as a work of art?[173] Why is the charm, of the woman or the picture, unexpected? Why does a problem of choice among seductive details exist? And why the selection of the colors rose and black? These colors, in the context of making a choice, occur in "Toute Entière," one of Baudelaire's poems from *Les Fleurs du Mal*. In the longer poem, Baudelaire gives us a fuller explication of his symbols. Here, the demon appears to the poet one morning and, in an attempt to mislead him, asks:

> Parmi toutes les belles choses
> Dont est fait son enchantement,
> Parmi les objets noirs ou roses
> Qui composent son corps charmant,
> Quel est le plus doux?[174]

> [Among all the lovely things
> That make up her enchantment,
> Among the rose and black objects
> That compose her charming body,
> Which is the sweetest?]

172. Baudelaire, *O.C.*, p. 152. The poet wished to have his verse inscribed on the painting itself. It was finally written on the frame instead.

173. Tabarant maintains that Baudelaire had originally written "en Lola" but quickly changed it to "dans Lola," thereby shifting the emphasis from the woman to the picture. (Tabarant, *Manet et ses oeuvres*, p. 53.)

174. Baudelaire, *O.C.*, p. 40. Alain de Leiris has noted the presence in both poems of the black and rose jewel in his essay, "Baudelaire's Assessment of Manet," *Hommage à Baudelaire* (exhibition catalogue, University of Maryland, 1968), p. 10.

In "Toute Entière" Baudelaire specifies that actually to be led to make a choice is a grave error, that it amounts to falling into the devil's trap. The poet evades the pitfall and proclaims the importance of the whole. The woman ("elle") in question remains completely mysterious and seems to be symbolic of any attractive entity encountered in life, and the "rose" and the "noir" are the polarized attracting forces of a higher and a lower or of a benevolent and malevolent order, once again.[175] This impression is reinforced by a similar juxtaposition further on in the poem:

> Lorsque tout me ravit, j'ignore
> Si quelque chose me séduit.
> Elle éblouit comme l'Aurore
> Et console comme la Nuit.

> [When the whole enchants me, I am indifferent
> To the seductiveness of a part.
> She shines like the dawn
> And comforts me like the night.]

The word "ravit" is used here in its spiritual sense (as in "ravir l'âme") and refers to the effect of the whole, in opposition to the more sensual "séduit," a response to a part only; the last two lines oppose day and night along with the emotional states of excitement and calm, respectively (associations that could easily be reversed). In the last verse, Baudelaire describes his synesthetic experience, in which the interchangeability of the senses prepares the way for an awareness of their single spiritual source.

The brief "Lola de Valence," then, is simply a reference to "Toute Entière" and its philosophy. As far as Manet is concerned, the verse may be assumed to refer superficially to the woman of the title, on a deeper level to the concept of the painting, and, fundamentally, to its creator, Manet, as a kindred spirit. The charm is "inattendu" because the qualities of the "rose" and the "noir," although originating from opposing realms, are understood to be interdependent by the painter-philosopher.

That Manet did share this most central of Baudelaire's beliefs must have been known at least to a few friends of the artist. In 1867 Philippe Burty wrote to Manet asking him to contribute an illustration to a collection of thirty sonnets. "Voici un sonnet qui me paraît cadrer parfaitement avec ce que nous connaissons de

175. Baudelaire is quite explicit about this polarity in a note accompanying his verse "Lola de Valence," published in the collection *Les Epaves*. In answer to charges of obscenity, Baudelaire states that "le poète a voulu simplement dire qu'une beauté, d'un caractère à la fois ténébreux et folâtre, faisait rêver à l'association du *rose* et du *noir*" [the poet simply wished to say that a thing of beauty, simultaneously sinister and playful, evoked dreams of the association of *rose* and *black*]. (Baudelaire, *O.C.*, p. 1571.) This pairing of the apparently incompatible "ténébreux" and "folâtre" recalls the poet's description of the face of Manet's assistant, Alexandre, in "La Corde" as "ardente et espiègle," and of the dandy as "joli" and "redoutable."

vous" [Here is a sonnet that seems perfectly suited to what we know of you],
wrote Burty, in suggesting a poem by Armand Renaud for Manet's consideration.
The sonnet itself presents a situation remarkably similar to the one in "Lola de
Valence" and "Toute Entière," in which a seductive figure is described in terms
of its antithetical qualities, and here, too, the poet questions their origin and
meaning:

> Vous avez admiré la langueur dans la force,
> Le tour voluptueux de ce bel animal.
> Les cheveux bruns, contraste aux pâleurs de son torse,
> Les grands yeux reposant dans le calme normal.
>
> Mais vous ne savez pas si toute cette amorce
> De chair épanouie en calice anormal,
> Vient du profond de l'être ou ne tient qu'à l'écorce.
> Ne le sachez jamais! La science est le mal.
>
> Laissez-la, nonchalante, ôter son dernier voile,
> L'étendre dans la nuit du boudoir qu'elle étoile,
> Du coeur, sur un lutte d'or, chanter le requiem.
>
> Elle vient d'orient où la vie est mystère,
> Ne chercher que l'extase, et laissez-la se taire
> L'énigme aux senteurs de harem.[176]

> [You have admired languor in strength,
> The voluptuous mold of this handsome animal.
> Her dark hair against her pale torso,
> Her large eyes calmly gazing.
>
> But you do not know if this lure
> Of flesh blooming in an abnormal calyx,
> Comes from the depths of her being or only from the surface.
> Do not ever find out! Knowledge is evil.
>
> Let her, nonchalant, lift her last veil,
> Spread it in the night of the boudoir she brightens
> And sing the requiem of the heart on a golden lute.
>
> She comes from the East where life is mystery,
> Look only for ecstasy, and let her be silent,
> An enigma redolent of the harem.]

176. Burty's letter to Manet may be found in Marcel Guérin, *L'Oeuvre gravée de Manet*
(Paris, 1944), under entry no. 51, but Renaud's poem is not included. The original letter
(with the poem) is at the Bibliothèque Doucet in Paris.

44. *Fleur exotique*, 1868, etching and aquatint (second state), Museum of Fine Arts, Boston, gift of George Peabody Gardner.

Manet accepted the commission and submitted his print *Fleur exotique* (fig. 44), which even in black and white refers back to Baudelaire's color analogy, for the figure (inspired by an etching by Goya) is clothed in black and holds a rose in her hand! The woman described in the poem is not illustrated by Manet. He transcribes, however, its dualistic basis.

In specifically referring to the suitability of Renaud's sonnet to Manet's temperament, Burty may have associated its imagery with *Olympia* (fig. 45). And for that painting, Zacharie Astruc had written a long poem, "La Fille des îles," which bears more than a passing resemblance to Renaud's "Fleur exotique" and plays with antithetical concepts, such as the one we have encountered in "Toute Entière":

> C'est l'esclave, à la nuit amoureuse pareille,
> Qui vient fleurir le jour délicieux à voir.[177]

> [She is the slave, similar to the amorous night,
> Who comes to decorate the day delightful to see.]

177. Astruc's entire poem may be found in Julius Meier-Graefe, *Edouard Manet* (Munich, 1912), pp. 134–36.

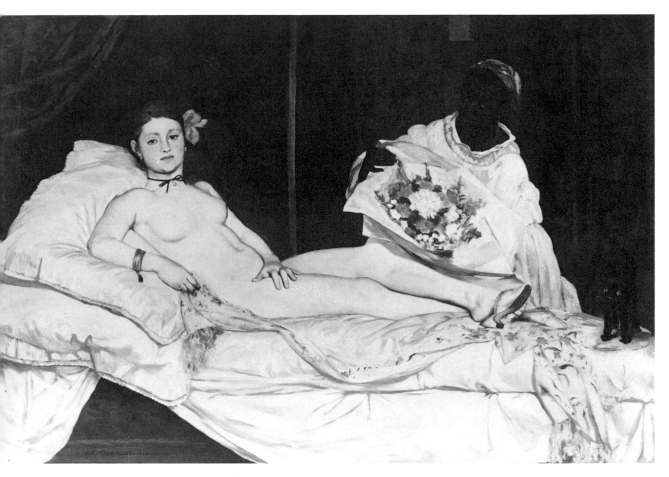

45. *Olympia*, 1863, Musée du Louvre, Paris.

How much Astruc knew of Manet's intentions is uncertain. The portrait that Manet painted of him, however (fig. 96), has distinct compositional affinities with *Olympia*, and it may be a reference to Astruc's understanding. In his criticism of his friend's art, published in 1863, Astruc does give at least some indication of his comprehension when he insists that Manet's *oeuvre* transcends technique and must be grasped in its "metaphysical and tangible meaning."[178]

In 1876 Manet organized a competition among his poet-friends with the hope of finding a suitable original verse to accompany his experimental color lithograph, *Polichinelle*. It has long been something of a mystery why Manet chose the two lines by Théodore de Banville when better poets such as Mallarmé took part in the contest. Manet's choice has even been used as evidence of his poor taste in matters of literature. If we admit the possibility, however, that Manet looked for certain specific awarenesses of content, we may give his choice a more charitable interpretation. The chosen lines read:

> Féroce et rose, avec du feu dans la prunelle,
> Effronté, saoul, divin, c'est lui, Polichinelle.[179]

> [Ferocious and rose, with fire in his pupil
> Impudent, drunk, divine, there he is: Polichinelle.]

The couplet, not really so poor at all, is evocative, if ambiguous. The word "rose," of course, in the light of the foregoing argument, is striking, and although the poet does not specifically oppose it to "féroce," a possible equivalent for "noir," Polichinelle does emerge as a complex personality made up of disparate elements, a human amalgam, ultimately divine. The suggestion of universality, concisely expressed by de Banville, recalls the eternal and mystic concept of the figure published earlier by Charles Nodier, which also contains de Banville's exclamation, "C'est lui, c'est lui, c'est Polichinelle."[180] Manet's choice may have been governed by de Banville's reference to Nodier's philosophic interpretation.

The rose and the black polarity occurs in still another example of Manet's art, one that has been entirely overlooked. Among Manet's papers that Léon Leenhoff carefully transcribed for Moreau-Nélaton is a review by Catulle Mendès of Mallarmé's *L'Après-midi d'une faune*, illustrated by Manet and published in a limited edition in 1874. This piece of criticism gives us probably the best evidence of Manet's acceptance of Baudelaire's symbolism of the "rose" and "noir" as an expression of the dual principle found in his art:

> Two silk bands, one black, one rose, cross the cover and fuse at the bottom
> in a frail rosette—adding thus a little frivolous mystery to the envelope of

178. "Le role de la peinture s'efface pour laisser à la creation toute sa valeur métaphysique et corporelle." *Le Salon de 1863*, no. 16. Cited in L. Rosenthal, *Manet aquafortiste et litho-graphe*, Paris, 1925, p. 39.

179. The couplet was printed at the bottom of the lithograph.

180. Nodier, "Polichinelle," p. 88.

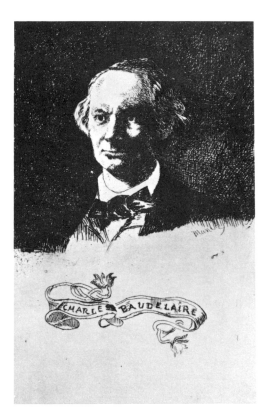

46. *Portrait of Baudelaire*, 1869, etching (third state),
Cabinet des Estampes, Bibliothèque Nationale, Paris.

Japan paper, gray of a sunny gray, gay, soft, and resistant at the same time, as if it were made of the pulp of a tiger lily and whereupon are barely inscribed the golden letters of an ancient title. Untie the silken mystery. . . .[181]

Of course, Mendès's romantically mysterious description of the interlacing rose and black bands is revealing in itself, but the really significant thing from our point of view is that Manet, usually misunderstood by the critics, cut this article out and preserved it.

In the verses by Baudelaire the rose and the black are not only antithetical symbols but are fused into one harmonious entity, just as the bands that adorned Mallarmé's poem fuse into a rosette at the bottom of the page. Again, we have the expression of the indivisibility of these fundamental opposing forces and, further,

181. "Deux cordonnets de soie, noir celui-ci, celui-là rose, traversent la couverture et se rejoignent au bas dans une frêle rosette—ajoutant ainsi un peu de mystère frivole à cette enveloppe en carton de Japon, grise d'un gris ensoleillé, joyeuse, molle et résistante à la fois, charnue dirait on, comme si elle était faite de la pulpe d'un lys tigre et où s'incrustent à peine les lettres d'or d'un titre ancien. . . . Dénouez le mystère de soie. . . ." Leenhoff's notes for Moreau-Nélaton are at the Cabinet des Estampes of the Bibliothèque Nationale, Paris. Mendès's review appeared in *La République des Lettres*, March-April 1876.

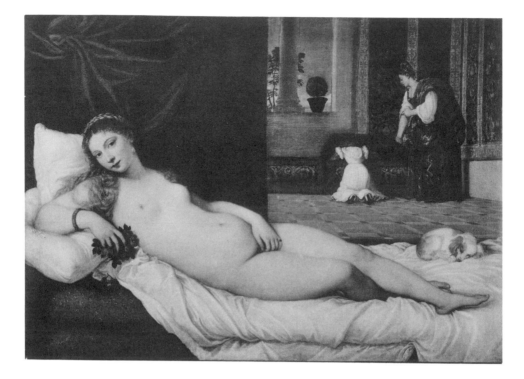

47. Titian, *Venus of Urbino*, 1538, Uffizi, Florence.

the presence of each half of the polarity within the other. And this interlacing of opposites was literally used in still another instance by Manet with direct reference, not surprisingly, to Baudelaire. On one of two etched likenesses that Manet wished to be included in Asselineau's memorial edition of the poet's works in 1869, he went so far as to include beneath the portrait a scroll bearing the poet's name, terminating at both ends in a knotted band that is transformed into a flower sustained by a twisting stem (fig. 46). One flower points upward, the other downward. Only one known impression of the portrait with the scrolls exists, for Manet cut off the lower part of the plate and satisfied himself with the likeness alone. The face divides into sharply contrasting light and dark halves, and for Manet the scroll may simply have become superfluous.[182]

Of all Manet's major works of the early 1860s, the best-known one with a division into two parts, one bright and the other dark, is *Olympia*. It has been agreed that the artist, in his subject and composition, depended on Titian's *Venus of*

182. These etched portraits and the emblems beneath them received an interesting interpretation by William Hauptman in a paper, "Manet's Portrait of Baudelaire: an Emblem of Melancholy," read at the *Middle Atlantic Symposium of Art History*, Washington, D.C., 15 April 1972, soon to be published in *Art Quarterly*.

Urbino (fig. 47);[183] of all the possible reclining Venus prototypes available to him, the choice of this one may well have been determined by the division of Titian's canvas into two distinct parts by means of a sharp vertical line that separates the spatial areas of the work. This division, which Manet adapted to his own purposes, plus the subject of a reclining nude with an animal at her feet, is sufficient to recall Titian's painting, although the two works are utterly different in the most essential ways. The languorous Venus and the sensual climate she establishes are features entirely alien to the rigid Olympia, who conveys instead a spirit of modern Parisian intelligence. This is a nimble woman, frozen in a moment of inactivity. Her nervousness is projected by the tension of her pose, an original solution to the problem of suggesting these characteristic unstable qualities in a timeless way, so that the evocation of the traditional and symbolic goddess of love is not lost in a quintessentially modern image. In choosing to evoke a Venus by Titian, Manet may have also been conscious of challenging Baudelaire. In his article on the painter of modern life, the poet had specifically stated that any modern artist who bases his Venuses on those of Raphael and Titian is bound to produce a false or ambiguous work.[184] *Le Déjeuner sur l'herbe* and *Olympia* were painted in the same year; in the one Manet had looked to Raphael for his nude, and in the other he had turned to Titian. Both works were modern and viable. It could be done.

But both works were also deeply unsettling, and this, in addition to certain technical devices (the flesh tone of *Olympia*, the spatial ambiguities of the *Déjeuner*), was perhaps the result of Manet's having reversed accepted practice in his references to time. Whereas Couture, like David, had in good academic practice painted a Roman scene with the purpose of making a critical comment on modern life, Manet depicted scenes of modern life with reference to the pre-existence of their essential significance. There is another important difference, and that is Manet's refusal to make moral judgments. There is little doubt that *Olympia* is a courtesan, but whereas to Couture modern morals suggested the Roman orgy, which he painted and condemned through the presence of the two Stoic philosophers who observe the festivities, to Manet the prostitute of his own day recalled a divine prototype. She is the reduction to a symbol of the appeal to one side of man's nature. In this we have a clear demonstration of Manet's proclaimed scorn for history painting.[185] The event in itself was of no interest to him as an artist, unless it could be made to illuminate unchanging, fundamental truths, and these could be understood only by the direct experience available in one's own time and place. Modernity had to provide the motifs for the artist. Historical images that were heroic or moralizing had no place in Manet's conception of art. He refused to judge modern life—or ancient life either, for that matter. He viewed no one period as either superior or inferior to another. This does not mean that he

183. Manet had made a small oil copy of this painting. It is reproduced in color in Bataille, *Manet*, p. 68.

184. Baudelaire, *O.C.*, p. 1165. This breaking of Baudelaire's "rules" has been noted by Meyer Schapiro in "The Apples of Cézanne," p. 51, n. 24a.

185. Schapiro, p. 51, n. 24a. For Manet's remark about history painting, see Proust, p. 80.

was disinterested in contemporary events of a historical nature, as *L'Exécution de l'Empereur Maximilien* and the naval battle *Le Kearsarge et l'Alabama* prove. It does mean that he rejected the notion of history as a flow of events leading to new situations morally better or worse than others. At least, this seems to be true as far as his work as an artist, his means of communication with his public, was concerned. For Manet, the *peintre-philosophe*, history was a constant repetition of eternal truths appearing in an endless variety of guises—all of the experienced ones appealing to the senses and fascinating to the painter. The philosopher, however, never fails to remark on the fact that an unalterable inner situation is being replayed once more. The coolness with which his figures and situations are treated, regardless of the intensity that the scene may have had in life, is indicative only of a rejection of the notion of a moralized history. The visual sensation may always be unique, and unique each picture remains, but the historical interpretation is not, so that in Manet's art we cannot speak of a narrative at all.

While Olympia is less sensual than Titian's Venus, she is more awesome. The mood and personality of Titian's figure are relatively clear. Olympia remains a cipher. Her alert but uninformative stare, her rigid, uncompromising posture, and her starkness emphasized by strong juxtapositions of light and dark (not within an area, necessarily, but in one large area against another) constitute her uniqueness and transcend the modernity of 1863. It is, of course, the unknown, the complex human mystery at which the painter hints in this fusion of the directly given and the elusive, qualities in both life and his own art. No doubt the frustration that gave rise to anger when the painting was shown in 1865[186] and that is still felt by some today is the consequence of being confronted by a mystery, presented in a forceful image of the utmost clarity.

Two old master paintings had served Manet in the construction of the design of *Le Vieux Musicien*. He again used two in 1863 when painting *Le Déjeuner sur l'herbe*, only by that time he had taken the idea of duality to the sources themselves, as we have seen, so that one (*Le Concert Champêtre*) was painterly and sensual, and the other (the *Judgment of Paris*), a black and white engraving, was selected for its more intellectual qualities of line and form. In considering the relationship between Titian's *Venus of Urbino* and *Olympia*, we observe that with the exception of the division of the canvas Manet used the Renaissance work freely, and we may conclude that the relationship is analogous to that of Giorgione to the *Déjeuner*. The form is alluded to, but its sensual quality has been preserved by Manet in his touch and not in the figure. Since the *Déjeuner* and *Olympia* were painted during the same year and probably were conceived together, we might do well to seek another source, of opposite character to Titian's picture, with a more direct correspondence to Olympia's pose and character. In addition to the probability that in seeking our source we should restrict ourselves to "classical," form-conscious works, previous experiences with Manet's methods offer some other clues. We know, for example, that close as Raimondi's river gods are to the trio of figures in the *Déjeuner* Manet did take the liberty of dressing two of them.

186. Hamilton, *Manet and his Critics*, pp. 65–74.

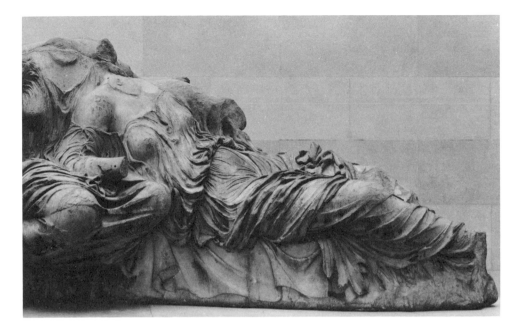

48. Reclining Goddess from the Parthenon, fifth century B.C., British Museum, London.

Furthermore, these river gods as a self-contained group constitute only a detail of Raphael's total composition. Therefore, in our search for Olympia's direct ancestor, we need not limit ourselves to nude figures (a restriction that, perhaps more than any other, has prevented an earlier discovery of the source), nor to complete works. We now also know that Manet's theme in the *Déjeuner* is suggested, albeit in somewhat different form, in his direct source, another condition that we ought to keep in mind. Finally, there is the title *Olympia,* long a troublesome bit of information that has been given several interpretations. Although Paul Jamot has dismissed the name as unimportant,[187] Bodkin, Mathey, and Reff [188] have taken it to be an allusion to the courtesan who bears that name in Dumas's *La Dame aux camélias.* Without discrediting this connection, it is possible that the name "Olympia," purposefully given, is simply a reference to its formal classical derivation, in addition to the identification of the woman as a goddess. Let us also bear in mind Manet's references to the frescoes of the Stanza della Segnatura as well as the general principle that the major sources of the artist were famous works and that he depended upon their recognition.

187. Paul Jamot, "Manet and the Olympia," *Burlington Magazine* 50 (1927), p. 31.
188. Theodore Bodkin, "Manet, Dumas, Goya and Titian" (letter), *Burlington Magazine* 50 (1927), pp. 166–67; François Mathey, *Olympia* (Paris, 1948), unpaginated (opposite fig. 8); Reff, "The Meaning of Manet's Olympia," p. 120.

Olympia's prototype is, indeed, to be found—at home, on Mount Olympus—in the most famous of all strictly classical (that is, ancient Greek) works of art, the east pediment of the Parthenon (fig. 48). She is the much-admired reclining goddess on the north half of the pediment, whose true identity is still unknown but who has most frequently been identified as one of the three Fates. She is, as suggested earlier, draped, and she lacks a head, while her arms are incomplete. But the pose, if we are not diverted by the undulations of the drapery, is quite rigid, consistent with the "severe style" of Greek sculpture, and the angle created by her raised torso is identical to that of Olympia. She rests her weight partially on her right arm, as does Olympia, and the left, fragmentary arm can be extended by the imagination to conform to that of Manet's figure. In fact, we have no difficulty in visualizing Olympia's head on this ancient piece of sculpture. The identification becomes still more satisfactory, however, when we consider the other factors, iconographic and symbolic, that may have determined Manet's choice.

We have already spoken of the fame of the work, so great that Manet's transformations do not produce an impenetrable disguise. Phidias was the artist whose name was most often associated with that of Raphael during the 1860s, and this pediment was viewed as his masterpiece. A new biography of Phidias was published in 1861 by Louis de Ronchaud,[189] and the *Gazette des Beaux-Arts* printed two articles based on it, those dedicated to the pediments, with line engravings of the best-preserved figures, including our goddess.[190] This publication closely followed the first appearance in French of Passavant's two-volume work on Raphael, published in 1860,[191] and the *Gazette* was led to proclaim the two artists as the two great summits of art.[192] The east pediment of the Parthenon is, of

189. Louis de Ronchaud, *Phidias, sa vie et ses ouvrages* (Paris, 1861). This book received a laudatory review by Charles Blanc in the *Gazette des Beaux-Arts* 12 (1862), pp. 465–75. Ronchaud's name appears in Manet's address book (Cabinet des Estampes).

190. The east pediment, the one that concerns us here, was studied in de Ronchaud's article, "Les Statues du Parthenon: le Fronton Oriental," *Gazette des Beaux-Arts* 9 (1861), pp. 148–66. An engraving of the reclining goddess included in this article was also the first work of art reproduced in the *Gazette* in its first issue (January 1859), p. 8.

191. J. D. Passavant, *Raphael d'Urbin et son père Giovanni Santi*, trans. J. Lunteschutz (Paris, 1860).

192. Charles Blanc wrote, "Les plus grands sont ceux qui l'ont dominé [nature] en l'adorant, qui n'ont approché de la sirène qu'après avoir mis dans leurs oreilles la cire d'ulysse. Ceux-là s'appellent Phidias et Raphael." [The greatest are those who have conquered her (nature) while worshipping her, who have only dared approach the siren after plugging their ears with the wax of Ulysses. They are called Phidias and Raphael.] ("Les Dessins de Raphael," *Gazette des Beaux-Arts* 4 [1859], 209.) In his review of de Ronchaud's book, Blanc proclaimed, "C'est un honneur pour notre siècle que d'avoir eu à un si haut degré l'intelligence de Phidias et de Raphael. Le plus grand sculpteur de la Grèce et le plus grand peintre d'Italie ... n'ont été bien compris que de notre temps." [It is an honor for our century to have had, to such a high degree, the intelligence of Phidias and Raphael. The greatest sculptor of Greece and the greatest Italian painter ... have only been well understood in our time.] (*Gazette des Beaux-Arts* 12 [1862], p. 465.) In an earlier issue, the *Gazette* happily announced Brognoli's forthcoming publication of an album of large engravings of Raphael's Stanze

course, monumental and symmetrical, in this respect recalling the Vatican frescoes. In these frescoes the dualistic theme is one element in the programmatic unification of the decorated walls of the room. The temple pediment, representing the birth of Athena at its center, is enframed by two opposing symbols that unify not only the composition but the cosmic, central drama as well. Night and Day, represented by the chariots of the Sun and Moon, are situated in the angles. Astruc's lines, written for *Olympia*, come immediately to mind:

> C'est l'esclave, à la nuit amoureuse pareille,
> Qui vient fleurir le jour délicieux à voir.

The idea of night and day is transformed by Manet into the light and dark figures, who represent still another expression of the dualism of life. *Olympia*, in this connection, also reminds us once again of Baudelaire's "Toute Entière":

> Elle éblouit comme l'Aurore
> Et console comme la Nuit,[193]

in which the capitalized "Aurore" and "Nuit" suggest personifications in the ancient sense. That *Olympia* is "Baudelairean" has become a commonplace observation on the painting. For the most part, however, commentators have been content to cite only an atmospheric affinity.[194] It was a prose poem from *Le Spleen de Paris*, "La Corde," that revealed Baudelaire's knowledge of Manet's intentions, and it is in two other pieces from this collection that we find more precise evocations of *Olympia*. Before continuing this discussion of the role of the Parthenon pediment in the genesis of the painting and its relationship to Titian's *Venus* in this regard, it will be necessary to consider the meaning of these prose poems.

In *Le Désir de peindre*, Baudelaire says of "celle qui m'est apparue si rarement" [the one who appeared to me so seldom], whom he would like to paint:

> I would compare her to a black sun, if one could conceive of a black star shedding light and happiness. But it is the moon she leads one to dream of more readily, the moon that has probably touched her with its dangerous influence; not the white moon of the idylls who resembles a cold bride, but a sinister and intoxicating moon, suspended in the depths of a stormy night and swept by the driven clouds; not the peaceful and discreet moon that visits the sleep of pure men, but the moon torn from the sky, con-

(*Gazette des Beaux-Arts* 5 [1860], p. 253), *Les Stances de Raphael* (Rome, n.d.), while in May 1859 (*Gazette des Beaux-Arts* 2, pp. 189–90), F. A. Gruyer's *Essai sur les Stances de Raphael au Vatican* (Paris, 1859) received high praise, the reviewer noting the author's eloquent way of analyzing Raphael's treatment of "les sommets opposés de la religion et de la science, de l'histoire et de la poésie" [the opposing summits of religion and science (knowledge), of history and poetry].

193. See n. 175 above.

194. Léon Rosenthal makes a convincing comparison between Baudelaire's poem "La Beauté" and Manet's art in general. (*Manet aquafortiste et lithographe* [Paris, 1925], p. 154.)

quered and revolted, that the witches of Thessaly force harshly to dance upon the terrified grass.[195]

Baudelaire is careful in his astral definition of his subject. Before likening her to the moon, he terms her first a black sun and then a black star. It is only then that he is willing to invoke the magical moon. Sun and moon in this way are not only opposites but are paradoxically related. They represent opposite aspects of the same entity, antitheses that seek unification. Thus, the moon is first called a "black sun," so that the reader will be prepared to receive the image of the moon as another aspect of the sun. Baudelaire even asks the reader to envision "a black star that sheds light and happiness" and proposes the further paradox of happiness emanating from evil when he invokes the image of Thessalonian witches in conjunction with his lunar figure.

In "Les Bienfaits de la lune," Baudelaire develops the idea of the lunar woman into an emblem of a personality type of a specific temperament and destiny. The moon, who created this creature, now speaks to her:

> You shall be beautiful in my manner. You shall love what I love: the water, the clouds, the silence and the night; the vast green sea; the formless and multiform water . . . monstrous flowers; the perfumes that drive men wild; the cats that swoon upon pianos and moan like women with hoarse, sweet voices.[196]

Baudelaire goes on to describe, in the same terms, the men who will be fatally attracted to her, stressing "la mer immense" [the vast sea], "les animaux sauvages et voluptueux" [wild and voluptuous animals], and "les fleurs sinistres" [ominous flowers]. He concludes by proclaiming that he will ever seek in her that redoubtable divinity, the moon. Baudelaire's procedure, like the one that he proposed for the painter of modern life, is to discover a reflection of some eternal archetype in his earthly confrontations, the constant and timeless in the shifting mortal sphere. With Baudelaire's writing in mind, we may return to the Parthenon pediment and the meaning that Manet was likely to have given it.

As mentioned earlier, the most popular interpretation of the reclining figure

195. "Je la comparerais à une soleil noir, si l'on pouvait concevoir un astre noir versant la lumière et le bonheur. Mais elle fait plus volontiers penser à la lune, qui sans doute l'a marquée de sa redoutable influence; non pas la lune blanche des idylles, qui ressemble à une froide mariée, mais la lune sinistre et enivrante, suspendue au fond d'une nuit orageuse et bousculée par les nuées qui courent; non pas la lune paisible et discrète visitant le sommeil des hommes purs, mais la lune arrachée du ciel, vaincue et revoltée, que les sorcières thessaliennes contraignent durement à danser sur l'herbe terrifiée!" (Baudelaire, *O.C.*, p. 289.)

196. "Tu sera belle à ma manière. Tu aimeras ce que j'aime: l'eau, les nuages, le silence et la nuit; la mer immense et verte; l'eau informe et multiforme . . . les fleurs monstrueuses; les parfums qui font délirer; les chats qui se pâment sur les pianos et qui gémissent comme les femmes, d'une voix rauque et douce." (Ibid., p. 290.)

was that she was one of the Fates.[197] De Ronchaud in 1861 imagined a new identity and set about proving it with considerable skill. In the excerpt published in the *Gazette des Beaux-Arts*, he wrote:

> In my opinion we must see the goddesses of the sea in this famous group of three women called, wrongly, the Fates.[198]

De Ronchaud's attribution of these figures is consistent with his overall interpretation of the pediment, which is a well conceived one. He envisions Phidias's drama taking place at three locations: the central birth of Athena on Olympus, Bacchus (his identification of the famous reclining male figure, often called Theseus) on the earth, and the three goddesses described in the quotation above on the sea. News of the birth of the "déesse auguste" is taken to earth and sea by the messengers Hermes and Victory. The three goddesses could not, in de Ronchaud's view, be the Fates since, among other reasons,

> The marks of necklaces and bracelets that were detected on these figures are not at all appropriate to divinities of a stern character, such as were the terrible goddesses, but the diversity of beauty one notices in these three women can very well suit the different states of the mobile and capricious sea.[199]

Titian's *Venus of Urbino* wears a bracelet but no necklace; Olympia, like the Parthenon goddess, was given both. But de Ronchaud is still more specific about the identity of the reclining goddess:

> However I would rather see in the seated figure Perseis, the Oceanid, who holds in her arms the magician Circe, represented by the reclining figure whose voluptuous pose is so full of seduction.[200]

Circe, of course, provides a most suitable mythological identity for Manet's temptress and contributes the note of mystery and lovelessness suggested by Manet's image and described in Baudelaire's prose poems. It also gives some meaning to the title of Astruc's poem, "La Fille des îles," so long considered obscure in its relationship to the painting. Olympia as Circe, better than as Venus

197. A table listing the identities assigned to the three goddesses during the nineteenth century by various scholars can be found in Adolf T. F. Michaelis, *Der Parthenon* (Leipzig, 1871), p. 165.

198. "Car ce sont, à mon avis, des divinités de la mer qu'il faut voir dans ce groupe célèbre des trois femmes auxquelles on a donné mal à propos les noms des Parques." (De Ronchaud, "Statues," p. 156.)

199. "Les traces de colliers et de bracelets qu'on a trouvé sur ces figures ne conviennent nullement à des divinités d'un caractère sévère, telles qu'étaient les terribles déesses, mais la diversité de beauté qu'on remarque dans ces trois femmes peut très-bien convenir aux différents états de la mer mobile et capricieuse." (Ibid.)

200. "Je préfère cependant voir dans la figure assise Perse, l'Océanide, qui tient dans ses bras la magicienne Circé, représentée par la figure couchée dont la pose voluptueuse est si pleines de séductions." (Ibid.)

(who is not, however, to be eliminated from her identity), explains also the impression of being a sorceress that she has made on some observers, including Theodore Bodkin, who suggests that Baudelaire understood the cat as being "the familiar of a witch."[201] Baudelaire had also likened his creation to the moon of the Greek witches, an association made pertinent to *Olympia* by virtue of another feature of de Ronchaud's pediment Circe. In discussing her relative position within the sculptural complex, the scholar writes:

> One will notice that, just as the figure of Bacchus, at the other angle of the pediment, is related to the Sun, the one of Circe, if we want to accept this name for the corresponding statue, is related to the Moon, which is appropriate to the goddess of magic spells.[202]

In a footnote, de Ronchaud even touches on the intimate and reciprocal relationship between those opposites, sun and moon, as Baudelaire had done in "Le Désir de peindre." He observes that in Homeric mythology sun and moon were brother and sister and reminds us of the paired Homeric hymns to these heavenly bodies.[203]

While Manet strongly suggests the "dark" brilliance of the figure evoked by Baudelaire, he could not very well introduce the moon into Olympia's room, least of all by the romantic device of revealing it through a window. He does introduce it, however, in the guise of the most lunar of all creatures, the cat. This animal, generally associated with sensuality, is here not so much sensual as tense, like Olympia herself, and may be considered her emblem or talisman. It is probably as a result of this visual relationship between Olympia and her cat that Bodkin was led to conclude that Manet had painted a witch and her familiar. This cat, however, was undoubtedly suggested to Manet by Titian's painting, in which another domestic animal, a dog, is placed at Venus's feet. Manet has chosen a cat, however, because it suggested the moon, the enchantress, and the night, none of which is identified with a dog, and also because it allowed him to stay within the context of the modern interior, the experienced situation. At the feet of the Parthenon goddess there is also an animal, the horse that has drawn the chariot of Selene, the moon goddess, and iconographically Manet's cat has replaced this symbol. The dog in Titian's Venus is placed behind the legs of the goddess, deeper in the pictorial space. Manet's cat has come forward and conforms to the more planar arrangement of the relatively shallow pediment.

201. Bodkin, "Manet, Dumas, etc.," p. 166.

202. "On remarquera que, de même que la figure de Bacchus, à l'autre angle du fronton, se trouve en rapport avec le soleil, celle de Circé, si l'on veut adopter ce nom pour la statue correspondante, est en rapport avec la Lune, ce qui convient à la déesse des enchantements." (De Ronchaud, "Statues," p. 156.) This author also observes that we know from the figures of sun and moon alone that "le monde entier avait été représenté symboliquement dans l'ensemble de la composition" [the entire world was symbolically represented in the totality of the composition] (p. 151). This concept is similar to Manet's concerns in *Le Vieux Musicien.*

203. Ibid., n. 1.

49. Chardin, *La Raie dépouillée* (detail),
1728, Musée du Louvre, Paris.

Manet himself related the cat directly to the moon later, in 1868, in his illustration for Champfleury's book *Les Chats* (fig. 111). But Circe, like Baudelaire's heroine, was also identified with the sea. The cat, since it invokes the moon, may also be thought of in connection with the sea, but Manet has made this association specific by referring through the pose of his cat to a particular and similar creature in France's artistic past. The cat has been modeled after Chardin's cat in the famous painting, *La Raie dépouillée* (fig. 49), now, as in 1863, in the Louvre.[204] Manet, obviously, could paint a perfectly good cat without a model, and we must conclude that the similarity between Chardin's famous cat and Manet's exists because Manet wished to refer the viewer to Chardin's picture. It is important, then, to realize that the cat in that picture is part of a marine still life, where it preys upon an array of appetizing oysters and fish. It was, incidentally, in 1864, the year before *Olympia* was exhibited, that Manet painted his own marine still life, very reminiscent of Chardin's style and containing a platter of oysters—a clue, at least, that Manet may have been interested in Chardin's painting at this very time. This becomes significant when we remember that, although *Olympia* had been painted in 1863, the cat was a later addition. Baudelaire was still in Paris in 1863, and it is fairly certain that he had seen the painting before leaving for Belgium the following year. In 1865 the poet wrote to Manet, recounting the opinion of another who had seen Olympia in its completed state:

204. This derivation has been observed by Fried ("Manet's Sources," p. 71) and has been refuted by Reff ("'Manet's Sources,'" p. 47). I agree with Fried that Manet alludes to Chardin's cat, but not with the reasons imputed to the artist for doing so.

He added that the picture representing the naked woman with the negress and the cat (is it really a cat?) was very superior to the religious picture.[205]

It has been assumed from Baudelaire's description that the painting had not yet been given its title when he wrote to Manet,[206] a conclusion that is ill-founded, for Baudelaire is not speaking for himself but is quoting a third person. At any rate, even had the title *Olympia* not yet been decided upon, we certainly need not assume that the theme of the picture was not yet clear in the painter's mind. Baudelaire's parenthetical reference to the cat, however, does express his own surprise. Since there is nothing unusual in the presence of a cat in an interior scene, Baudelaire's rhetorical query and the forceful "décidément" can only suggest that he was not prepared for Manet's solution to a problem of symbolism within a philosophical scheme of which he had prior knowledge. If Baudelaire was familiar with Manet's theme and the literary and visual sources that had gone into its expression, he must have been aware that the cat, in addition to everything else, was also a reference to himself, for the poet had concluded "Les Bienfaits de la lune" with the line

> And that is why, dear child, accursed and spoiled, I lie now at your feet, seeking in all your being the reflection of that dangerous divinity, that fateful godmother, that poisonous nurse of all *lunatics*.[207]

The day-night, sun-moon duality of the Parthenon pediment has, as we have seen, been transformed into the black and white figures of *Olympia*, separated by the divider suggested by the *Venus of Urbino*. The usual associations of white with good and black with evil are reversed by Manet, in that it is Olympia who suggests wickedness and the servant kindness. In fact, the figures are so treated in Astruc's poem, and we have already called attention to the reversibility of Baudelaire's association with day and night, as well as to his preoccupation with the notion of reversibility in general. In "Le Pauvre diable," a poem attributed to Baudelaire (and only published in 1878), we find the curious four-word verse,

> Maigre
> Flanc,
> Nègre
> Blanc,[208]

205. "Il a ajouté que le tableau représentant la femme nue avec la négresse et le chat (est-ce un chat décidement?) était très supérieur au tableau religieux." (Moreau-Nélaton, *Manet raconté par lui-même*, vol. 1, pp. 69–70.)

206. Jamot, "Manet and Olympia," p. 31.

207. "Et c'est pour cela, maudite chère enfant gâtée que je suis maintenant couché à tes pieds, cherchant dans toute ta personne le reflet de la redoutable Divinité, de la fatidique marraine, de la nourrice empoisonneuse de tous les *lunatiques*." (Baudelaire, *O.C.*, pp. 289–90.)

208. Ibid., p. 211.

[Spare
Flank,
Negro
White,]

which manages to evoke both figures of *Olympia*.[209] Although the elements of night and day are both symbolically present in *Olympia*, the scene, with its lunar cat and its suggestion of a client waiting behind the curtain to receive the courtesan's favors, may be understood to take place at night. In its nocturnal mood and interior setting, it is the opposite of the *Déjeuner sur l'herbe*, which occurs out of doors and in daylight. This particular opposition between Manet's two great paintings of 1863 may not be merely fortuitous, since the Parthenon pediment, in its own day-night polarity, provides a link on precisely this level. De Ronchaud had opposed the reclining Circe, whom he associates with the moon, to its formal pendant, the reclining male figure, whom he has named "Bacchus" (fig. 50) and whom he associates with the sun. Manet's life-size nude strikes the pose of Circe, while in the daylight scene, the *Déjeuner*, we discover that the equally monumental reclining "philosopher" repeats the pose of the Parthenon Bacchus! If the two paintings are placed next to one another so that these figures are back to back, the format of the pediment and its division into day and night are recreated in abbreviated form (fig. 51). This is not to suggest that the philosopher in the *Déjeuner* incorporates the characteristics of this divinity; his origins are essentially different. But it is inconceivable that Manet did not see the obvious resemblance between the Raphael-Raimondi water god and Phidias's pedimental sculpture. This could only have struck him as another of those "mysterious coincidences" of which Baudelaire spoke in his defense of Manet's originality to the critic Willem Bürger in 1864.[210] Manet knew, of course, that Raphael had actually worked from Antique sculpture and, possibly, that Beham had borrowed Raphael's water nymph before he himself had done so. Thus, the notion of "mysterious coincidence" represented for him an idealization of the existence of kindred spirits across time, an interpretation probably held by Baudelaire himself. Through interlocking his two paintings by means of the more ancient of his monumental sources, Manet refers to Baudelaire's concept of the immortality of forms and ideas, to the relationship across time between Phidias and Raphael, to the complex tradition of which he sees himself a part and, ultimately, to the grandeur of his own dreams.

The interpretation here presented of *Olympia* is consistent with the larger interpretation of a quality of Manet's art and character that has received little or no attention. It is not really at odds with older ideas about the painting, but it serves to give them greater validity within a wider context. Theodore Reff has emphasized that the false interpretations of this picture and of Manet's art in

209. Reff discusses the attraction of "meagre women" as expressed by the Goncourts and Baudelaire ("The Meaning of Manet's Olympia," p. 114).
210. Moreau-Nélaton, *Manet raconté par lui-même*, vol. 1, pp. 58–59.

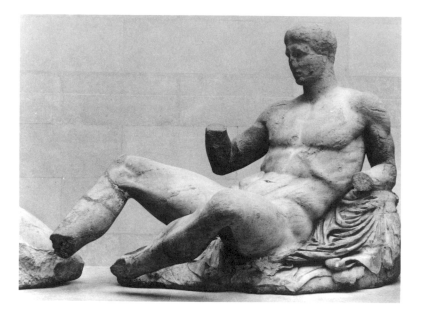

50. Reclining Male Figure from the Parthenon, fifth
century B.C., British Museum, London.

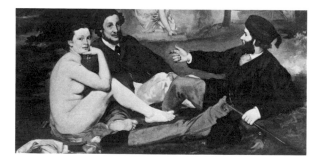
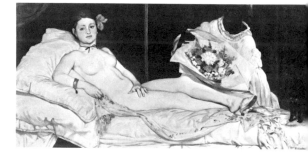

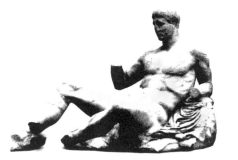
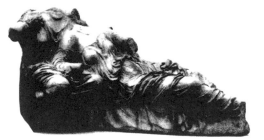

51. Diagrams of the Parthenon pediment and elements from *Le Déjeuner sur
l'herbe* and *Olympia*.

general have been fostered by Zola's impassioned, if very one-sided, defense of the painter in 1866 and 1867.[211] From that time onward, it had become customary to regard Manet as a pure painter, whose subjects were nothing more than pretexts for the elaboration of a superb *métier*. Reff maintains that the subject was, indeed, important for Manet and claims that *Olympia* was intended as a learned and witty comment on modern life.[212] He recalls, too, the argument that Manet's title refers to Dumas's character Olympe, a name that was associated with courtesans in general. Manet certainly knew all this and intended for the association to be made by his public. But such an aim alone is incomplete, as, in Baudelaire's view, it represents only one half of art—i.e., modernity and its transitory nature. The modern courtesan and the eternal Circe are related, in that the latter is the symbolic, unchanging principle of which the former is a modern incarnation. Both convert men to brutes, the one figuratively and the other literally. This parallel was recognized and specifically stated by Eliphas Lévi in his *Rituel*:

> Who then is this enchantress who changes her worshippers into pigs, and whose spells are destroyed as soon as she submits to love? She is the ancient courtesan, she is the marble daughter of all times.[213]

"Fille de marbre" is a popular epithet for a prostitute and, for Lévi, the marble of antiquity is a metaphor useful in evoking the eternal prostitute without love. Manet's Olympia refers to both the "coldness" of the woman and an actual piece of Greek marble identified with the mythic enchantress. Here we may find at least a partial explanation of the color of Olympia's flesh, which so distressed some critics of the Salon of 1865.

Reff holds that *Olympia* lies midway, both chronologically and conceptually, between Couture's *Orgie Romaine* (fig. 52) and Manet's *Nana* of 1877, and that *Olympia* is a commentary by allusion and *Nana* a direct and frank study of modern life, painted in the Impressionist technique.[214] With the discovery of Olympia's other, deeper identity we may conclude that Manet makes no comment at all with this painting, if by comment we understand judgment or criticism. In this "fille des îles," his observations relate to the modern forms of timeless things. Reff has also noticed the existence of similarities between Couture's central nude and Olympia. It is curious, in this connection, that Couture's nude has also been likened to the Parthenon goddess. In an old guide to the Louvre, under a reproduction of *L'Orgie Romaine*, we may read:

211. Reff, "The Meaning of Manet's Olympia," p. 112.

212. Ibid.

213. "Quelle est donc cette magicienne qui change ses adorateurs en pourceaux et dont les enchantements sont détruits dès qu'elle est soumise à l'amour? C'est la courtisane antique, c'est la fille de marbre de tous les temps." (Lévi, *Dogne et rituel*, p. 274.) F. Mathey, in his discussion of the meaning of Olympia's name (*Olympia*), recalls, in addition to Dumas's *Dame aux camélias*, *Les Filles de marbre* by Théodore Barrière. Manet's use, then, of a marble sculpture representing the prototype of the courtesan Circe becomes still more logical.

214. Reff, "The Meaning of Manet's Olympia," pp. 119–21.

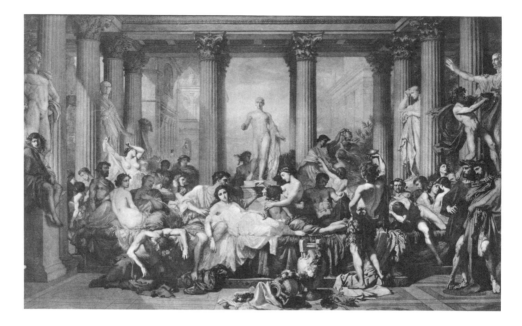

52. Thomas Couture, *L'Orgie Romaine*, 1847, Musée du Louvre, Paris.

> The woman lying languorously at the center of the picture reminds one of
> a Parthenon figure.[215]

Couture had heightened the languorous quality of the pose, whereas Manet
had preserved its underlying rigidity. Proust recalls Manet's words: "I express
as simply as possible the things I see. Thus, *Olympia*, what could be more naïve?
There are hard edges there, they tell me, they were there, I saw them."[216] Where
he had seen these "duretés" is not told to us by his biographer, but the assumption
has always been that the reference was to his model, Victorine. This rigidity is
absent in the nude of the *Déjeuner*, however, for which Victorine had also posed,
and it seems more likely that Manet was referring to his source, the Parthenon
goddess, an embodiment of the Greek "severe style," whose rigidity is masked
by her undulating drapery. Manet had also flattened the figure, inspired, as

215. "La femme langoureusement allongée au centre du tableau rapelle beaucoup une
figure du Parthénon." (*Les Plus Beaux Tableaux du Louvre* [Paris, 1929], p. 157.) Paul de
St. Victor, in a review of Couture's painting (*La Semaine*, 4 April 1847), had recognized the
relationship of the reclining figure to Parthenon sculpture. (See Francine Klagsbrun,
"Thomas Couture and the 'Romans of the Decadence'" [M.A. thesis, New York University,
1958], p. 17f.)

216. "Je rends aussi simplement que possible les choses que je voie. Ainsi, *L'Olympia*,
quoi de plus naïf? Il y a des duretés, me dit-on, elles y etaient, je les ai vus. J'ai fait ce que
j'ai vu." (Proust, p. 80.)

Sandblad has shown, by Japanese prints and possibly, as suggested here, by the planar aspect of the pedimental decoration.

Olympia, then, represents two traditional types that fuse in the image of the modern courtesan: the enchantress Circe and the seductive Venus, who in the chosen Titian prototype is clearly the "Venus vulgaris" half of the two aspects of that goddess, discussed in the notes. For Baudelaire, imagination consists in the gift of recognizing analogies. His demand on the modern painter, that he "see" the eternal in the transitory, represents one particular kind of analogical perception—the relationship between the present and the eternal. Manet tried to give expression to his own recognitions of this kind. He does not judge. He is concerned with good and evil as an expression of the principle of opposites, and with the reciprocity and indivisibility of these qualities in the unchanging human condition.

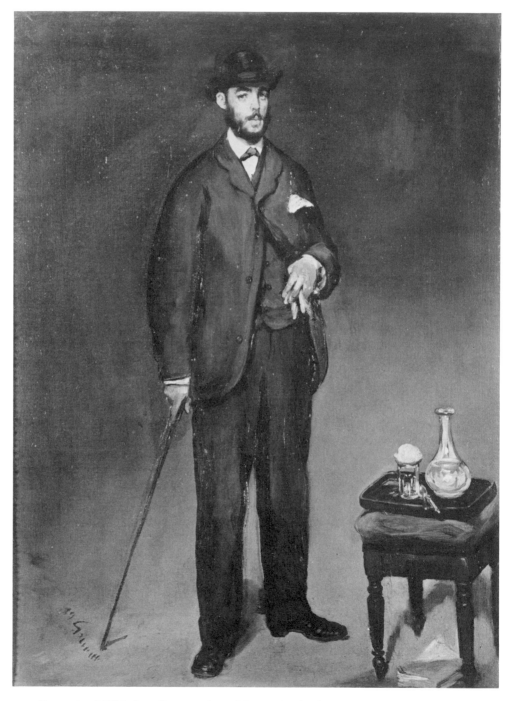

53. *Portrait of Théodore Duret*, 1868, Musée du Petit Palais, Paris.

3 An Answer to a Critic

Manet's mode of operation was not limited to monumental works designed to convey timeless themes to a larger public. In fact, it is in a small picture destined for a single individual and concerned with a private matter that it can be most concisely demonstrated. That picture is the *Portrait of Théodore Duret*. Manet and his future biographer, Théodore Duret, had met for the first time in Spain in 1865. Duret himself has recounted the circumstances of this meeting, after which the two Parisians toured Madrid together.[1] In 1867, Duret published his book, *Les Peintres français en 1867*, in which he discussed Manet's art and, the following year, Manet painted the small, full-length portrait of his friend, which is now in the collection of the Petit Palais in Paris (fig. 53).

Duret expressed his gratitude with a case of cognac and a letter that also contained the surprising request that the artist either change the location of his prominent signature or remove it altogether.[2] The reason given by Duret for this request is an unconvincing attempt to conceal its impertinence: Manet, the object of widespread abuse and notoriety, would serve his cause better, claimed Duret, by not announcing his authorship of the work before allowing its viewers (presumably notable visitors to Duret's apartment) the opportunity of considering it objectively. Following the general acclamation that was sure to ensue, Duret would have the pleasure, he goes on, of announcing the artist's name. Anticipating Manet's compliance, Duret half-jokingly imagines that people might take the painting for a work by Goya, Regnault, or Fortuny. While Duret's motives in making this request have not been questioned in the Manet literature, his duplicity

1. Duret, *Histoire d'Edouard Manet et de son oeuvre* (Paris, 1902), pp. 35–36.
2. Duret's letter is published in its entirety in A. Tabarant, *Manet et ses oeuvres*, p. 151. The pertinent passages are as follows: "Il me semble donc que vous devriez effacer votre signature dans le clair, sauf à ne pas signer, ou à signer *invisiblement* dans l'ombre. De cette façon vous me donneriez le temps de faire admirer le tableau et la peinture. Je pourrais dire, selon l'occasion, que c'est un Goya, un Regnault ou un Fortuny." [It therefore seems to me that you ought to remove your signature from the light area, perhaps not sign at all, or sign *invisibly* in the shadow. In this way you would give me the time to evoke admiration for the picture and the technique. I could say, according to the situation, that it is a Goya, a Regnault, or a Fortuny.]

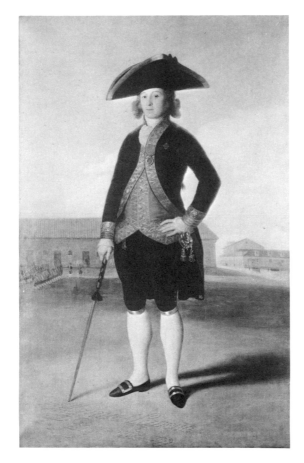

54. Goya, *Portrait of Manuel Lapeña,
Marquis of Bondad Real,* 1799,
Hispanic Society of America, New Y

could hardly have escaped the thin-skinned Manet, particularly in view of the fact that Duret's appraisal of the artist, as he had expressed it in *Les Peintres français en 1867,* was less than flattering and, given his friendship with the painter, completely lacking in courage. It must now have been clear to Manet that Duret, still embarassed by this association, did not wish to flaunt it on his own walls. Nor, of course, could he very well avoid hanging the picture, for this would, sooner or later, necessitate an explanation to the artist. Manet's response, an extremely resourceful one as we shall see, was to invert his signature but to leave it exactly where it was.[3]

We may deduce from this maneuver that the precise location of the signature, below the tip of Duret's cane, was important to Manet and that he considered its removal damaging to his intention. This intention is not difficult to guess. While

3. That the signature is upside down is obvious. Tabarant calls this a "bizarrerie," and apparently does not see it as Manet's answer to Duret's request (ibid., p. 150).

55. Detail of fig. 53. 56. Detail of fig. 54.

Duret is portrayed as the well-dressed gentleman with his white gloves, *chapeau melon*, and walking stick, ostensibly posing for his portrait, what he is actually doing is using his walking stick to point out, quite emphatically, the name of his portraitist to the viewer, whose gaze he forthrightly returns (fig. 55). In other words, Manet has obliged Théodore Duret to do precisely what he could not bring himself to do in his critical writings at that time, a weakness he manifested again to the artist in the letter relevant to this very portrait! And Manet has made his point with a device now familiar to us, the overt gesture which leads to the discovery of the concealed subject.

There is something very familiar about the pose and dress of Théodore Duret in Manet's portrait, and we may well ask if there is not some older image behind it, one that might even support the interpretation of the picture given here. Duret himself provides the strongest clue by mentioning in his letter the name of Goya (as well as of his imitators), whose influence on Manet is rather obvious in *L'Exécution de Maximilien* and *Le Balcon*, both painted within a year of the Duret portrait. And it is particularly appropriate to seek it here not only because of Duret's written reference but because he and Manet had visited the collections of Spanish art together.

The *Portrait of Théodore Duret* is, indeed, a paraphrase of Goya's *Portrait of Manuel Lapeña, Marquis of Bondad Real*, now in New York at the Hispanic Society of America (fig. 54). The general stands in quite the same wooden pose as does Duret, his hat has been converted by Manet into the Parisian model of 1868, his badge of the Order of Calatrava to a breast-pocket handkerchief, the tassel of the sword hilt to the fingers of a white glove, and the military baton to a walking stick. Most significant of all is the fact that Lapeña's baton points to the name "Goya," inscribed on the ground (right-side up, the way Manet had originally placed his own signature), while his gaze meets that of the viewer (fig. 56).

Even the way the jacket is fastened only by the uppermost button to reveal the vest is identical in both works. Although Manet has not worked a reversal of right and left as was sometimes his procedure in dealing with older source images, he has nonetheless reversed the direction of his model's position so that, unlike Lapeña, Duret faces slightly to our right. This is a modification to which we shall return.

Claims of Goya's influence on Manet have always been weakened by the artist's own stated lack of enthusiasm for the Spanish master, despite pictorial evidence to the contrary. Manet, while in Madrid, had expressed his view in a letter to Fantin-Latour. It is important to stress, however, that Manet's opinion was an admittedly tentative one, given before having seen many of Goya's works. His letter makes this clear:

> What I have seen of his work until now has not pleased me enormously. I shall shortly see a magnificent collection of it at the home of the Duke of Ossuna [*sic*].[4]

The portrait of Manuel Lapeña, a friend of the Duke and Duchess of Osuna, is known to have hung in the Alameda, or country home, of that family and thus was part of the "magnifique collection" that Manet looked forward to seeing,[5] and it is likely that he visited the collection in the company of Théodore Duret. At least it would appear from Duret's letter to Manet that he was aware of the Goya source behind his portrait. When we look into the personality of Manuel Lapeña, however (and Duret's facial expression is as blank as that of Lapeña), we are led to recognize that Manet's choice of a model on which to base his portrait was not dictated by formal considerations alone, and that if Duret knew something about that model, surely he knew nothing of the full extent of Manet's reason for having chosen it.

Lapeña had been a general in the Spanish War of Independence and has been described by one historian as "incapable of a swift and heroic decision, a selfish colleague and a disloyal subordinate."[6] This description, published too late for Manet to have known it, did not, however, represent a new historical interpretation of Lapeña. The poet Robert Southey in his *History of the Peninsular War*, a part of which appeared in a French translation in 1828, said of the general, "An excess

4. "Ce que j'ai vu de lui (Goya) jusqu'ici ne m'a pas plus énormement. Je dois en voir, ces jours-ci, une magnifique collection chez le duc d'Ossuna [*sic*]." This letter was first published in E. Moreau-Nélaton, *Manet raconté par lui-même*, vol. 1, p. 72.

5. See E. Du Gué Trapier, *Goya and His Sitters* (New York, 1964), p. 19. The author writes: ". . . it hung for years in the Alameda, although there is no documentation on the subject." In fact, it is not known when the portrait was removed from the Alameda of the Osunas. Alice Jane McVan has shown that the painting was there during and at least shortly after the War of Independence, since it shows the repairs of a slash administered by an angry mob that had entered the collection at that time. (A. McVan, "The Alameda of the Osunas," *Notes Hispanic*, vol. 5, [New York, 1945], p. 128.) Manet's use of the portrait in connection with Duret allows us to assume that the Lapeña portrait was still in the Alameda in 1865.

6. Charles Osman, *History of the Peninsular War* (London, 1911), vol. 4, p. 95. Cited by Trapier, p. 18.

of caution seems to have been Lapeña's failing."[7] Manet might have found his information in the history books or he may have obtained it directly from a guide while touring the Alameda. In any event, the historical judgment of Lapeña confirms the impression Goya's portrait gives us. Elizabeth Trapier has seen in the portrait Goya's ridicule of the "conceit of military men."[8] Tabarant has told us of Manet's deep depression upon reading Duret's criticism and that he was driven to lock himself for long periods into the "cabinet-Bibliothèque" of his parents' apartment.[9] If he never expressed his unhappiness directly to Duret, he certainly expressed it in the conception of this portrait.

In 1867, the publisher Dentu brought out two brief works of criticism dealing with Manet. One was the aforementioned *Les Peintres français en 1867* by Duret, which considered Manet among others; the other was Emile Zola's defense of the artist. Whereas Zola's statements were powerful, passionate, and unswerving in their praise, containing such exclamations as

> Destiny had surely already reserved a future place in the Louvre for *Olympia* and the *Déjeuner sur l'herbe*, [10]

Duret's was, on the whole, negative or, at best, halfhearted and weak:

> We quite simply discover the work of an artist whose principal faults are the result of his having begun to paint before having an adequate mastery of the brush....
>
> M. Manet has not completely succeeded in achieving his goals because his imperfections render him an artist still too incomplete today to be accorded the rank he wished to attain in a single bound, but neither has he broken his neck as he might have done....

Getting down to specifics, Duret remarks:

> His technique is not yet developed to a sufficiently secure level, his modeling lacks solidity, and his faults are particularly noticeable in his treatment of figures. It is essential, if an artist wishes to prove himself fully, to develop the value and merit of the form as much as possible, and M. Manet prevents himself from rising to what he could be by painting in a too-rapid and hasty manner.[11]

7. Robert Southey, *History of the Peninsular War* (London, 1832), vol. 3, pp. 164, 175–76. Cited in Trapier, p. 19.

8. Trapier, p. 19.

9. Tabarant, *Manet et ses oeuvres*, p. 139.

10. "Le destin avait sans doute déjà marqué au Musée du Louvre la place future d'Olympia et du Déjeuner sur l'herbe." Emile Zola, *Manet (O.C., Oeuvres Critiques)*, p. 279.

11. "... on découvre tout simplement les oeuvres d'un artiste dont les principaux défauts viennent de ce qu'il a commencé à peindre avant de savoir suffisament manier le pinceau.... M. Manet n'a point réussi complètement dans ce qu'il a voulu faire, car ses imperfections en font un artiste encore trop incomplet pour qu'on puisse dès aujourd'hui le placer au rang qu'il a voulu conquérir d'un bond, mais il ne s'est point non plus cassé le cou comme il eut pu le faire.... Son faire n'est pas poussé a un point assez arrêté, son modelé manque de

If Zola was inaccurate in his view that Manet was a painter whose art contained no ideas, he could, at least, not have been found lacking in courage and good intentions as well as in some important observations concerning Manet's technique. It was natural, on the other hand, for Manet to suspect Duret of having acted in bad faith, a suspicion that Duret's request concerning the artist's signature inevitably confirmed. In his biography of Manet, published originally in 1902, Duret describes the painting of his own portrait and recalls how, apparently as an after-thought, Manet added the little still-life arrangement in the lower right corner and how he got the idea to take "un volume broché, qu'il jeta sous le tabouret" [a paperbound volume, which he threw under the stool].[12] Now, in the *Portrait of Manuel Lapeña* the names of Lapeña and Goya (as well as the date) are placed together at the lower left corner, and with his baton Lapeña is able to point to them both. His body is also turned toward the left, consistent with his gesture. In the case of Zola's portrait, Manet was also able to combine his name with that of his subject by means of the book on the desk, but in the *Portrait of Théodore Duret*, the subject's name never appears. He has, however, been turned to the right and *away* from the indication made by his cane. His rightward stance directs our attention to the stool in the opposite corner, and there on the floor, as a kind of pendant to the signature (which we may also read as being inscribed on the ground in Goya's picture), is the book that Manet "threw under the stool." What can the nameless volume represent but Duret's *Les Peintres français en 1867*, apparently discarded, separated from the painter's name, which Duret is made to acknowledge?

As is well known, Manet and Duret remained good friends. Duret was named executor of Manet's estate, and in 1902 he wrote the biography of the artist. The first sign that Duret had revised his opinion of Manet's art or, to be more accurate, that he had decided to defend him unequivocally is an article that appeared in *L'Electeur Libre* on 9 June 1870 in which Duret is not only forceful but, in view of the foregoing events, insists a bit too much:

> We will summarize the opinion that we formed of Mr. Manet long ago in saying that he is a creator, one of those rare ones who have their own view of things and who, as a consequence, is alive.[13]

fermeté, et ses défauts s'accusent surtout chez lui dans le traitement des figures. Il faut, pour qu'il donne toute sa mesure, qu'un artiste pousse la valeur et le mérite de la forme aussi loin que possible, et M. Manet se condamne a rester fort au-dessous de ce qu'il pourrait être en peignant d'une manière trop rapide et trop hâtive." Théodore Duret, *Les Peintres français en 1867* (Paris, 1867), pp. 108–10. A passage from this essay is quoted by Tabarant (*Manet et ses oeuvres*, p. 138), and a longer excerpt in translation appears in Hamilton's *Manet and his Critics* (New Haven, 1954), pp. 108–11.

12. Duret, *Histoire d'Edouard Manet*, pp. 71–73. Duret also mentions the addition of the lemon. William Hauptman has called to my attention Mathias Holtzwart's *Emblematum* (Strasbourg, 1581, emblem no. 21) where the lemon signifies the false friend, *Amicus Fictus*. Perhaps this explains Manet's pointed use of the lemon above the discarded book.

13. "Nous résumons l'opinion que nous nous sommes depuis longtemps formée de M. Manet, en disant que c'est un inventeur, un des rares qui ait sur les choses sa vue propre, et qui, par là, soit vivant." Part of the article is cited by E. Bazire, *Manet* (Paris, 1884), pp. 63–64.

4 Immortality

Manet's art covers all the subject categories. In this respect, he was the complete artist as Baudelaire had defined him, for the poet considered subject specialization as a limitation. It is a simple matter to arrange Manet's works along the conventional lines of genre, still-life, landscape, portrait, religious, and historical pictures. It has also become standard practice to divide his work into several distinct periods: the early and more or less immature paintings before 1860, the great figure pieces of the 1860s, the Impressionist manner of the 1870s, and the work of the last few years in which a fusion of the figure paintings of the sixties and the Impressionist palette of the seventies is attempted. There are the familiar subdivisions also, such as the "Spanish" works of the early 1860s, although these belong, stylistically, to the *oeuvre* of that decade as a whole.

Such an analysis certainly has its justification and is indeed helpful in establishing an orderly basis for the study of the artist. It has, however, also had the tendency to become too binding and has contributed to the long delay in the detection of the highly significant continuity of ideas in Manet's art, a continuity as admirable as it is logical. There was in Manet's nature an obstinacy and tenacity that argue against any fundamental changes in his idea of art. Paul Jamot has rightly said, "It is always the same Manet,"[1] and there are some paintings throughout the 1870s that, despite transformations in style, strongly recall the works of the preceding decade and the feelings they arouse. The enigma is still there, although we may find its setting a little less stark, the paint application a little more nervous. It is clear, however, that during the mid-seventies, when Manet applied himself to *plein-air* painting, notably with Monet at Argenteuil in 1874, there was a relaxation in his art, an easing of that compelling intensity that marks the earlier work and returns in some of the late pictures, notably in the *Bar aux Folies-Bergères*. But even the Argenteuil production is accented by pictures in which he paints monumental figures and continues to struggle with the problem of confrontation, and in which we remain aware of the continuing tension between the

1. "C'est toujours le même Manet." (Jamot-Wildenstein-Bataille, *Manet* [Paris, 1932], p. 3.)

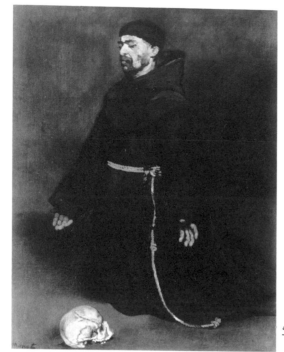

57. *Moine en prière*, ca. 1865,
Museum of Fine Arts, Boston.

expression of individual personality and universal principles—between the partic-
ular and the general.

The recognition of a few profound philosophical themes in Manet's work enables
us to regroup his pictures along unconventional lines. In the process of making
such a new arrangement, we also discover greater continuity and consistency in
his thinking, a quality masked by his stylistically rich and diversified *oeuvre*. For
example, although we have long been aware that Manet treated the subject of
death with more than expected frequency, these pictures have never been seriously
considered as a group and, consequently, much of their fundamental meaning for
the artist, as well as his motivation in painting them, has eluded us. So strong has
been our prejudice in favor of a Manet without ideas and without passion that
such an investigation has been altogether neglected. Manet has never been thought
of as a morbid painter, a qualification that his forthright style, even more than his
usual choice of subjects, has rendered inappropriate. Yet it is remarkable that he
returned with regularity to the subject of death, although always with a singular
lack of pathos and compassion, so that these, more than his other works, have
created the impression that Manet was without feeling and that his subjects
were only pretexts for pure painting.

Pictures that come quickly to mind, such as *Le Christ aux anges*, *L'Exécution de Maximilien*, *Le Torero mort*, *Le Suicide*, *La Barricade*, *Guerre civile*, and *L'Enterrement*, usually separated into categories of religious or history painting, genre or even landscape, all have death as their overt theme. Less obviously but no less intensely concerned with death are the *Bullfight* pictures and *Pertuiset, chasseur de lions*, in which the victims are animals. This by no means exhausts the list. Of particular interest is the *Moine en prière* (fig. 57), actually a monk meditating on the subject of mortality, as the skull that lies before the kneeling figure informs us. This painting may be regarded as emblematic for the group since it illuminates the inner theme of the other works. It suggests that these pictures do not, as Zola intimates, merely convert humanity and its problems to still life for the sake of aesthetic arrangement and rendering. It further suggests that the artist is not primarily interested in an individual demise regardless of its historical significance (and Manet is known to have shunned the role of history painter) or picturesque qualities. We may surmise that Manet is principally concerned with the theme of death as the transition from one state of being to another, in the relationship between body and soul, mortality and immortality—perhaps the most fundamental dualism of all. The theme is handled more richly and with far greater subtlety in what has been thought of as one of several aberrations in Manet's work, the religious picture of 1864, *Le Christ aux anges* (fig. 58).

In a corner of this painting Manet has placed a rock, which appears to be crushing a serpent, and on this rock we find the inscription "Evang. sel. St. Jean chap. XX 5, 12" (fig. 59). If we read this passage of the Gospel we find that Manet's image bears an imperfect relationship to the text. The story of the angels at Christ's tomb is told by all four Evangelists. It is true that Matthew and Mark speak of only one angel, but Luke and John speak of two, and Manet's image, if interpreted literally, is as close to the description of Luke as it is to that of John. In one important particular it differs from all the Gospels, for the Evangelists speak of the resurrected Christ who is no longer in the tomb. John alone adds the information that the angels were placed one at the head and the other at the foot of where Christ had lain. Manet has, the literal description notwithstanding, made Christ his central image and has placed one angel at either side of him. It is not reasonable to belittle or to ignore this discrepancy, since Manet invites the comparison with the text by clearly citing his source.

The figure of Christ is convincingly rendered as a cadaver, and we can appreciate Zola's defense of it as a bit of superb, realistic painting.[2] Yet Christ sits up and reveals the stigmata willfully and the expression of death on his face mingles with an other-worldliness that mitigates it. Our feeling that this figure is both dead and alive is in accordance, of course, with the theme of the Resurrection, and it receives further visual support from the opposed character of the two angels. The one at the left covers his face with his hand in an obvious gesture of grief, while the other looks forward, transfixed, as if possessed by a superior knowledge. In the etching

2. Zola, *O.C.*, vol. 41, pp. 243–79.

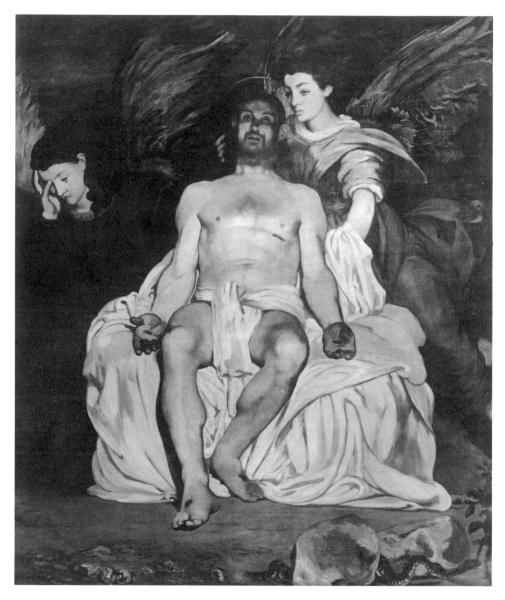

58. *Le Christ aux anges*, 1864, Metropolitan Museum of Art, New York, the
H.O. Havemeyer Collection.

59. Detail of fig. 58.

Manet made of this composition, the expression on the face of this angel is more intense, and is framed by a shock of hair that stands away from the head as if electrically charged. Furthermore, we note that Christ is received by this angel and that the direction of the wings and key compositional lines all move toward the right. Finally, the wings of the angel at the left are rather dull in color, while those of the other angel are a brilliant, one might say triumphant, blue.

On the ground at the left is a row of snails; at the same level on the right we find the rock and snake. Both creatures traditionally symbolize the Resurrection, which is completely consistent with the subject of the painting. However, there may be a further significance to their use here, one that emphasizes the division of the painting into two iconographically opposing halves. The rock, if it crushes the snake (and this is not absolutely clear here), as it does in Vermeer's *Allegory of the Catholic Faith* (Metropolitan Museum, New York), would be read as the triumph of Christ over the powers of darkness, including mortality. The snails may be seen as eminently earthbound creatures, as they were for Baudelaire in the poem "Le mort joyeux," which greets death as a comfort:

> Dans une terre grasse et pleine d'escargots
> Je veux creuser moi-même une fosse profonde.[3]

> [In a soil rich and full of snails
> I want to dig my own deep grave.]

Thus we have a painting of which the left side speaks of Christ the man and of his physical death, while the right proclaims his spiritual rebirth and its significance

3. Baudelaire, *O.C.*, p. 67. The association of these creatures with the Resurrection derives from the fact that the snail breaks the cover of its house in spring, while the snake sheds its skin and is thus, in a sense, reborn. It would, however, only be misleading to enter into all the subtle possibilities provided by the emblem books in this case. In view of the left and right division of the painting, the more obvious interpretation, that the snails are identified with the earth and the crushed snake with Christ's triumph, seems the more logical one.

for mankind. One angel mourns the man and expresses the sufferings of the flesh, while the other welcomes the god. This, then, is Manet's translation of the information given by Saint John, that the angels were at the "head" and "foot" of the tomb. He has seen in these words the "higher" and "lower" of the spiritual and the physical states. This description is given in verse 12, which closes Manet's inscribed reference.

A more literal handling of the images of "head" and "foot" had occurred in the *Déjeuner sur l'herbe* of the preceding year, wherein the vertical line drawn through the center of the hemicycle (see schema I, fig. 7) runs through the head of the wading figure (derived, let us recall, from a Saint John) and the foot of the seated nude. In that painting, the two figures represent the polarity of the sacred and the profane. Here, spirit and matter are combined in one figure, a religious symbol, at the instant of final passage from the one state of being to the other. In both paintings Manet was conscious of the "head" and "foot" metaphor as a microcosmic equivalent to the "above" and "below."

Of the four Gospels, that of Saint John is the most thoroughly mystic. It is Saint John who tells us less of the life of Christ on Earth, but who stresses the meaning of the "logos" become flesh, and the role and lesson of love in the Passion. It is an interesting and not generally remembered fact that only Saint John speaks of the lance wound in Christ's side. This wound, in the painting, is the subject of some advice given to the painter by Baudelaire. Manet, he suggested in a letter, had put the wound on the wrong side of the body and had better correct the error before submitting the picture to the Salon and himself to further ridicule on the grounds of ignorance.[4] Manet, as we can see, made no changes, and it has been customary to assume that he no longer had sufficient time to make them.[5] In view of Manet's unexpected but pictorially logical interpretation of John's words, with which we are now familiar, we may expect to find a more convincing reason for Manet's refusal to make a reversal by turning our attention once more to the text.

Saint John does not, in fact, tell us on which side the wound was inflicted, and Manet clearly knew this, since he cites his textual source. However, John does write that Jesus was the only one of the three martyrs to receive the wound, rather than have His legs broken like the others, in fulfillment of the Old Testament prophecy of the Messiah. From this wound, writes the Evangelist, poured blood and water, traditionally interpreted as symbols of the Eucharist and the Baptism. It does not seem to be a matter of indifference, nor of error, that Manet placed the wound on Christ's left side (the right side of the painting), with the angel of the Resurrection and the symbol of spiritual triumph, for of all the stigmata, only the lance wound is described specifically as a symbol of Christ's divinity and immortality.

The *Moine en prière* with its memento mori and the *Christ aux anges* are rather special treatments of the theme of physical death and spiritual immortality. The

4. Tabarant, *Manet et ses oeuvres*, p. 81.
5. Ibid.

other pictures that have death as their subject rediscover this central problem in the incidents of modern life. This is suggested by a recognition of the fact that the incidents Manet has chosen as vehicles for the expression of his ideas all treat death as part of a ritual, hence their dispassionate, preordained character. The Emperor Maximilian's life is taken in the cold, military ritual of the firing squad (fig. 60). In Manet's painting, he appears to be resigned to his fate and to his sacrifice. If Manet, when conceiving this picture, had Goya's *Executions of the Third of May* (fig. 61) in mind, we may be sure that it was the subject and the arrangement and not the horror of that painting that interested him. Manet is not, as an artist, concerned with either the injustice of the event nor the torment of the individual, but with the phenomenon of death itself at the moment of its intervention. As in the *Christ aux anges* he remains resolutely philosophical toward his theme, and in both works it is the instant of death that he treats in a fixed and timeless way.

It has long been thought strange that Manet, who was so opposed to history painting, should have painted this execution and on so monumental a scale. It is the wider theme of death itself that gives us the painter's justification. Maximilian, as a tragic public figure, serves well as the symbol of everyman at the moment of his final crisis. The event gave Manet the opportunity to treat his subject on a scale worthy of the importance it had for him and in the form of a widely known current news story. It has been shown that Manet went to great lengths to inform himself of all possible details of the execution.[6] This may, at first, seem an odd procedure in the light of the interpretation of the picture given here. It is, however, completely consistent with the painter's expressed desire to paint only what he had seen.[7] In this case, having found an ideal subject for the expression of this theme, but one that he had not actually witnessed, he did the next best thing: he worked from news photos and information, in conjunction with live models, to produce as accurate a reconstruction as possible. Once again, Manet was at pains to paint modern life with an awareness, as Baudelaire had written, of the presence of the timeless principles it encloses. To reach this eternal element, he had to be scrupulously faithful, if selective, toward the transitory. The exploded bullets that have just been fired leave a cloud of smoke that envelops the still-standing Maximilian. Above it we see his impassive face and can hardly imagine that an instant later, when the smoke clears, we will have a bleeding cadaver before us. It is actually easier to imagine that the figure will disappear. To have fixed this dramatic split second in a manner that gives it classical stability and denies its very transience is a tour de force that merits greater appreciation than it has received.

Both Sandblad and Kurt Martin before him have observed that the soldiers in *L'Exécution de Maximilien*, in all but the first version, wear French uniforms.[8] These, although very similar to those of the Mexican soldiers, are, nevertheless,

6. Sandblad, *Manet*, see the chapter "L'Exécution de Maximilien," pp. 109–58.
7. Proust, p. 91.
8. Sandblad, *Manet*, pp. 129–33, 137, 143; Kurt Martin, "Die Erschiessung Kaiser Maximilians von Mexico von Manet," *Der Kunstbrief* (1948), p. 11. (Martin is quoted by Sandblad on p. 132.)

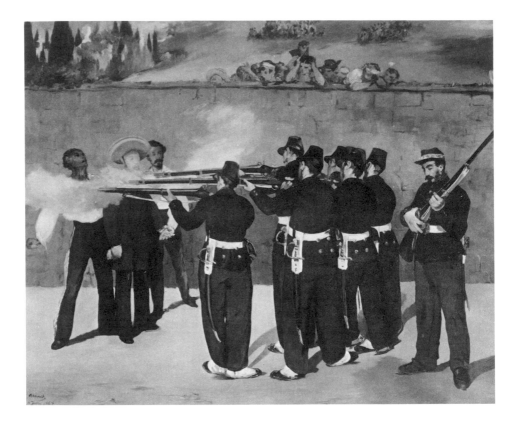

60. *L'Exécution de Maximilien*, 1868, Kunsthalle, Mannheim.

not identical with them. It is true that Manet used French soldiers as models, but this would not explain why he neglected to change the necessary details of the uniforms while otherwise being so scrupulous in regard to data from Mexico. Martin concluded that Manet simply surrendered to the visual qualities of the object before his eyes at the expense of factual accuracy. Sandblad has rejected this argument, but he fails to articulate an alternative explanation, although he strongly believes that Manet's choice was calculated. Martin's analysis may well be correct insofar as the artist's involvment with his immediate world is concerned. But a fuller explanation is suggested by Manet's use of still another pictorical source for his painting, one that has so far gone unnoticed. In a book by Baudelaire's friend Alphonse Esquiros, *Les Fastes populaires*,[9] there is an engraving entitled *Justice du peuple*, which represents a French execution by firing squad (fig. 62).

9. Alphonse Esquiros, *Les Fastes populaires*, 4 vols. (Paris, 1851). The engraving is bound in at the back of vol. 4. According to Marc Eigeldinger ("Baudelaire et l'alchimie verbale," *Etudes Baudelairiennes*, vol. 1 [1971], pp. 81–98), it was Esquiros who introduced Baudelaire to Eliphas Lévi.

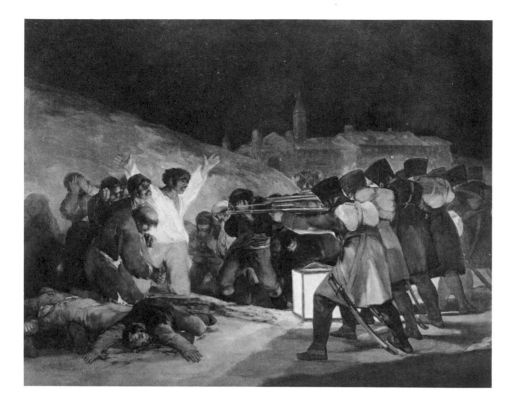

61. Goya, *The Executions of the Third of May*, 1815, Prado, Madrid.

Beyond the general similarities with Manet's picture of the subject and composition, there are two details that tend to preclude the possibility of coincidence here: the hand gripping a sword seen rising above the heads of the executioners (present in all but the Mannheim version of Manet's picture—compare with fig. 63) and the position and pose of the rifleman at the extreme right. Although the uniforms are not those of Manet's picture, since the engraving depicts an earlier moment in history, the scene is clearly French. When we recall that the other pictorial source for Manet's composition was Goya's *Executions of the Third of May*, a Spanish subject, we must conclude that despite his accuracy in regard to certain Mexican details, Manet is fundamentally more universal in his interests: Maximilian is everyman, and the viewer is intended to enlarge the subject of a particular and distant execution to the theme of death in its most unlimited sense.

But this universal meaning, as we know, had to be presented within the context of modern life. The execution of Maximilian, although of historical importance, was a modern subject. Since Manet has demonstrated his acceptance of Baudelaire's conviction that the eternal had to be distilled from the familiar, Manet may well have retained French elements of costume (particularly since these were very similar to the Mexican ones in general) as a statement of concern for the spatial

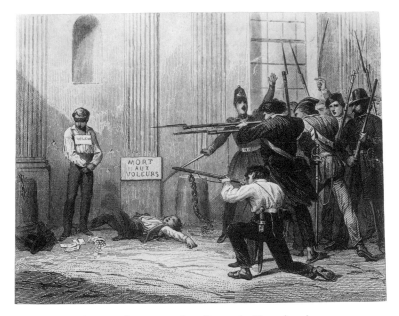

62. *Justice du peuple*, engraving from A. Esquiros'
 Les Fastes populaires, 1852.

equivalent of this temporal consideration. In other words, Manet's time was paired with Manet's place for a fuller reference to the sphere of his own experience.

Certainly the presentation of French costume and military pose seems to have been a calculation in view of still another source for the painting, which has recently been suggested. Thomas Schlotterback has found a prototype for the figure inspecting his rifle in a French battle painting by Paul Alexandre Protais.[10] Since this painting won a prize at the Salon of 1863, it is likely that Manet knew it. In some ways the pose (notably the tilt of the head) is closer to Manet's figure than is the corresponding character in *Justice du peuple*, although in that picture, the stance is also very close to that of Manet's figure and, of course, we are dealing with executions by firing squad in both the source and its derivation. Furthermore, Manet has omitted the spats of the Protais figure (although his other riflemen wear them), and the trousers and shoes are closer to the earlier print. It seems probable that Manet knew both pictures and may have been concentrating on French sources for precisely the purpose suggested above.

Sandblad has not only firmly established the chronology of the five versions of *L'Exécution de Maximilien* (one of them a lithograph), but he has pointed out the change in mood from one of romantic passion in the early Boston version, painted

10. Thomas Schlotterback, "Manet's 'L'Exécution de Maximilien,'" *Actes du XXII^e Congrès internationale d'histoire de l'art—1969* (Budapest, 1972), vol. 2, pp. 785–98; vol. 3, p. 600.

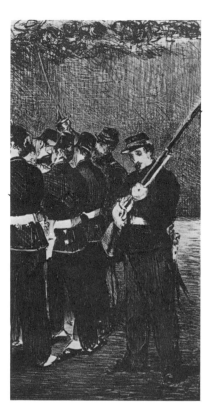

63. *L'Exécution de Maximilien*, lithograph (detail),
National Gallery of Art, Washington, D.C.,
Rosenwald Collection.

in August 1867, to the others, painted after 10 September, which he describes as
objective and "illustrative."[11] Sandblad explains this change in attitude as the
result of a shift in popular sentiment, as the details of the execution gradually
became known, away from pure sympathy for the emperor and toward the Mexican
people in their quest for freedom and independence. Thus, the author argues,
Manet could not allow his initial statement to remain the definitive one. That there
is a real change from the first to the subsequent versions cannot be denied. But
this change lies more in the quality of the stroke than in the arrangement. The
Boston version already contains the most salient ideas of the later ones: the
proximity of the firing squad to the victims; the still-standing emperor while the
figure at the left has already been hit; the blocklike configuration of the firing squad
(in fact this calculated element is even stronger in the first "passionate" version);
the indifferent attitude of the rifleman at the extreme right who, although not
mentioned in the news reports, was retained by the artist in the later versions, as
Sandblad states.[12] In other words, the nature of Manet's interest in painting this

11. Sandblad, *Manet*, see the chapter "L'Exécution de Maximilien," particularly pp.
152–53.
12. Ibid., p. 137.

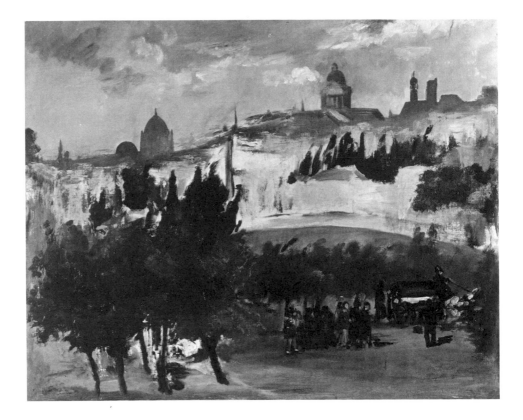

64. *L'Enterrement*, ca. 1870, Metropolitan Museum of Art, New York, Wolfe Fund.

subject was clear from the start and never fundamentally changed. The first picture, in spite of its size, makes the impression of a sketch. The information Manet received concerning details of the event led to a more meticulous handling, which, together with some compositional adjustments, produced a more objective statement. Sandblad's political explanation of this increased detachment, an interpretation designed to demonstrate the artist's compassion for the Mexican people, is a weak point in his argument, particularly since he exaggerates the "passionate" quality of the first version. It is more likely that the development of, rather than the alleged shift to, a disengaged attitude may be linked to another event that had taken place between August and September of 1867: the death of Baudelaire on 31 August. On 2 September, Manet attended the poet's funeral, and the descriptions given by witnesses of that occasion, including the threatening summer storm and the small cortège moving toward the cemetery of Montparnasse, suggest Manet's painting *L'Enterrement* (fig. 64). Here there are few human mourners, but nature grieves in the sketchy patch of trees, probably cypresses, which echo the shape of the carriage and figures directly below it.

It is in Baudelaire's diaries that we find a remarkable entry on the subject of executions, not a stray notation, but a highly developed idea that he had planned to use as the basis of a novel:

> The death penalty is the result of a mystical idea, totally misunderstood today.... So that the sacrifice be perfect, there must be assent and joy on the part of the victim. To give chloroform to a condemned man would be impious because it would mean depriving him of the consciousness of his greatness as a victim, and suppressing his chances of gaining paradise.[13]

The best evidence of Baudelaire's attachment to Manet, an attachment born of the sharing of ideas and sentiments, is given in a letter written by Nadar in which the photographer and friend of both men implores Manet to visit Baudelaire, who had lost the power of speech, with the exception of the obsessive oath, "crénom" [damn it]:

> Baudelaire clamors for you. Why didn't you come with us and him today? Will you make up for that Friday morning? He missed you and he surprised me when I went to get him, by shouting from the back of the garden: Manet!! Manet!! That has replaced the "damn it."[14]

As the details of the execution reached Paris, Manet found more and more justification for treating his painting as a philosophical study of death, specifically by finding support for Maximilian as the ideal hero of this theme, the hero who fulfilled the requirements of the mystic death postulated by Baudelaire. Sandblad has cited the words of the emperor to the officer in command, who had expressed his reluctance to carry out his orders, as they appeared in the *Mémorial Diplomatique*: "I thank you with all my heart for your kind feelings, but I demand that you follow your orders."[15] Here, then, was the "assent" Baudelaire had felt was necessary to "gain Paradise," and Manet could paint the emperor as completely calm, noble, and in possession of the "consciousness of his greatness as a victim," with

13. "La peine de mort est le résultat d'une idée mystique, totalement incomprise aujourd'hui.... Pour que le sacrifice soit parfait, il faut qu'il y ait assentiment et joie de la part de la victime. Donner du chloroform a ùn condamné à mort serait une impiété, car ce serait lui enlever la conscience de sa grandeur comme victime et lui supprimer les chances de gagner le paradis." (Baudelaire, *O.C.*, p. 1278.) Among his projects, Baudelaire notes a "roman sur la sainteté de la peine de mort" [novel on the sanctity of the death penalty], and the thought, "Le sacrifice n'est complet que par le *sponte sua* de la victime" [The sacrifice is only completed by the willingness of the victim] (p. 521).

14. "Baudelaire vous demande à cor et à cris. Pourquoi n'êtes-vous pas venu avec nous et lui, aujourd'hui? Réparerez-vous cela vendredi prochain? Vous lui avez manqué et il m'a surpris quand je suis allé le chercher, en me criant à pleine voix du bout du jardin: Manet!! Manet!! Ça a remplacé le crénom." (Tabarant, *Manet et ses oeuvres*, p. 132.) The letter is also cited in Francis and Lois Boe Hyslop, "Baudelaire and Manet: a Re-appraisal," *Baudelaire as a Love Poet and Other Essays*, ed. Lois B. Hyslop (University Park, Pa., 1969), pp. 87–130 (quotation on p. 129).

15. "Je vous remercie de tout mon coeur pour vos bons sentiments, mais j'exige que vous suiviez vos ordres." (Sandblad, *Manet*, pp. 112–13.)

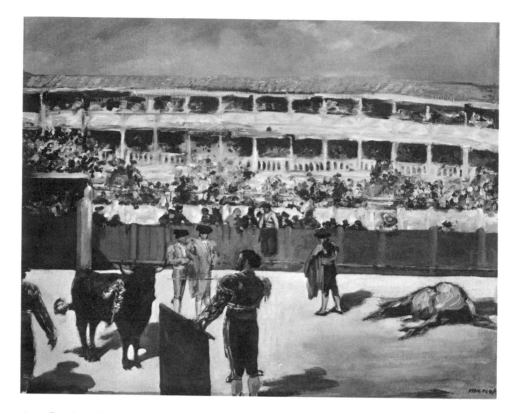

65. *Combat de taureaux*, 1866, Art Institute of Chicago.

the cloud of gunsmoke enveloping him in unearthly fashion. That he is destined
to attain his supreme goal is indicated by the golden rings of his sombrero, which,
as Sandblad was the first to point out, become a corona or halo; thus, "an incon-
sequential ethnographic attribute has been turned into a universal symbol."[16]

It was Sandblad's purpose to show that Manet was far from indifferent to the
human and moral meaning of this shooting, and in such a symbol as the "halo"
and, primarily, in the sobriety and "finality" of the image, Manet's eloquent
response to the event is to be found. He even speaks of an "outer" and "inner"
theme,[17] as I have done, but the interpretation of this painting given here and

16. Ibid., pp. 147–48. Sandblad's interpretation of this detail is strongly supported by
Folke Nordström's subsequent discovery of the pierced palms of the principal victim in
Goya's *Executions of the Third of May* (*Goya, Saturn and Melancholy*, Uppsala, 1962, p. 178).
This identification of the victim with the crucified Christ was surely of importance to Manet
who, in his picture, represents three martyrs and provides the central one with a halo. The
"voluntary sacrifice" idea of Baudelaire is in perfect accord with this Christian subject.

17. Ibid., p. 127.

supported by the studies of the other major works leads to a somewhat different conclusion, namely that both these aspects of Manet's picture are to be viewed as "outer," reserving the characterization of "inner" for the impersonal, philosophic meditation on the meaning of death. This does not contradict Sandblad's conclusions as to Manet's humanity but preserves something of the older notion of the artist's detachment, albeit as an artistic principle, the result not of an inability to feel but of the conscious decision to limit has major works to monumental questions of universal concern. The anecdote is, indeed, destroyed, but the thematic motivation and content remain completely intact.

The spectators behind the wall had led Sandblad to recall Manet's *Combat de taureaux*[18] (he does not specify which of several versions), in which a similar group appears, and which Manet had seen during his visit to Spain. In addition to his own memories and possible sketches, Manet had the example of Goya's *Tauromaquia* etchings to help him re-create the motif in the Maximilian scene. But one particular version of the *Combat de taureaux* (fig. 65) in the Art Institute of Chicago is particularly revealing and presents a deeper and far more unexpected parallel with the *Exécution de Maximilien*, as a whole. In this example, not only do we have the spectators in the background above a wall, but also a similar placement of executioner and victim. The angle of the torero and bull to the picture plane, their proximity to one another, the sword held, like the rifles, in such a manner that it is parallel to the horizontal edges of the picture, and, most important, the selection of the same instant in time, a split second before the weapon penetrates the victim, must represent a deliberate duplication in the *Exécution* of the earlier scene. This is further suggested by the objective air that is shared by both works. We must ask why this duplication? What do the subjects have in common? Why is the emperor of Mexico asked to replace a bull? The only possible answer is that Manet's principal interest in both works is the theme of imminent death occurring in ritualistic circumstances. In both cases has the victim, who stands perfectly still, come to accept his fate; in both cases is the death blow to be delivered in a calculated, dispassionate fashion; in both are executioner and victim very near each other in what is a unique moment of the unity of opposites. What is a popular and accepted symbol in the *corrida*, where one bull replaces another day after day, is instilled into a singular historic event, reducing it, perhaps, in historical significance, but also expanding its meaning to encompass humanity without restrictions of time or place.

Before considering another of Manet's scenes of death in the bull ring, it will be necessary to turn our attention to a painting that, at first glance, may not appear to properly belong in this discussion at all: the *Portrait of Emile Zola* (fig. 66). Manet painted this work in 1868, twelve years after having left Couture's studio. The last recorded contact between Manet and his teacher took place in 1858 or 1859 when Couture, upon Manet's invitation, came to his old student's studio to give an opinion on *Le Buveur d'absinthe*. Although Proust has written that

18. Ibid., p. 146.

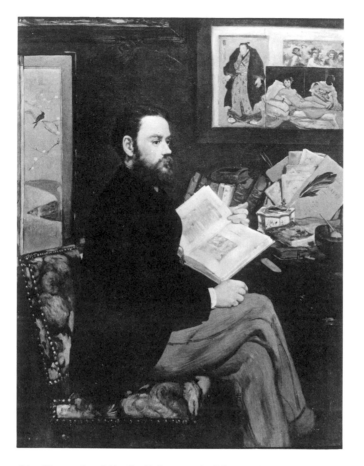

66. *Portrait of Emile Zola*, 1868, Musée du Louvre, Paris.

Couture's strong condemnation of the work on that occasion provoked Manet into declaring his future independence of his master's opinions,[19] it is unlikely that he lost all interest in Couture and his teaching. Manet's lingering interest in Couture, even if maintained in a spirit of contradiction, is suggested by the curious similarities that exist between the *Portrait of Emile Zola* and Couture's *Les Bulles de savon* (fig. 67), painted at about the time the two men had had their last meeting.

Les Bulles de savon, nominally a genre picture, is actually an allegory on the passing of material existence. The books, the laurel crown, the mirror on the table top are all vanities, while the bubbles that rise in the air, referring to the fragility and brevity of human life, are the fundamental ingredient of the *homo bulla* subject, a popular variant of the *vanitas* theme. Both paintings contain a single figure seated

19. Proust, pp. 32–33.

67. Couture, *Les Bulles de savon*, 1859,
 Metropolitan Museum of Art, New York,
 bequest of Catherine Lorillard Wolfe.

at a desk and looking off into space; each seems to have momentarily abandoned the activity in which he had been engaged: Zola holds an open book but does not look at it, and his spectacles are hung loosely around his neck; Couture's youth absentmindedly holds a bubble pipe in his lap and stares dreamily before him, while bubbles rise in the background. Both desks have closed books on them, and on Zola's there is a lacquered bowl with what appears to be a pipe in it, while on the boy's desk is placed the glass of soap solution with the projecting stem of a bubble pipe. The genre subject is not intended to obscure Couture's allegory too efficiently, for the languorous pose of the boy makes it clear that he did not actually blow the soap bubbles that rise behind him and, consequently, that they have an emblematic function. To make himself even more explicit, Couture has painted a slip of paper into the mirror frame on the table. It contains a brief but telling inscription: "L'immortalité de l'un" [The immortality of the individual].

The portion of Zola's room that we see is filled with objects that refer to the relationship between the artist and his apologist. Most striking are the Japanese screen behind the writer and the Japanese print in the frame at the upper right,

68. Detail of fig. 66.

an influence that Zola recognized in Manet's art (fig. 68).[20] The Japanese print shares its frame with a photo of Manet's *Olympia* and a print of Velasquez's *Los Borrachos*, probably the etching by Goya. Both Velasquez and Japanese prints were an inspiration to Manet, and it is surely not accidental that they are here overlapped by *Olympia*, serving literally as background for that work. Reff has observed that the eyes of Olympia, Bacchus (in the Velasquez subject), and the Japanese figure all look in Zola's direction.[21] He does not return their glances but looks out into space, thereby acquiring that characteristic iconic look, which is one of the most consistent features of Manet's figures. At the top of the painting, above Zola, Manet has introduced the lower horizontal segment of a picture frame, which, together with the inner edges of the screen at the left and the frame of prints at the right, produces a new frame around Zola himself. When isolated in this way, the strange expression becomes a more conventional three-quarter-view portrait within the larger "portrayal" represented by the entire painting. By being "framed" in this way, Zola acquires a special relationship to the three figures who share a frame and who look down at him.

We must now inquire whether these three figures do not have in common some other quality in addition to the stylistic one mentioned earlier. Bacchus and Olympia are immortals in earthly settings, this much is clear, but the identity of the Japanese figure has always presented some problems. He has been identified as both a wrestler and an actor, but the two swords worn at his belt identify him

20. See S. Lane Faison, "Manet's Portrait of Zola," *Magazine of Art* 42 (1949), pp. 162–68.
21. T. Reff, "The Pictures within Degas' Pictures," *Metropolitan Museum Journal* 1 (1968), pp. 125–66 (the observation appears on pp. 149–50).

specifically as a samurai warrior (although the image may well represent an actor in the role of a samurai or a wrestler of noble lineage).

The swords not only identify the figure type but constitute the specific emblem of his immortality.[22] That this fact was known to Manet is suggested first by his great interest in Japanese art at this time (an interest that was surely cultural as well as purely aesthetic) and by evidence that it was known to Manet's circle, to Burty, Duret, and the Goncourts, in particular. During the World Exhibition of 1867 (of which Manet painted an impressive view) the artist and his friends had the opportunity of visiting the Japanese Pavilion. Two articles in a series covering the fair discuss the pavilion and pay special attention to the samurai and his remarkable swords.[23] In 1888, Burty, writing in Bing's magazine, *Le Japon Artistique*, has much to say about these swords; he informs us that by 1875, after many years of interest in Japan, he already had a collection of objects. This collection was modest, he writes, but "a sword . . . was the object of general admiration." Citing the "illustre prince Iéyas," Burty tells us that "the sword in the scabbard is the very soul of the samurai,"[24] and that even the most humble of these swords "are made to interest artistic temperaments."[25] In 1881, Edmond de Goncourt gives a more extensive account of the spiritual value of the Japanese sword:

> The Japanese Kachi, believing he was about to die, according to the story of Ricord, turned his sword over to his servants, the *paternal* sword, as he calls it, to have it taken to his son. In Japan, in this land of samurais, of the knights with two swords, the sword, the blade at least, is the most precious inheritance of the dead man, the object that is passed from father to son, and even, they say, an inalienable object. . . . Among the precious things, it is the thing par excellence for this warrior people. . . . In short the sword in Japan takes on a kind of sacred character.[26]

22. Hermann Smidt ("Die Buddha des Fernöstlischen Mahayana," *Artibus Asiae* 1 [1925], p. 28) states that the samurai, under the influence of Zen, wished to *become* his sword. This sword, passed on from one generation to the next, came to be viewed as a symbol of continuity. A Japanese proverb states: "As the sword is the soul of a samurai, so is the mirror the soul of a woman" (J. Piggott, *Japanese Mythology* [London, 1969], p. 46).

23. A. Chirac, "Le Guerrier japonais," p. 186, and R. Ferrère, "Le Kiosque japonais," p. 235, *L'Exposition Universelle de 1867 Illustrée*, vol. 1 (Paris, 1867).

24. "Un sabre . . . était cependant un objet d'admiration générale." "Le sabre à la ceinture c'est l'âme même d'un samourai." (Philippe Burty, "Les Sabres," *Le Japon Artistique* 1 [1888], pp. 135, 130.)

25. . . . sont faites pour interesser les natures artistes." (Burty, "Les Sabres," *Le Japon Artistique* 1 [1888], p. 139.)

26. "Le Japonais Kachi, ce croyant au moment de mourir, d'après le récit de Ricord, remet à ces domestiques son sabre, le sabre *paternel*, ainsi qu'il l'appelle pour le porter à son fils. Au Japon, dans ce pays des samourais, des chevaliers aux deux sabres, le sabre, la lame du moins, est l'heritage le plus precieux du mort, l'objet transmissible de père en fils, et même, dit-on, un objet inaliénable.... C'est parmi les choses précieuses, la chose par excellence pour ce peuple guerrier.... Le sabre prend enfin au Japon une espèce de caractère sacré." (Edmond Goncourt, *La Maison d'un artiste*, 2d ed. [Paris, 1881], vol. 2, pp. 278–80.)

69. Frederick Sandys, *After her Death*, illustration from *Good Words*,
 October, 1862.

Manet's general interest in swords is, of course, obvious from their frequent
occurrence in his art. It is well known that he and Duranty had fought a duel with
swords but less well known that toward the end of his life Manet had been invited
to illustrate an article for *L'Art de la mode* on swordsmanship, "sure then," the
editor wrote, "that it will have the greatest success."[27] Manet's interest in the
Japanese sword and his familiarity with its lore can hardly be doubted. The
samurai figure in the print, then, can be understood as representing still another
immortal in earthly form who, together with Olympia and Bacchus, speaks to
Emile Zola with silent glances in his direction.

There is a likelihood that Manet's use of the samurai as a symbol of immortality
was suggested by another, earlier image. In an illustration by the Pre-Raphaelite
artist Frederick Sandys entitled "After her Death" (fig. 69), we see a figure who
faces the specter of death with a contemplative air while reaching back to take
firm hold of the growing live plant at the left of the design. The symbolism of the

27. "Sûr alors," the editor wrote, "qu'il aura le plus grand succès." A copy of the letter
from Henri de Montant to Manet made by Léon Leenhoff for Moreau-Nélaton is located in
the Cabinet des Estampes, Bibliothèque Nationale, Paris. It is catalogued under the number
Yb3/2401.

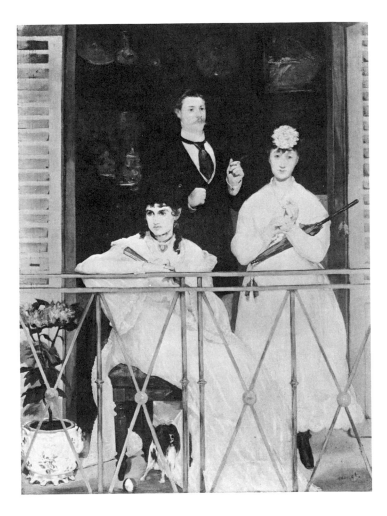

70. *Le Balcon*, 1868, Musée du Louvre, Paris.

opposition of the skeleton and plant—of death and life—is plain, and on the oriental flowerpot is clearly and minutely depicted a samurai with sword suspended from his waist.

The comparison becomes still more meaningful when we recall that Manet has placed a similar plant in the same relative position in *Le Balcon* (fig. 70), also painted between 1868 and 1869. In addition to the plant, these works are compositionally related in other specific ways. The Japanese screen behind Zola finds its equivalent in the balcony shutter to the left; the picture frame containing the three prints is matched by the small painting included at the upper right of *Le Balcon*, and the hands of the standing figure in that picture repeat the gestures of Zola's hands. While the cigar smoke may be viewed as still another *vanitas*

71. Detail of fig. 70.

element, the really telling detail in this connection is the aforementioned painting within *Le Balcon*, the compositional equivalent of the framed immortals in mortal form in the *Portrait of Zola*. Close scrutiny reveals what resembles a Dutch seventeenth-century still life, probably a *vanitas*, with a suggestion of a death's head, although this is intentionally left obscure (fig. 71).

In the light of the foregoing, still another transposition by Manet of a detail in Couture's *Bulles de savon* becomes meaningful. The laurel wreath on the wall above the head of Couture's youth is transformed in Manet's *Portrait of Emile Zola* into a pair of peacock feathers that create an arch over the model's head. In this way, Manet is able to retain the connotation of vanity while preserving the consistency of the room's decor and the plausibility of its assortment of objects. The peacock feathers have their stems pinned to the wall behind the picture frame containing the three immortals, and Manet has plotted their course so that they continue the line of the pipe stem across the brochure that bears the names of Zola and Manet and terminate in the exotic feathers over Zola's head.

The soap bubbles, the primary *vanitas* element in Couture's *Bulles de savon*, are omitted entirely from Manet's *Portrait of Zola*. Manet could not include them in his realistic representation without reference to a literary artifice, something he consistently avoided. His allegorical intentions are, as we have seen, much more concealed in the situations and appearances of modern life. But his involvement with the theme of the *homo bulla* is directly revealed in his portrait of Léon Leenhoff painted in 1867 and entitled *Les Bulles de savon* (fig. 72). The standard early rendering of this theme, as we find it in Goltzius's engraving *Quis Evadet* of 1594 (fig. 73) includes a putto blowing bubbles while leaning on a death's

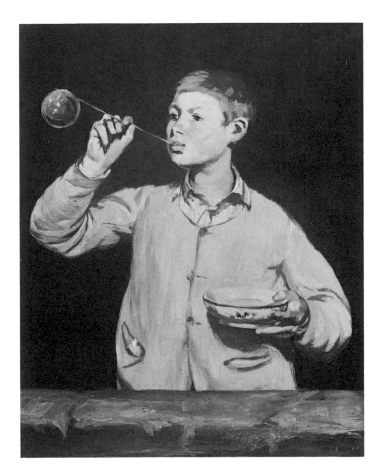

72. *Les Bulles de savon*, ca. 1867,
 Calouste Gulbenkian Foundation, Oerias (Lisbon).

head.[28] But great liberties were taken with it in the seventeenth and eighteenth centuries. Frequently the putto was replaced by a youth (fig. 74) or a pair of children, as in a painting by van Slingeland (fig. 75). This painting, an example of a type, bears remarkable similarities to *Le Balcon*. We have, in the first place, the figures framed by a window, the plant in full sunlight at the lower right, and the shelf with objects within. In this case, the hourglass and death's head leave no doubt about the significance of the soap bubbles being blown by the children,

28. See Horst W. Janson, "The Putto with the Death's Head," *Art Bulletin* 19 (1937), pp. 423–49, particularly pp. 446–49. For a list of Baroque treatments of the theme, see A. Pigler, *Barockthemen* (Budapest, 1956), vol. 2, pp. 580–81.

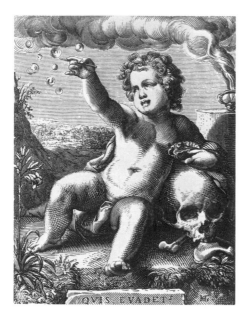

73. Goltzius, *Quis Evadet*, engraving, 1594, from Charles Blanc's *Histoire des peintres*.

74. German book illustration, eighteenth century (source not known).

while the Bacchic relief below the window completes the allegorical reference. The larger child holding his bubble pipe aloft occupies the equivalent position to the smoker in *Le Balcon*.

Artists frequently omitted the skull (fig. 76) and other obvious *vanitas* symbols altogether, leaving the soap bubble theme as, to all appearances, a genre picture (fig. 77). In his argument that Frans Hals's lost *Boy with Bubbles* (of which an old copy is in the Virginia Museum of Fine Arts), which contains no direct *vanitas* references, is, nevertheless, to be considered a *vanitas* picture, Seymour Slive states:

A seventeenth century man did not need the skull, flowers, smoke and Latin inscription to get the point. Not only is the comparison of man's

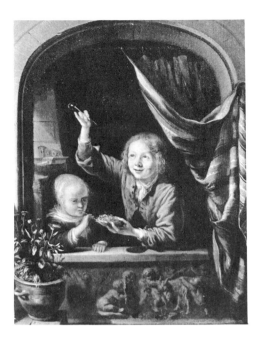

75. Pieter van Slingeland, *Children Blowing Soap Bubbles*, seventeenth century, coll. of His Majesty, The Prince of Liechtenstein.

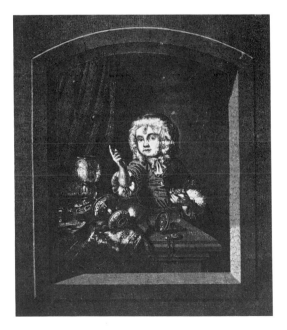

76. Frans van Mieris, *L'Observateur distrait*, from Charles Blanc's *L'Histoire des peintres*.

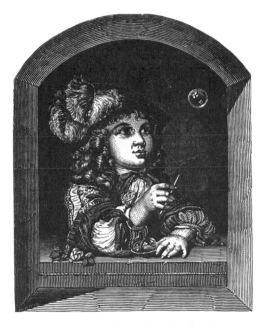

77. Caspar Netscher, *Les Bulles de savon*, from Charles Blanc's *L'Histoire des peintres*.

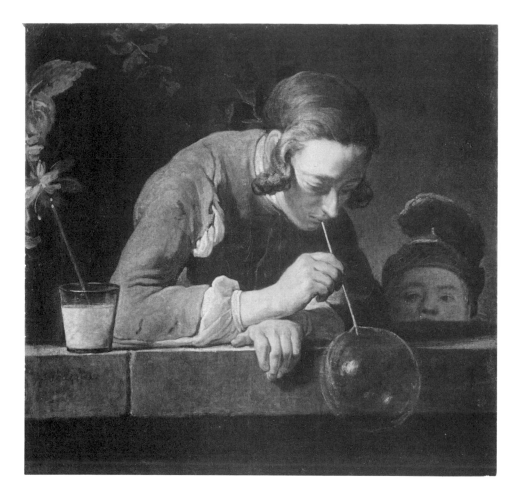

78. Chardin, *Les Bulles de savon*, eighteenth century, Metropolitan Museum of
Art, New York, the Catherine D. Wentworth Fund.

life to a bubble found in the writings of the ancients, frequently invoked
again after the fifteenth century, but also artists before Hals often used
the subject of a child blowing bubbles to convey the idea that the life of
a man resembles things of small account. As it was put in *An Herbal for
the Bible* published in 1587, man's life can be compared "to a dreame, to
a smoke, to a vapor, to a puffe of wind, to a shadow, to a bubble of water,
to hay, to grasse, to an herbe, to a flower, to a leave, to a tale, to vanitie,
to a weaver's shuttle, to a winde, to dried stubble, to a post, to nothing."[29]

29. Seymour Slive, "Realism and Symbolism in Seventeenth-Century Dutch Painting,"
Daedalus (Summer 1962) (issued as vol. 91, no. 3, of the *Proceedings of the American Academy*

Chardin's *Les Bulles de savon* (fig. 78) is as free of overt philosophical references as is the painting by Hals, and in both its realism and vigor is related to Manet's portrait. Particularly in its vigor, as Meyer Schapiro has observed in his lectures, is Manet's *Bulles de savon* at variance with Couture's treatment of the same subject. In another version of the theme by Couture (Walters Art Gallery, Baltimore), the message in the mirror is not "L'immortalité de l'un," but "The slothful man, unworthy of living." Manet's bubble-blower and his *Emile Zola* have nothing of the indolence characteristic of Couture's youth. Perhaps the justification of life for Manet is artistic activity, certainly an apt description of Zola as well as himself. Schapiro has made the remarkable observation that Manet's bubble-blower holds his bubble pipe like an artist's brush and his bowl like a palette.

In the *Portrait of Emile Zola*, with its references to Couture's *Bulles de savon* and its position amid a group of thematically related works, notably his own *Bulles de savon*, Manet appears to be posing the question of the efficacy of the active artistic life as a road to immortality, a matter of "ars longa, vita brevis," or as Gautier put it in his poem, "L'Art:"

> Tout passe—l'art robuste
> Seul a l'éternité
> Le buste
> Survit à la cité.[30]

> [Everything passes—robust art
> Alone has eternity
> The bust
> Survives the city.]

Zola had written a great deal of well-meaning nonsense on behalf of Manet during the two years before this portrait was made. But among his statements we find the assertion, "La place de M. Manet est marquée au Louvre" [The place of M. Manet is reserved in the Louvre], in other words, among the immortals of art. It is this immortality that Manet has called into question.

The question had been posed by the Dutch painter David Bailly, whose self-portrait (fig. 79) is a *vanitas* image containing all the expected objects including the ubiquitous soap bubbles rising above examples of the painter's art. This work was reproduced by Charles Blanc in the Dutch volume of his *Histoire des peintres* and was certainly known to Manet. Manet's question applies not only to

of Arts and Sciences), pp. 469–500. The quotation appears on p. 491. See also Robert Altmann, "Die Zitronenschale und das Kosmische Theater," *Liechtensteinische Kunstsammlungen*, no. 1 (1971), n.p. The author discusses the replacement of traditional *vanitas* symbols with less obviously emblematic objects in seventeenth-century Dutch art, i.e., the clock by the spiraling lemon peel.

30. T. Gautier, *Emaux et camées* (Paris, 1954), pp. 131–33. This collection includes "Symphonie en blanc majeure," which Manet knew, and "Affinités secrètes," both very close in theme to Baudelaire's "Correspondances."

79. David Bailly, *Self Portrait* (vanitas vanitum et omnia vanitas), seventeenth
century, from Charles Blanc's *L'Histoire des peintres*.

Zola, but to himself as well, as all the self-directed references of the painting make
clear.

Another painting of this year, *Le Déjeuner dans l'atelier* (fig. 80), also contains
a smoker, a picture at the upper right, which the smoke helps to obscure, and the
familiar plant at the left. In this case, the plant is placed directly above and behind
the studio armor, objects with strong *vanitas* associations.

Related to the *vanitas* theme is another favorite Dutch motif, that of the five
senses. I believe that this is the correct way to interpret another of Manet's major
paintings, *La Femme au perroquet* (fig. 81), completed in 1866. This eloquent study
in tonal variations is puzzling as to pose, gesture, and choice of objects. Again,
the symbolic character of the piece has been thinly (but apparently efficiently)
disguised by an appearance of the ordinary and the nonchalant. Nevertheless,
the lady pointedly holds the magnifying glass by its ribbon (sight and touch) and
sniffs the violets (smell) while a brilliant parrot (hearing, since the parrot is capable
of speech) is perched above a succulent, partly peeled orange and a glass of water
(taste). Once again, the transitory sensual life has been emblematized by his
model, Victorine Meurend.[31]

31. John Connolly's similar interpretation of the *Femme au perroquet* has just been called
to my attention: "Ingres and the Erotic Intellect," *Woman as Sex Object, Art News Annual*
38 (1972), pp. 17–31. The reference to Manet's picture is on p. 25.

80. *Le Déjeuner dans l'atelier*, 1868,
Neue Staatsgalerie, Munich.

81. *La Femme au perroquet*, 1866,
Metropolitan Museum of Art,
New York, gift of Erwin Davis.

82. *Le Torero mort*, 1864, National Gallery of Art, Washington, D.C., Widener Collection.

The *Torero mort* (fig. 82), painted in 1864 as part of a larger picture from which it was later cut, represents another ceremonial sacrifice of the bull ring. For the pose of the figure, Manet looked to the *Orlando muerto*, as it was then known and attributed to Velasquez (fig. 83). We should now have no difficulty in understanding Manet's interest in this work. On either side of the so-called Orlando we see a skull, while bubbles rise to the surface of the shallow pool of water in which he lies. The figure, surrounded by these reminders of his physical mortality, directs his lifeless gaze not at them, but at the eternal light in the form of a lamp suspended from the branch of a tree directly above him. Of the objects associated with Orlando, Manet retains only the sword for his torero, and turns the figure's head away from the sword in the shadow at the right, and toward the cape bathed in light. We can follow Manet's development of this division by looking at the several states of his etching of the subject. In the final state (fig. 84), a clear division exists between the dark and light segments of the picture, and the man is placed along this demarcation. Just as Orlando had directed his gaze toward the lamp above him, Manet's torero looks toward the light at the left. It is in this change of the angle of the head that Manet appears to have used the variant provided by Gérôme's adaptation of the Spanish figure as a dead Caesar, a painting that has been proposed as another source for the *Torero mort*.[32] Manet could not have

32. The part played by Gérôme's picture in the creation of the *Torero mort* was first noticed by Bates Lowry, *Muse and Ego* (75th Anniversary Exhibition of the Pomona College Gallery, Claremont, Cal., 1963), p. 33. For a further study of the relationship between the two works, see Gerald Ackerman, "Gérôme and Manet," *Gazette des Beaux-Arts* 70 (1967), pp. 163–76. Manet's dependence on the *Orlando muerto* had already been noticed by Thoré-Bürger in 1864.

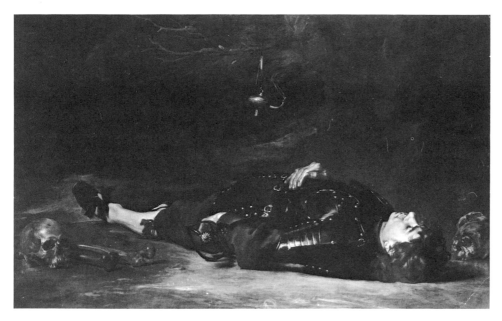

83. *Orlando muerto*, Spanish school, seventeenth century, National Gallery, London.

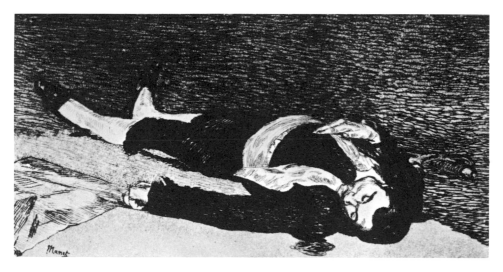

84. *Le Torero mort*, 1864 or 1868, etching and aquatint (sixth state), Philadelphia Museum of Art.

included skulls and the lamp in the tree, just as he could not include soap bubbles in his *Portrait of Zola*, but in translating the idea of the lamp into a flood of light on the ground and altering the position of the head to face it, he has preserved the idea in rationally acceptable terms. The change in the position of the head is reinforced by the change in the position of the fingers of the right hand. Whereas in the *Orlando* they curve gently over the rounded waist, in the *Torero* they stiffen out and point, along with the direction of the face, toward the light.

The original form of this painting entitled *Episode d'un combat de taureaux* had been sharply criticized at the Salon of 1864, and Manet cut the canvas up in 1865 or earlier, for in that year the portion now called *Le Torero mort* was exhibited at Martinet's gallery. Although it has often been asserted that Manet cut the canvas in response to this criticism,[33] it is more likely that he did so in the belief that the matador was self-sufficient, that it contained the entire "idea" of the painting and gained in force when alone and set against a neutral ground.[34] The device of the neutral ground, incidentally, is generally associated with works of the year 1866 (*Le Fifre*, *La Femme au perroquet*, and *L'Acteur tragique*), all painted after his return from Spain, where he had been impressed by Velasquez's *Pablillos de Valladolid*, in which such a handling is striking. In actuality, it is in the *Torero mort* that such a dramatic figure-ground relationship is established for the first time in Manet's *oeuvre*.

Given the principal source for the *Torero mort* and Manet's transformation of it, we may see its affinities with *Le Christ aux anges*. The two works can, of course, be characterized as sacred and secular, but they do share the theme of death and, more specifically, the artist's interpretation of it as the moment of transformation, as the symbolic portal to eternal life. Manet has taken the notion of duality so far as to give serious consideration to the relationship of the two works submitted to the Salon to each other. This should no longer strike us as coincidence. In any case, there is further evidence that Manet was conscious of the suitability of his choice of pictures. The following year, Manet sent to the Salon his *Olympia* and the *Jésus insulté par les soldats*, one a religious, the other a worldly subject. For this case, Theodore Reff has suggested that Manet may have been emulating Titian who, according to Northcote, wished to present Charles V with such a complementary pair. Titian's works were also a *Christ Scourged* and a *Venus*.[35] The hypothesis is probably correct, but whether or not Manet was knowingly emulating Titian, we may be sure that the dualism suggested by the pair, as in the preceding year, was a conscious calculation.

If we still doubt that Manet, in the *Exécution de Maximilien* and the *Torero mort*, was seeking to fix images of the transformation of physical death into spiritual

33. Edmond Bazire, *Manet*, p. 42. Also, Tabarant, *Manet et ses oeuvres*, p. 86 and Moreau-Nélaton, *Manet raconté*, vol. 1, p. 57.

34. For a good study of Manet's cutting techniques and a refutation of the simplistic view that the picture was cut as a result of criticism, see Anne Hanson, "Edouard Manet, 'Les Gitanos' and the Cut Canvas," *Burlington Magazine* 112 (1970), pp. 158–67.

35. T. Reff, "The Meaning of Manet's *Olympia*," pp. 115–16.

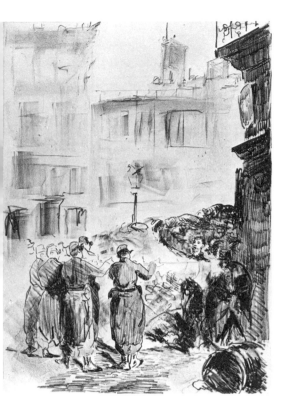

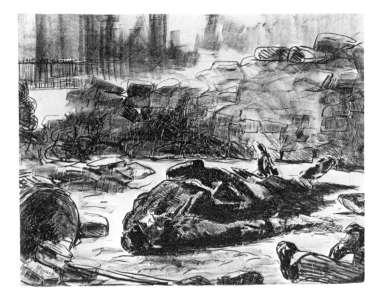

86. *Guerre civile*, 1871, lithograph, New York Public
Library, Astor, Lenox, and Tilden Foundations.

85. *La Barricade*, 1871, lithograph, New York Public
Library, Astor, Lenox, and Tilden Foundations.

life, we have only to look at two lithographs made during the siege of Paris in
1870 and 1871. In *La Barricade* (fig. 85) he has recreated with exactitude the
firing squad from the *Exécution de Maximilien*. This set detail is completely at
variance with the remainder of the scene, which is convincing as a sketch made
on the spot. The only explanation for this strange procedure is that Manet was
again reminded of the unchanging sense of the death penalty. His image for it
had been fixed in 1867, but now, in another time and another place, the emperor
has been actually replaced by everyman. In the second lithograph (fig. 86) a dead
soldier is found among the rubble of Paris. He is posed like the *Torero mort* and
is viewed from a similar angle. In 1870, then, when Manet was surrounded by
the specter of death, he returned to his two earlier paintings of the subject and
this time resuscitated them, so to speak, in situations that he had actually wit-
nessed. Such a practice again clearly recalls Baudelaire's notion of the immortality
of images, of "form molded on an idea."[36]

36. "La forme moulée sur une idée" is a phrase used in a letter of 1856 to Alphonse
Toussenel (Baudelaire, *Correspondance Générale*, ed. J. Crépet [Paris, 1947], vol. 1, p. 368).
In his journals, Baudelaire had made the following observation: "Toute forme crée, même
par l'homme, est immortelle. Car la forme est indépendante de la matière, et ce ne sont pas
les molécules qui constitue la forme." [All created forms, even those created by man, are
immortal. Because form is independent of matter, and it is not molecules that constitute form.]

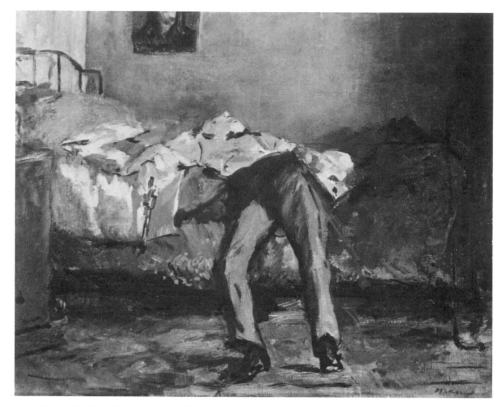

87. *Le Suicide*, 1881, coll. E. Bührle, Zurich.

Manet's association of death with rituals (the firing squad, the bull ring, the funeral procession) provides the air of detachment that has so often been lamented in his work. It also provides, of course, the key to the artist's intention to be not so much impersonal as universal and philosophic. The order of the ritual can be said to parallel the relentless order of the impersonal laws of death and rebirth in nature. The ritual, furthermore, creates a situation in which the victim always has a consciousness of his impending death. In no situation is this condition more agonizingly present than when the victim is his own executioner, fusing the roles of the firing squad and victim, already in exaggerated proximity to one another in the *Exécution de Maximilien*, completely. It was therefore inevitable that Manet should, at least once, have painted a suicide. The excellent little picture that bears that title (fig. 87) has not been easy to understand in Manet's *oeuvre*, given the personality and aims imputed to him. The victim lies across a bed still holding the revolver with which he has taken his life. Again, Manet has chosen the instant of death. The bullet has obviously just been fired, since the revolver has not yet fallen from the man's hand. Above the bed, a portion of a painting on the wall can be seen. The hooded subject appears to be a monk.

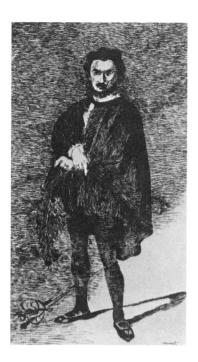

88. *L'Acteur tragique*, 1865, etching (second state),
National Gallery of Art, Washington, D.C.,
Addie Burr Clark Collection.

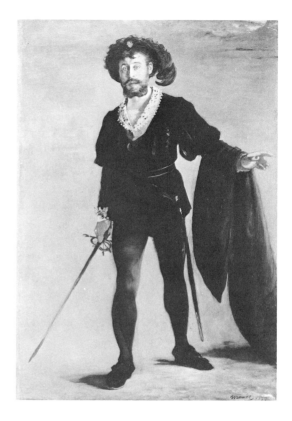

89. *Faure dans le rôle de Hamlet*, 1877,
Folkwang Museum, Essen.

Gotthard Jedlicka has written that in Manet's *oeuvre Le Suicide* is practically unique.[37] This is true neither of its style nor, as we can now judge, of its content. The brushwork and the frontal foreshortened figure on the bed recall, most of all, the *Portrait of Mallarmé*, painted a few years earlier, while its subject is the natural consequence of the artist's own meditations on death in the series of pictures that preceded it.

For Baudelaire, the agony of man's dual nature found a resolution in death. If *Le Suicide* depicts the desperate action that would provide this resolution, Manet's representations of Hamlet express the meditation preliminary to such action. Manet painted the character several times. The first attempt is the portrait of the actor Rouvière in the role, entitled *L'Acteur tragique*, of which the artist also made an etching (fig. 88), a picture that was rejected by the Salon jury of 1866. He returned to the subject in 1877 with the singer Faure as his model (fig. 89). In each

37. G. Jedlicka, *Manet* (Zurich, 1941), p. 192.

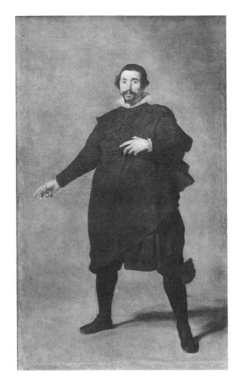

90. Velasquez, *Pablillos de Valladolid*,
ca. 1628, Prado, Madrid.

case, Hamlet is depicted alone, against a neutral ground and in association with
a sword. *L'Acteur tragique*, as the title indicates, is primarily a character study,
while *Faure dans le rôle de Hamlet* has been generally considered as a portrait of
one of the artist's patrons in a successful role. It is more likely that the late as well
as the earlier work reflects Manet's enduring interest in the character of Hamlet
and certain fixed qualities he associated with it.

 L'Acteur tragique was partly inspired by Velasquez's *Pablillos* (fig. 90). The
single figure against the neutral ground, as well as similarities of pose, has long
made this kinship evident. Of further interest, however, is the fact that Pablillos
gesticulates with his left hand, a dramatic gesture calling attention to something
beyond the confines of the picture frame. Manet's actor also points, although the
artist has disguised this symbolic gesture (as he had done in the *Déjeuner sur
l'herbe*) beneath a prosaic one, the holding of a plumed hat. Furthermore, the
pointing has a dual character (again, reminiscent of the *Déjeuner sur l'herbe*), for
Hamlet's hands are crossed and point in opposite directions toward the floor. In
response to this gesture, we discover, once again, that the ground is divided into
light and dark portions with the sword underscoring the line of demarcation. The
whole recalls the *Torero mort*, with the difference that here the figure is alive and
freely contemplates the juncture at which he stands. The hands point to the light
and the shadow but, being crossed, suggest the paradoxical relationship between

91. *Faure dans le rôle de Hamlet*, 1877, pastel, Marcus Wickham-Boynton coll. Burton Agnes Hall, E. Yorks.

92. A. Lamy, *scene from "Hamlet"* by Ambroise Thomas, lithograph, ca. 1868.

the two worlds—life and death—that these areas represent. Rouvière's intense stare at the viewer, as with the old violinist, makes an irresistible appeal for comprehension. One again, it is in the etching of the subject that Manet is more explicit about the dark-light division. It is indeed bizarre, to say the least, that Rouvière died while the painting was in progress. Antonin Proust, finally, posed for the hands, which are such an important part of Manet's concept.[38]

Rouvière had played Hamlet in the adaptation by Dumas and Meurice. Faure sang the role in the opera by Ambroise Thomas. Manet made at least three versions of the portrait of Faure, one of them a pastel. It is the pastel (fig. 91) that informs us of the specific moment of the drama that is represented. [A more literal rendering of the scene as it was staged is the lithograph by A. Lamy (fig. 92).] In Manet's pastel we see Hamlet face to face with his father's ghost, sword drawn, in apparent shock. In the two oil versions, the ghost has been removed, and Hamlet is turned toward the viewer, but his posture, awed expression, and drawn sword all remain as they were, and we see a man who, at that very moment, is looking beyond the grave.

With the exception of the hands (and we have understood their purpose in the *Acteur tragique*), the Faure Hamlet is close to the one posed by Rouvière, and even closer than that picture to Velasquez's *Pablillos*, since Hamlet's sword is directed downward and to the right like Pablillos's finger. More than a decade separates Manet's two treatments of the Hamlet theme, and since the models were different men and even the stage works in which they had performed were in different media, we are justified in concluding that what really interested Manet was the Hamlet character and his obsession with death. He fixed it as a symbol, just as the firing squad and the dead torero had been fixed and used again in other appropriate circumstances. Faure, we are told, did not like the portrait. He objected to the pose, finding it alien to his characterization.[39] This is quite probably true, for the characterization and all it meant was likely to have been Manet's alone, and he refused to change it. Manet thought long and worked hard to materialize his pictorial ideas, and we can appreciate his obstinacy after he had satisfied himself that his image could not be improved. Hamlet, and his meaning for Manet, was a closed issue for the painter. He could joke with his model about their differences, but he would not, could not, change the pose without destroying his conception of its meaning. Let us recall his refusal to change the position of the wound in Christ's side despite Baudelaire's suggestion that he do so and his response to Duret's request that he remove his signature from his portrait. Such changes, as we have seen, would have destroyed the entire iconographical structure of *Le Christ aux anges* and the meaning of the Duret likeness.

The removal of the ghost is consistent with Manet's penchant for condensation. Hamlet stands alone, marked by his confrontation, just as Susanna of the final version of the *Nymphe surprise* remains alone to face us, just as the torero was cut

38. Proust, p. 49.
39. Tabarant, *Manet et ses oeuvres*, p. 301.

93. Pertuiset, *Chasseur de lions*, 1880–81, Museu de Arte, São Paolo.

away from the bull ring and its other inhabitants. The single figure was Manet's great challenge. As he explained to Proust, it was far more difficult to paint a single figure than a pair, wherein the tensions of the opposing characters can be more readily brought to bear.[40] Evidently, the problem for him was to produce this tension or polarity within the single figure, far more complicated but more accurate a reflection of his idea concerning the interpenetration of opposite qualities. These great isolated figures set against a neutral ground with no demarcation between wall and floor have a special iconic force and serve as concentrated statements of Manet's most important ideas. The *Acteur tragique*, *Faure dans le role de Hamlet*, *Le Torero mort* are treated in this way and thus take their place alongside his two paintings each entitled *Philosophe*. These works represent a continuing interest in the concept of the philosophic work of art summed up, where possible,

40. Proust, p. 102.

in a single figure, a device he had already attempted in the *Buveur d'absinthe* and *Le Vieux Musicien.* The former still lacks the neutral ground, while the latter, like the *Déjeuner sur l'herbe,* still required auxiliary figures around the philosopher-protagonist. Baudelaire had been able to say of himself,

> What is quite certain, however, is that I have a philosophical mind that leads me to see clearly what is true. . . .[41]

Manet's art makes it clear that he thought of himself in the same way, and it is not surprising, therefore, that he painted a full-length self-portrait set against a neutral ground and reminiscent in pose of Faure's Hamlet.

The strangest of all the pictures with death as their theme is undoubtedly *Pertuiset, Chasseur de lions* (fig. 93) painted in 1881. While the academic painter Cabanel may have admired the skill with which the lion is painted,[42] there was no easy explanation for the setting, which was frankly not the jungle, nor for the naïve pose and expression of the hunter. Pertuiset, as unmoved as Maximilian's firing squad, becomes emblematic of the executioner. He is separated from the monumental head of the lion by a tree, of which we see only a portion of the trunk and which serves, therefore, all the more pointedly as a bisecting element. Pertuiset is frozen, lifeless, while the victim's head with its pained expression is far more "alive." We are reminded of the two poems by Gautier, "La Vie dans la mort" and "La Mort dans la vie," in the constructed cross-over of the two figures in this painting. Pertuiset and the lion are carefully placed, perpendicular to one another. Manet's signature appears on the tree trunk, the portal that both divides and unites life and death.

41. "Ce qu'il y a de bien certain cependent, c'est que j'ai un esprit philosophique qui me fait voir clairement ce qui est vrai. . . ." (Stated in the letter to Toussenel. See note 36 above.)
42. Proust, p. 124.

5 The Mirror

Manet, who painted only two self-portraits, managed to convey some idea of himself to the viewer by means of unexpected directives. I do not refer here so much to his personal style or "handwriting," but to his penchant for calling attention to himself in concealed but insistent ways: the semi-concealed portrait in *Le Vieux Musicien* and the disguised self-portrait in *La Pêche*; substitutions for himself in the persons of his brothers; the contrived and integrated placing of his signature. In view of the silent commentary he was able to make in such portraits as those of Zola and Duret, both of whom had written about him, we may safely assume that the rare self-portrait should be at least as informative.

In the *Self Portrait* bust of 1879 (fig. 94), there are two peculiarities that are particularly striking: the formal attire, complete with *chapeau melon*, an unexpected toilette for a painter at work, and the reversal of right and left in regard to the brushes and palette. This reversal results, of course, from the mirror image he copied but would not be evident had he not chosen to display these attributes. Although we are told that Manet was always elegantly dressed, even when in the country or at work, we may be certain that he is not here wearing his working clothes. It is the combined inclusion of the formal attire and the implements of his profession that largely account for the strangeness of the image and attest to a preconceived idea about the meaning of the portrait. The same combination of incongruous elements, although not used in as pointed a fashion, can be found in the self-portrait of Velasquez in *Las Meninas* (fig. 95). The relationship of Manet's image of himself to it is very strong yet, characteristically, concealed. If we compare the appearances of the two artists, we find that the similarities go beyond that of the similar conception of the working painter elegantly clad. The poses are clearly related, and the hand holding the brush in each case has lost all detail. Manet goes further than Velasquez here, blurring his hand beyond recognition, an indication of his interest in this device for fusing the brush with the hand used by the Spanish master. Velasquez presents himself as a court painter to Philip IV and is dressed as a nobleman, with the cross of Santiago prominently displayed on his breast. Manet, in his own likeness, has created the nineteenth-century Parisian equivalent of such a figure. He does not sport the ribbon of the

94. *Self Portrait*, 1879, Private collection, New York.

Légion d'Honneur, but we know that he coveted and finally received it two years later. However, this portrait was painted in the very year in which Manet had written to the municipal council proposing to decorate the new Hotel de Ville with murals under the collective title "le ventre de Paris" [the belly of Paris].[1] There can be no clearer indication of Manet's view of himself as the official painter of Paris, a kind of summing up of his lifelong ambition for academic recognition of which all his biographers speak. This letter is all the more striking when we remember that at the time of writing the artist was already quite ill and must have known that he could hardly have completed such a commission even had he received it. It strikes us as a last desperate attempt to claim the status that he fervently desired and undoubtedly felt that he fully deserved by dint of his thoroughly Parisian temperament, as well as his talent.

We have seen Manet's open and direct identification with an old master when he painted himself in the same costume and pose as Rubens in the youthful *La*

1. Tabarant (*Manet et ses oeuvres*, p. 350) states that the letter was written in April 1879. See also Proust, p. 94.

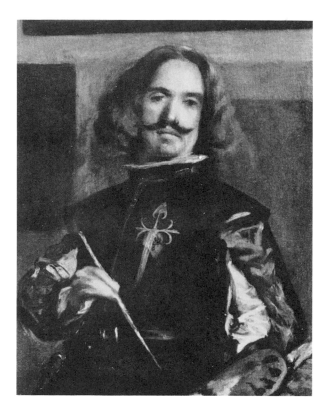

95. Velasquez, *Las Meninas* (detail), 1656, Prado, Madrid.

Pêche. It is hardly surprising, then, that his sense of identification with Velasquez, whom he described as "the painter of painters,"[2] should have been even more profound. So we see that just four years before his death Manet, far from having forgotten Velasquez, reveals an affection for him that even surpasses that suggested in his earlier quotations of his art, and he does so by referring for the first time to one of his greatest masterpieces. In his letter to Fantin-Latour from Madrid, Manet mentions the *Meninas* as a "tableau extraordinaire,"[3] yet there had been no direct reference to it in his earlier work. But this self-portrait, while clearly linking himself as a personality to Velasquez, does not exhaust his use of *Las Meninas.* In fact the painting in its concept and structure may have been the initial stimulus for the greatest picture of Manet's last years, *Un Bar aux Folies-Bergères.* *Las Meninas* is treasured as one of the most successfully realistic pictures ever painted. Velasquez's ability to achieve such visual truth is all the more admirable

2. "Le peintre des peintres." Moreau-Nélaton, *Manet raconté*, vol. I., p. 72.
3. Ibid.

in this work, since it does not simply become the means for a technical tour de force. *Las Meninas* is a sober painting, and, for all the appeal of its subject, communicates an earnestness about the act of painting. This is not merely the result of the fine self-portrait it contains, but is a part of the structure of the entire painting. Its forthrightness and richness of pigment, in fact, remind us of Manet. Velasquez has not only captured the form and surface of things admirably, but he has extended his visual space by means of the famous device of the background mirror. We are able to see not only the space behind the artist but, in the mirror, what is before him as well. Velasquez has painted a picture that represents himself painting. We see him, his model, and even his spectators, the royal couple who stand where we stand, and who replace us in the mirror. There hardly exists a painting that more clearly poses the problem of the nature of a painted reality, of the transformation of the painted surface into a world that at once reflects and distorts. It is the kind of awareness we might expect of an extraordinary technician whose intelligence guides and controls his skills, and it is natural that the same question should have become a major preoccupation of the equally gifted Manet.

Manet's first notable use of the mirror idea as a structuring and informing device had occurred fifteen years before in the *Portrait of Zacharie Astruc* (fig. 96). A consideration of that work is in order here before continuing this discussion of the late works.

Whether or not Zacharie Astruc named Olympia, as he is reputed to have done, he was obviously deeply involved with this painting, which inspired his poem "La Fille des îles," and he appreciated the temperament of its creator, whom he was the first to strongly defend publicly in 1863.[4] Manet painted the *Portrait of Astruc* (as he was later to portray Zola and Duret, who also wrote about his art), a likeness that, we are told, did not please the sitter.[5] The reasons for Astruc's displeasure, if indeed the story is accurate, remain obscure, but to us the picture has a particular fascination because of its compositional affinities with *Olympia*. Like that painting, it dates from 1863–64.

Both paintings are rigorously divided into two unequal rectangular fields. In both cases the division is bound up with the distinction of light and dark, although this is managed in different ways: in *Olympia* the torso of the bright nude occupies one side and the negress the other, while the *Portrait of Astruc* splits into generally light and dark segments. Both figures, Olympia and Astruc, have a hieratic appearance, an effect achieved by the frontal stare given to each, and a certain rigidity in their bearing. In each work, a bit of drapery is allowed to cut across a corner (upper left in *Olympia*, upper right in the *Portrait of Astruc*), adding still another note of artifice to the arrangements, and probably intended to heighten the relationship between the two works.

4. *Le Salon de 1863*, 20 May 1863. Partly quoted by Moreau-Nélaton, vol. 1, pp. 51–52. Astruc has written, "Manet! Un des plus grands caracteres artistique du temps ... il en est [of the Salon] l'éclat, l'inspiration, la saveur puissante, l'etonnement...." [Manet! One of the greatest artistic personalities of our time ... he is the sparkle (of the Salon), its inspiration, its powerful savor, its astonishment....]

5. Tabarant, *Manet et ses oeuvres*, p. 92.

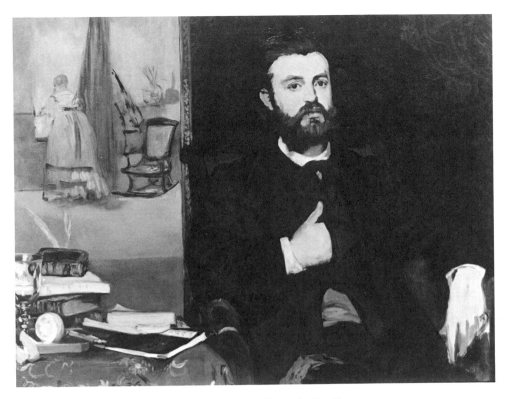

96. *Portrait of Zacharie Astruc*, 1863–64, Kunsthalle, Bremen.

Astruc's face and hands contrast sharply with the dark tonality of his clothing and the wall behind him. The artist has been careful to strictly separate this portion of the painting from the other, brighter side, and reveals the purposefulness of this division by allowing Astruc's sleeve as well as the little scroll on the back of his chair to extend precisely to the edge of the vertical gilt molding that divides the picture. The framelike, delicate character of this molding reduces the likelihood that the bright, distant scene is to be understood as a view through a doorway into another room. Such a reading is further discredited by the table and its still-life arrangement, placed to completely block access to the area behind it. What we see at the left can be only a painting or a mirror, and the composition of this rectangle with its deep empty foreground and small distant figure seen from behind, as well as its low placement, do not suggest a painting. The view at the left, then, is not a glimpse through a doorway into another room, but a reflection in a mirror of the opposite wall of the room in which Astruc is seated, a reversed image of what Astruc observes as he stares out before him.[6] Our attention inevitably returns to

6. Tabarant interprets this rectangle as a mirror (*Manet et ses oeuvres*, p. 92), but Gisela Hopp (*Edouard Manet, Farbe und Bildgestalt* [Berlin, 1968], p. 35) sees it as a doorway.

the figure of Astruc himself, to the brightness of his face and hands, and finally to the strangeness of the right hand tucked under the lapel of his jacket, with only the overlong thumb projecting. As for the other hand, Gotthard Jedlicka has made the observation that its downward direction is so emphatic as to suggest a directional marker.[7] That is, of course, exactly what it is, and it, in turn, helps us to understand the contrived position of the right hand. The fact that the vest conceals four fingers makes the already too-long thumb even more prominent. Besides, this seemingly relaxed placement of the hand is the only one that makes the upward indication of the thumb possible, without the gesture becoming self-conscious and, in the context of Manet's realism, silly. In short, we recognize again the double gesture we have discovered in the *Déjeuner sur l'herbe*, the thumb pointing up, the index down. (In the *Déjeuner sur l'herbe*, of course, the index points to the left rather than literally down, but toward the figure who represents the "down" of Astruc's more abstract indications.) In both works the gestures are placed openly before us but dissembled behind the contrived, relaxed attitudes of seemingly subjectless pictures.

The connection between the duality of the gesture and the duality of the painting, in its dark-light division, now suggests itself. Astruc is seated in the dark, but he looks at the light, no doubt a symbolic act, implicit in its starkness, which has its prosaic parallel in the distant woman who is looking out of the window.

Perhaps the duality expressed in the figure of Astruc as well as in the structure of the painting is intended to reflect an essential quality of awareness that the poet shared with Manet. Astruc, after all, had called attention to the metaphysical and tangible value of Manet's art.[8] Such an assumption is suggested by the book of Japanese prints that lies on the table, together with the other volumes, the glass, and the fruit, all strongly painted, earthy objects that, by contrast, endow the distant pale scene with an ethereal quality. On this book, Manet has written, "Au poète Z. Astruc, son ami Manet" [To the poet Z. Astruc, his friend Manet]. The two men are united by means of this book, which is the only object privileged to cut across the mirror's edge from one field to the other. The mirror, then, was a device Manet used to serve his interest in the expression of human duality, as early as 1863–64. In Manet's picture, however, the mirror is brought right up to the picture plane, making its identity ambiguous and imparting to the entire painting the enigmatic air that Manet sought to create.

In 1878 Manet returned to the device of the mirror, in the *Coin du café concert* (fig. 97), were we see both spectator and spectacle thanks to the mirror in the upper left corner. The spectator looks at the chanteuse directly while we observe her in the mirror. We *understand* that he is looking at her, but he is actually looking away from the mirror image, producing again the sense of two worlds that are related yet separate. It requires a correct reading of the picture to understand the relationship between the figures in their separate compartments. This phenome-

7. Jedlicka, *Manet*, p. 96.
8. Astruc, *Le Salon de 1863*. This passage is not included in the excerpt quoted by Moreau-Nélaton, but is given in English by Hamilton (*Manet and his Critics*, p. 46).

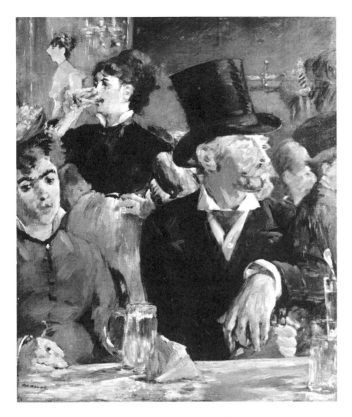

97. *Un Coin du café concert*, 1878, Walters Gallery, Baltimore.

non is ultimately to appear in Manet's last masterpiece, *Un Bar aux Folies-Bergères*.

Manet's tendency to condense and simplify leads, in the case of the *Self Portrait* of 1879 to an "inclusion" of the mirror simply by making his image left-handed. Such reversals are standard practice in Manet's art, and periodically disturb his biographers, because no satisfactory explanation for them has been found. The suggestion that such reversals are related to printmaking, and the reversals that process entails, is satisfactory for only some cases and has no bearing on others. And the most disturbing part of this practice is that Manet's intention to willfully reverse is as clear as the reasons for it are obscure. We have seen how the mirror in the *Portrait of Zacharie Astruc* serves not only to extend space but, more significantly, to allow for the juxtaposition of two "worlds," the light and the dark, a dualism Manet expressed in another but related way in the *Déjeuner sur l'herbe* and *Olympia*. In view of this fact and the artist's reversal of left and right as a reference to the mirror in his self-portrait, the possibility emerges that the form of exchange produced by the mirror, that of left and right, is yet another expression of identity in diversity, like the use of black and white, two inseparable sides of a coin, the positive and negative of a photograph.

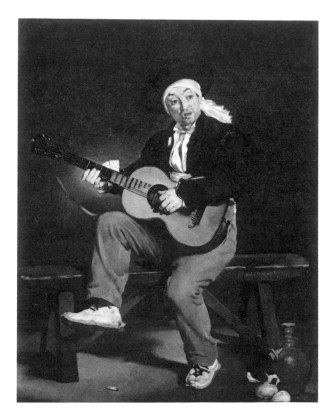

98. *Le Guitarrero*, 1860, Metropolitan Museum of Art,
New York, gift of William Church Osborn.

Manet's first success at the Salon, his *Guitarrero* of 1860 (fig. 98), is an early and monumental example of such a reversal, for the figure holds the guitar the wrong way round and plucks the strings with his left hand while producing the harmonies with his right. The obvious explanation that what we see is a left-handed musician cannot be sustained, for then the arrangement of the strings would be reversed too, which is not the case. Manet knew what he had painted. Proust tells us that it was specifically criticism concerning the left-right reversal that irritated the painter:

> Renand de Vibac was here. He saw only one thing, that my *Guitarrero* is playing with his left hand a guitar strung to be played with the right. What do you think of that?[9]

9. "Renand de Vibac est venue. Il n'a vu qu'une chose, ce que mon *Guitarrero* joue de la main gauche une guitare accordé pour être joué de la main droite. Qu'en dis-tu?" (Proust, p. 40).

Since Manet was familiar with the entertainment provided by Spanish dancers and musicians, it is inconceivable that his painter's eye had not fixed the proper position of the instrument. It is even likely, although not certain, that his model for the *Guitarrero* was a professional guitarist. We must, therefore, accept the fact that Manet intentionally reversed the instrument in his model's hands. His statement to Proust is another case of a refusal to heed the advice of a viewer to correct an "error." The deviations in certain works, then, were not only known to Manet before these works were shown publicly, but were planned by him. This conclusion is obvious and would have been reached earlier were it not for the troubling question of why such a strange procedure was adopted, and our natural reluctance, particularly in the case of Manet, to postulate an explanation based on the presence of a metaphysical idea.

Manet was in the habit of holding a dark mirror up to his works, a painter's device for judging the effect of his distribution of values. In fact he did so with the *Guitarrero*, and found it satisfactory.[10] In that mirror, of course, the playing of the instrument corrected itself, and it is possible that even this very practical use of the mirror acquired another meaning for him. Certainly the role given the mirror as an important element in his pictures seems to suggest that possibility. We should note that it was in this painting, as well as in the contemporary double portrait *Les Parents de l'artiste*, that Manet had, for the first time, eliminated halftones, stressing the two ends of the value scale, a parallel device for presenting the same idea of the fusion of opposites.

There is yet another perplexing aspect to the *Guitarrero* that, to my knowledge, has not been pointed out: the figure sits in a position so awkward that upon careful consideration, we no longer understand how he manages to hold his pose. The raised right leg is placed against the edge of the bench and the guitar rests upon it, while that leg itself is unsupported and can therefore provide only very inefficient support for the instrument. The result, however, is that the spatial arrangement of the picture becomes ambiguous. We may interpret the leg as leaning slightly over the bench, resting upon its edge, but the foreshortening without halftones renders such a reading difficult, and the leg tends to move forward into a position parallel to the picture plane. The stark realism of the picture, then, is something of an illusion, but one that was strong enough to win an honorable mention for the painter.

The conclusion that the ambiguity of space, the contrast of dark and light, and the reversal of right and left are intentional and meant to help us to recognize a central idea gains support from the presence of similar, if more rudimentary, devices in the slightly earlier and ill-fated *Buveur d'absinthe* (fig. 99). In this work Manet also treats a single figure, this time seated on a ledge. The length

10. Ibid., p. 41 and J.-E. Blanche, *Manet* (Paris, 1924), p. 55. Blanche writes "Manet aimait qu'on le regardat se pencher sur son chevalet, tournant la tête vers le modèle, puis vers l'image renversée dans le miroir à main." [Manet enjoyed being watched as he leaned over his easel, turning his head toward the model, then toward the reversed image in the hand mirror.] See Proust, pp. 40–41, for Manet's use of the hand mirror in connection with the *Guitarrero*.

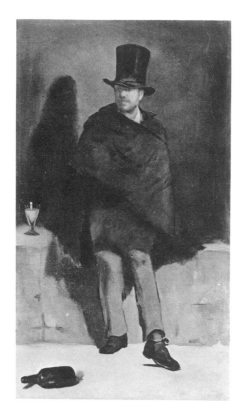

99. *Le Buveur d'absinthe*, 1858–59,
Ny Carlsberg Glyptothek, Copenhagen.

of the cloak and the same sort of flattened foreshortening of the legs render the pose ambiguous. Like the *Guitarrero*, the *Buveur d'absinthe* sits and leans simultaneously. And if the *Guitarrero* is neither right-handed nor left-handed, but rather both or neither, the same thing can certainly be said about the legs of the *Buveur d'absinthe*. There can hardly be a viewer of this painting who is not quickly struck by the strangeness of the legs and the feet of the figure. It is as though a bizarre exchange of right and left has taken place beneath the magic cloth of the *talma*, which, itself, refuses to express the folds produced by the lap of a seated figure. The *talma* in this sense, foreshadows the tablecloths of Cezanne's still-life paintings, beneath which the table edge has either moved up or down slightly, to emerge out of alignment with its other half. As the cloak is long and flat, so the ledge upon which the figure "sits" is allowed to continue beyond the edges of the painting on both the right and left sides, thereby denying us even the short perspective lines that would anchor the figure more firmly. The ambiguities of space and of right and left are already present in this early work. Only the elimination of halftones has not yet been effected, and the picture has often, on this

account, been described as still uncharacteristic of the painter. Actually, the placing of the ledge parallel to the picture plane gives this work a strangeness that the *Guitarrero*, due to the placement of the bench at an angle to the picture plane, does not have, at first glance. Manet thought of the two pictures in relationship to each other. In anger over his failure to have the *Buveur d'absinthe* accepted at the Salon of 1859, he was heard to remark:

> I have made a Parisian type, observed in Paris, while putting into the execution the technical naïveté I had found in the painting by Velasquez. They do not understand. Perhaps they will understand better if I make a Spanish type.[11]

The discovery of Manet's interest in the problem of the *homo duplex* and its expression in a variety of visual opposites suggests, then, an explanation for his frequently puzzling reversal of left and right. That the artist consciously made use of the polarity of right and left as a variation of the more obvious one of above and below (as in the *Déjeuner sur l'herbe*) is proven by a particular painting we have already discussed. It is in *Le Christ aux anges* that Manet transformed the "head and foot" of the Saint John Gospel to the right and left sides of his painting based on that quotation, as his inscription informs us.

The *Buveur d'absinthe*, as we have seen, makes another appearance in the *Vieux Musicien*. His ambiguous limbs and cloak, which allow for no clear reading of right and left, enforce the statement of the double life expressed by the opposition of black and white in the fraternally linked boys.

The *Buveur d'absinthe* is hardly mentioned in the Manet literature without some reference to the influence of Couture, which it still reveals. The supposed lack of originality was stated by Manet himself, if we are to believe Proust,[12] and in some respects this is a valid observation. However, the insistence upon this one point has discouraged recognition of the degree to which it already expresses Manet's individuality.

The horizontal object, such as the ledge in this work, placed parallel to the picture plane, is one of the most consistent features of Manet's art. We find it very early in the *Enfant aux cerises* and later in *La Chanteuse des rues*, *L'Exécution de Maximilien*, *Le Déjeuner dans l'atelier*, *Le Balcon*, *La Gare St. Lazare*, *La Serre*, *La Prune*, to name only some obvious examples. In fact, the angle of the bench in the *Guitarrero* seems a unique exception and may be viewed as a compromise. Of course, Manet included a number of ambiguities, but the arrangement

11. "J'ai fait . . . un type de Paris, étudié à Paris, en mettant dans l'execution la naïveté du métier que j'ai renconté dans le tableaux de Velasquez. On ne comprend pas. On comprendra peut-être mieux si je fais un type espagnol." (Proust, "L'Art d'Edouard Manet," *Le Studio* [French edition of *The Studio*] 21 [1901], p. 72. Quoted by Fried [who calls special attention to this article in "Manet's Sources," p. 33, note 31]. Hamilton [*Manet and His Critics*, p. 24] has published this quotation in English.)

12. Proust, p. 33. The author quotes Manet as saying in regard to Couture, "J'ai eu la stupidité de lui faire quelque concessions." [I was foolish enough to make a few concessions to him.]

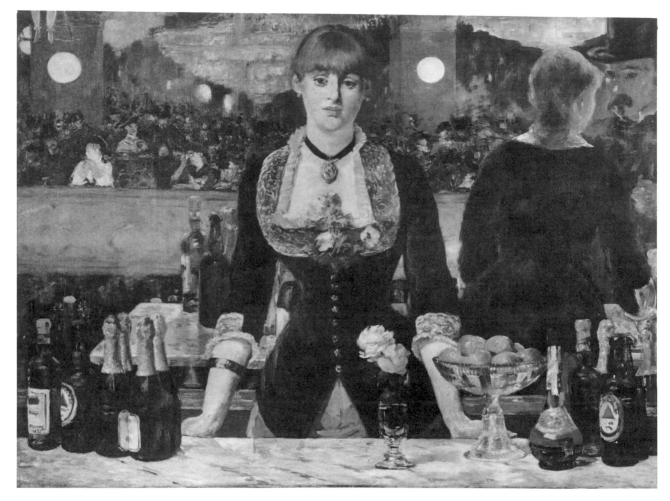

100. *Un Bar aux Folies-Bergères*, 1881, Courtauld Institute of Art, London.

of the picture is more agreeable and less severe than the earlier *Buveur d'absinthe*, and it is interesting that it was relatively well received. In the *Portrait of Zacharie Astruc* this object had been a mirror, symbolically used, and it is in this sense that it returns in the *Bar aux Folies-Bergères* (fig. 100), that last masterpiece, which so strongly recalls the enigmatic figure compositions of the 1860s.

We are struck at once by the glitter of this work, by the sheer brilliance of the variegated spots of color and the world they create. Simultaneously we submit to the strangeness of the gaze of the central and static barmaid. The picture is a fusion of carefully planned studio arrangement and the spontaneous jottings after nature, freely distributed. Behind the barmaid is a large mirror, placed parallel to the picture plane. We can clearly see its gold frame, interrupted by the girl and the bottles, stretch across the picture slightly above the edge of the marble-top bar. As in the *Portrait of Astruc*, it is this frame that assures us of the mirror's presence, and informs us that what we see behind the girl is a reflection and not a deeper space containing additional figures. The poses of the reflected girl in both works are in fact similar. In the case of the *Bar aux Folies-Bergères*, even the mirror's frame hardly clarifies the situation, for the reflected image is incorrect in relation to the actual objects reflected and the viewers' position. The gold frame establishes that the mirror is perfectly parallel to the picture plane, yet the re-flection of the barmaid, standing at the center and facing us, is at the right side of the painting, where she is seen to be engaged in conversation with a man on the other side of the bar. The reflected bottles do not correspond in any way to the actual ones, either in configuration or location, a phenomenon that leaves no doubt as to the artist's intention. These discrepancies have long been known, yet they have never received a convincing explanation. The fact that the mirror does not really reflect the phenomenal world as it should but, in effect, contains another and different one, should be enough, in view of the foregoing, to make Manet's purpose clear to us. The mirror, as in the Astruc picture, represents another dimension, the other half, the complement to the other reality, in this case the actual barmaid. Here Manet has found a more natural, less contrived way to indicate the double nature of the figure. There is a direct opposition between the "two" barmaids who are, nevertheless, undeniably the same person. The actual girl is conceived much in the manner of the early portraits: timeless, aloof, and enigmatic. The mirror, in which we cannot see her face, supplies her environ-ment and conversational partner, whose presence we could never have otherwise suspected. The brilliance of the setting with its gilt and crystal chandeliers, the mundane, glittering balcony, and, finally, the gentleman "client" who draws the maid into contact with the world of the mirror must all identify this looking-glass as the mirror of the vanities. Only a part of the girl belongs to it, and Manet has dissociated that part of her nature from the other part, viewed as aloof from the sensual surroundings. Hidden gestures are no longer needed, for Manet has, with the help of the mirror device, claimed the painter's right to alter the physical laws of the phenomenal world to express his idea as purely in terms of painting as possible. His abstraction, then, is realized in order to clarify his idea visually and is but a development of the collapsed-space device of the *Déjeuner sur l'herbe*,

painted twenty years earlier, in which two separate women were used to illustrate the duality of human nature, united in the single hand of the philosopher.

Of all Manet's paintings, perhaps it is the *Bar* that has succeeded best in giving observers a clue to the meaning of his *oeuvre* as a whole. Jedlicka responded to the iconic power of the picture and expressed the feeling of taking part in a cult ritual while contemplating it.[13] Vaudoyer noted that in this late work, the two styles of Manet, the "form-volume" of the 1860s and the "color-light" of the 1870s are perfectly fused. In this connection he cites Baudelaire's statement that modernity constitutes only half of art, while the other half belongs to the eternal.[14] Busch is certain that this is no simple genre picture, and that its several layers of reality are not only an optical matter. Busch understands that Manet is involved with the age-old question of "existence," a question that is "locked into the hieroglyphics of pure painting and enclosed in the glittering cloak of a genre picture of the nineteenth century."[15]

The discovery of Manet's interest in the theme of the *homo duplex* allows us to be more specific in interpreting the painting without losing sight of the truth of Busch's observation that Manet's success lies in the degree to which he has locked the meaning of the work into its closed, purely pictorial structure.

13. Jedlicka, *Manet*, p. 324.

14. J.-L. Vaudoyer, *E. Manet* (Paris, 1955), Introduction ("Manet, magicien du reel"), unpaginated.

15. ". . . eingeschlüsselt in die hieroglyphen reiner Malerei und gehüllt in das glitzernde Gewand eines 'Sittenbildes' aus dem späten neunzehnten Jahrhundert" (Günter Busch, *Edouard Manet—Un Bar aux Folies-Bergères* [Stuttgart, 1956], pp. 11–12). This is a particularly sensitive and intelligent study. For other extensive studies of this painting, see Raymond Mortimer, *Un Bar aux Folies-Bergères in the National Gallery* (London, 1944); Hans Jantzen, "Edouard Manet's Bar aux Folies-Bergères," *Beiträge für Georg Swarzenski zum 11. Januar 1951* (Berlin, 1951); Gisela Hopp, *Edouard Manet*.

6 The Emblems

One of Manet's earliest biographers, Jacques de Biez, recalled an interview in which the painter had made the following observation:

> Already many people speak well of me. But I feel they don't understand me. They don't grasp what there is in me or at least what I try to show. . . .[1]

Although we are not informed as to what these hidden qualities are (and de Biez gives no indication of having understood them himself), Manet had made an unmistakable reference to the concealed moral aspect of his work in the painting *Les Etudiants de Salamanque* (fig. 101). Inspired, in 1860, by Lesage's early-eighteenth-century novel *Gil Blas*, the picture faithfully illustrates the parable contained in the foreword ("Gil Blas au lecteur") of that classic. In view of the importance of this painting as a key to the nature of the content of Manet's work as a whole, it is necessary to cite here the entire passage upon which it is based:

> Reader! hark you, my friend! Do not begin the story of my life till I have told you a short tale.
> Two students travelled together from Penafiel to Salamanca. Finding themselves tired and thirsty, they stopped by the side of a spring on the road. While they were resting there, after having quenched their thirst, by chance they espied on a stone near them, even with the ground, part of an inscription, in some degree effaced by time, and by the tread of flocks in the habit of watering at that spring. Having washed the stone, they were able to trace these words in the dialect of Castille: Aqui esta encerrada el alma del licenciado Pedro Garcias. "Here lies interred the soul of the licentiate Peter Garcias."
> Hey-day! roars out the younger, a lively, heedless fellow, who could not get on with his deciphering for laughter: This is a good joke indeed: "Here lies interred the soul." . . . A soul interred! . . . I should like to

1. Déjà beaucoup de gens disent du bien de moi. Mais il me semble qu'ils ne voient pas très clair au fond de moi. Ils ne pénètrent pas très bien tout ce qu'il y a en moi, ou tout au moins ce que j'essaie de montrer. . . ." (Jacques de Biez, *Edouard Manet* [Paris, 1884], p. 8.)

101. *Les Etudiants de Salamanque*, ca. 1859–60, Museo Nacional de Bellas Artes, Buenos Aires.

know the whimsical author of this ludicrous epitaph. With this sneer he got up to go away. His companion, who had more sense, said within himself: Underneath this stone lies some mystery; I will stay, and see the end of it. Accordingly, he let his comrade depart, and without loss of time began digging round about the stone with his knife till he got it up. Under it he found a purse of leather, containing a hundred ducats, with a card on which was written these words in Latin: "Whoever thou art who hast wit enough to discover the meaning of this inscription, I appoint thee my heir, in the hope thou wilt make a better use of my fortune than I have done!" The student, out of his wits at the discovery, replaced the stone in its former position, and set out again on the Salamanca road with the soul of the licentiate in his pocket.

Now, my good friend and reader, no matter who you are, you must be like one or the other of these two students. If you cast your eye over my adventures without fixing it on the moral concealed under them, you will derive very little benefit from the perusal: but if you read with attention you will find that mixture of the useful with the agreeable, so successfully prescribed by Horace.[2] [Smollett's translation]

2. "Avant que d'entendre l'histoire de ma vie, écoute, ami lecteur, un conte que je vais te faire.

"Deux écoliers allaient ensemble de Pennafiel à Salamanque. Se sentant las et altérés, ils s'arrêtèrent au bord d'une fontaine qu'ils rencontrèrent sur leur chemin. Là, tandis qu'ils se délassaient après s'être désaltérés, ils aperçurent par hasard auprès d'eux, sur une pierre à fleur de terre, quelques mots déjà un peu éffacés par le temps, et par les pieds des troupeaux qu'on venait abreuver à cette fontaine. Ils jetèrent de l'eau sur la pierre pour la laver, et ils lurent ces paroles castillanes: Aqui esta encerrada el alma del licenciado Pedro Garcias.—'Ici est enfermée l'âme du licencié Pierre Garcias.'

"Le plus jeune des écoliers, qui était vif et étourdi, n'eut pas achevé de lire l'inscription, qu'il dit en riant de toute sa force: 'Rien n'est plus plaisant: ici est enfermé l'âme ... une âme enfermée.... Je voudrais savoir quel original a pu faire une si ridicule épitaphe.' En achevant ses paroles, il se leva pour s'en aller. Son compagnon, plus judicieux, dit en lui-même: 'Il y a là-dessous quelque mystère: je veux demeurer ici pour l'éclaircir.' Celui-ci laissa donc partir l'autre, et sans perdre de temps, se mit à creuser avec son couteau tout autour de la pierre. Il fit si bien qu'il l'enleva. Il trouva dessous une bourse de cuir qu'il ouvrit. Il y avait dedans cent ducats, avec une carte sur laquelle étaient écrites ces paroles en latin:

> Sois mon héritier, toi qui a eu assez d'esprit pour démêler le sens de l'inscription. Et fais un meilleur usage que moi de mon argent.

"L'écolier, ravi de cette découverte, remit la pierre comme elle était auparavant, et reprit le chemin de Salamanque avec l'âme du licencié.

"Qui que tu sois, ami lecteur, tu vas ressembler à l'un ou à l'autre de ces deux écoliers. Si tu lis mes aventures sans prendre garde aux instructions morales qu'elles renferment, tu ne retireras aucun fruit de cet ouvrage; mais, si tu les lis avec attention, tu y trouveras, suivant le précepte d'Horace, l'utile mêlé avec l'agréable." Le Sage, *Gil Blas de Santillane*, Paris, n.d., pp. 1–2. Proust (p. 48) tells us that Manet was impressed by the illustrations of Gigoux for the 1835 edition of Lesage's work. The "Avis au lecteur," however, is not accompanied by a picture in that edition.

The *Etudiants de Salamanque* provides further evidence of Manet's interest in things Hispanic, but more important is the fact that this painting clearly informs us of Manet's adoption of Lesage's admonition to his public; in pictorial rather than literary terms (yet by allusion to a literary work known to every French schoolboy), it invites the viewer to penetrate beyond the immediate pleasure afforded by the work of art to discover its moral or philosophical point.

In 1867, when Manet was making arrangements for the extensive showing of his work in a private pavilion, Zola proposed selling his little book, so flattering to the painter, on the premises. Manet tactfully rejected the idea on the grounds that to distribute such an "éloge aussi parfait de moi-même"[3] [perfect tribute to myself] would be in bad taste. Zola's praise was "perfect" in the sense that it was unconditional, but it was certainly erroneous in one of its basic tenets:

> But I think I can assert that the latter [Manet] never made the mistake of so many others of wishing to put ideas in his painting. The short analysis I have just given of his talent shows with what naïveté he looks at nature; he is only guided in his choice of objects and figures by the desire to obtain beautiful colors, beautiful contrasts.[4]

Not only is this statement misleading, but its inaccuracy is revealed specifically and clearly by the *Etudiants de Salamanque*, which was to be included in the exhibition. Thus, although Manet explained his unwillingness to associate Zola's text with his art on the basis of discretion, we must realize that he was aware of the fact that Zola was denying a basic principle of that art and that distribution of the book would have been a hindrance to the public's understanding of his work.

Among Manet's early works there are a few that may be regarded as emblematic and therefore merit careful attention in this inquiry. One of them is a print that was designed to serve as a frontispiece for a collection of etchings published by Cadart in 1862 (fig. 102). This composition (which was ultimately rejected as a cover design) has already been carefully studied by Theodore Reff,[5] who sees in it a number of concealed references of a highly personal nature, including Manet's paternity of Léon Leenhoff and his imminent marriage to Léon's mother, Suzanne.[6] Intriguing as Reff's decoding of this picture is, we have seen repeatedly that Manet's references to literature and to other works of art were meant to be understood by a thoughtful public and to lead such a public to uncover the moral meaning of his art. Such personal matters as the ones Reff sees expressed by the frontispiece etching could have interested no one but Manet himself. For an

3. Jamot-Wildenstein-Bataille, *Manet*, vol. 1, p. 82.
4. "Mais je crois pouvoir affirmer que ce dernier [Manet] n'a jamais fait la sottise, commise par tant d'autres, de vouloir mettre des idées dans sa peinture. La courte analyse que je viens de donner de son talent prouve avec quelle naïveté il se place devant la nature; s'il assemble plusieurs objets ou plusieurs figures, il est seulement guidé dans son choix par le désir d'obtenir de belles taches, de belles oppositions." (Zola, *O.C., Oeuvres Critiques*, p. 258.)
5. Reff, "Symbolism of Manet's Frontispiece Etchings," pp. 182–86.
6. Ibid., p. 186.

102. Frontispiece for an edition of etchings, 1862,
New York Public Library, Astor, Lenox,
and Tilden Foundations.

adequate explanation of this picture, it would be best to remain consistent and
assume that its meaning was intended to have universal validity and, further, that
as a frontispiece it probably was designed to illuminate the nature of the etchings
in the suite.

The background of the design consists of a theater curtain and a portion of the
platform before it. Also before the curtain—or, rather, superimposed on it as an
independent yet related set of images—are four distinct motifs of an emblematic
character. Reff calls attention to the ambiguous way in which the curtain
mysteriously becomes a wall strong enough to support the heavy sword on the left.[7]

7. Ibid., p. 182.

103. Edmond Morin, Frontispiece for
Aventures d'un petit Parisien,
by Alfred de Bréhat.

Actually, the sword is not suspended from anything and is given meaning only through the two-dimensional contacts it makes with the other motifs of the design. After all, the part in the curtain through which Polichinelle (or Pulcinella, to give him his Italian name, since Reff has shown that it is the Italian type that is represented here) peers does not correspond to the actual part in the background curtain, which is further to the right. Nor is the balloon print attached to the wall-curtain; it is suspended from a stick, itself only sketchily indicated. These three motifs, then—the sword, the Pulcinella, and the balloon print—are images quite free from a naturalistic or spatially consistent connection with the curtain, which serves as a general background and as a fifth emblem in the overall program. Only the basket with the Spanish clothing and guitar forms a spatially integral part of the curtain and platform design. Reff has recognized that the inscription at the center of the design is to be understood as being on the title page itself and not affixed to the curtain-wall backdrop,[8] without assuming a similar independent existence for the four motifs surrounding it. (Such an intentionally ambiguous presentation of a frontispiece text is common, and can be observed in the similar

8. Ibid.

104. Karel Dujardin, *Les Charlatans italiens*, seventeenth century (Louvre), as reproduced in Charles Blanc's *L'Histoire des peintres*.

example shown in fig. 103.) Consequently, he concludes that Manet began work on the etching without a clear idea of the final image, changing his conception from that of a studio to that of a stage and back again as he added elements to the page.[9] Reff's findings as to the order in which the motifs were introduced may be correct, but it seems more than likely that Manet knew from the outset what the message of the frontispiece was going to be and how he was going to express it.

Support for this view lies in the fact that all the elements in Manet's etching are to be found in a single seventeenth-century painting by the Dutch artist Karel Dujardin, entitled *Les Charlatans italiens* (fig. 104). This work already belonged to the Louvre collection in Manet's time and had enjoyed considerable popularity. Théophile Gautier has described it as a reflection of the essential character of its creator:

> If you want to see the true Karel Dujardin, look at his *Charlatans Italiens*, look at this Polichinelle who pokes his head through the canvas of the booth, and at this Scaramouche, parading and contorting his body on boards

9. Ibid., p. 184.

supported by barrels, while Harlequin at the bottom of the stage tickles the belly of a guitar to make it laugh.[10]

Of course, of the characters of the commedia mentioned by Gautier, only the Polichinelle appears in Manet's etching, and, whereas his facial type recalls the world of Jacques Callot, the position of the head and the angle at which it projects through the curtain are elements borrowed from Dujardin. Furthermore, *Les Charlatans italiens* contains, as I have mentioned, the other details of Manet's picture. There are the stage and curtain; the guitar (which in the source is in Harlequin's hands and in Manet's frontispiece is placed in the basket, but is at the bottom of both compositions); the sword (carried by Scaramouche); and, finally, the picture suspended from a vertical pole before the curtain. Furthermore, beneath this picture in Dujardin's design is a scrap of paper with some writing on it, in the same relative position to the picture as Manet's inscription is to the balloon print above it. In fact, all the details that Manet borrowed are found in a similar arrangement in Dujardin's painting. The suspended print is at the top, and the upward gesture of the arm of the figure depicted (and he, too, seems to be a Polichinelle, close in pose to Manet's famous lithograph of that character made in 1874) is replaced by a rising balloon; the sword is at the left, its tip just touching the print (Manet has retained the principle but has turned the sword right way round so that it is the knuckle-bow that touches the print at the same lower left corner); Polichinelle, peering through the curtain, is at the right, and the lettering is at the center. Manet certainly knew the painting in the Louvre but may have worked from an engraving of it that was published in Charles Blanc's *Histoire des peintres de toutes les écoles*,[11] a work that served as a storehouse of visual information for the artist.[12]

We should not be surprised that Manet turned to this little painting by Dujardin as his source for the frontispiece, because it has the same bohemian character as Le Nain's *Village Piper*, which Manet used as the basis for his *Vieux Musicien*, another work of 1862. As we have seen, *Le Vieux Musicien* also contains a character from the commedia, the Pierrot, and his presence among a carefully selected cast of characters established the ambiguous landscape setting as a stage of life, a forum for the enactment of the human comedy. Our actor is present again in the frontispiece etching, and the stage is present in more conventional form. As to the moral meaning of the monumental painting, it would be surprising indeed if we did not find some expression of it in this related etching of the same year, which is, in addition, an image designed to introduce a group of works and their creator to the public.

10. "Si vous voulez voir le vrai Karel Dujardin, regardez ces *Charlatans italiens*, ce Polichinelle, qui passe la tête à travers les toiles de la baraque, et ce Scaramouche faisant la parade et se démanchant en poses grotesques sur des tréteaux que supportent des barriques, pendant qu'Arlequin au bas de l'estrade chatouille le ventre d'une guitare pour la faire rire." (Théophile Gautier, *Guide de l'amateur au Musée du Louvre* [Paris, n.d.], p. 153.)

11. Charles Blanc, *L'Histoire des peintres: L'Ecole hollandaise*, vol. 2 (Paris, 1861).

12. Reff, "Manet and Blanc's 'Histoire,'" pp. 456–58.

We have noted Manet's belief in the importance of the device of the preface in his choosing to paint *Les Etudiants de Salamanque*. The frontispiece etching, itself a prologue-preface, calls to mind for a number of reasons still another literary preface, the one written by Aloysius Bertrand for his collection of evocative vignettes, *Gaspard de la Nuit*, of which the subtitle is *Fantaisies à la manière de Rembrandt et de Callot*. Bertrand's first words immediately evoke the dualism we have found in Manet's art:

> Art always has two antithetical faces, a medal one side of which expresses a resemblance to Paul [*sic*] Rembrandt and the reverse side to Jacques Callot.—Rembrandt is the philosopher. . . who consumes himself trying to penetrate the mysterious symbols of nature. —Callot, on the contrary, is the military braggart and roisterer who parades in the square, who is noisy in the tavern, who caresses the gypsy girls, who swears only by his rapier and his blunderbuss, and has no other worry but to wax his moustache. The author of this book has viewed art from this double angle.[13]

Reff has observed that the balloon print in Manet's etching seems to contain both a view of Paris at the right and one of Holland at the left.[14] He concludes that the balloon represents Manet's own thoughts (and Manet is symbolized by the actor) as they fly from Paris to Holland in anticipation of his marriage to Suzanne Leenhoff, whom he was free to marry now that his father, who had opposed the marriage, was dead. In addition to the unsuitability of such a theme for this preface-prologue, let us observe that the balloon is clearly going in the other direction. However, we are probably better off not to attach much importance to the possibility of any lateral motion but to assume the obvious: the balloon rises. The division of the scene above which it rises into French and Dutch landscape halves suggests the duality of Callot and Rembrandt, chosen as symbols for the material and spiritual sides of art by Bertrand. Reff has noted the relationship between the actor and the sword by means of a physiognomic quality in the sword and the similarities of the shadows cast by each motif on the background curtain.[15] There can hardly be any doubt that the relationship between them is knowingly suggested. Assuming that Manet's theme is more philosophic and meaningful to the viewer than Reff allows, and having discovered the essential nature of this theme as a continuing one from work to work, the relationship of the etching to Bertrand's

13. "L'art a toujours deux faces antithétiques, médaille dont, par exemple, un côté accuserait la ressemblance de Paul [*sic*] Rembrandt et le revers celle de Jacques Callot.—Rembrandt est le philosophe . . . qui se consume à pénétrer les mystérieux symboles de la nature.—Callot, au contraire, est le lansquenet fanfaron et grivois qui se pavane sur la place, qui fait du bruit dans la taverne, qui caresse les filles des Bohémiens, qui ne jure que par sa rapière et par son escopette, et qui n'a d'autre inquiétude que de cirer sa moustache.—Or, l'auteur de ce livre a envisagé l'art sous cette double personnification." (Aloysius Bertrand, *Gaspard de la nuit* [Paris, 1953], p. 45. The book was originally published, posthumously, in 1842.)

14. Reff, "Symbolism of Manet's Frontispiece Etchings," p. 185.

15. Ibid., p. 184.

105. Rembrandt, *Jan Six*, etching, 1647, as reproduced in Blanc's *L'Histoire des peintres.*

preface to *Gaspard de la Nuit* in function and concept is clear. Bertrand announces to the reader that there are two sides to art, the spiritual and the material, and that these are symbolized by the work of Rembrandt and Callot respectively. He admits, however, that he does not intend to restrict himself to scenes based only upon the pictures of these two masters and (like Manet) draws inspiration from a variety of sources. The basis of the book, nevertheless, is the essential duality of life as expressed in painting; and the first two sections are entitled "Ecole flamande" (including scenes of Haarlem and Leyden) and "Le Vieux Paris," the divisions we find in the balloon print in Manet's frontispiece. Furthermore, the actor—a Callot type, as Reff has recognized—is intimately associated with the French side of that print. Not only is he placed at the right side of the picture, but also the shadow of his mustache cuts across the lower right corner of the balloon print as if pointing to the little scene of Paris. The same is true of the sword on the left: its knuckle-bow just touches the lower left corner of the balloon print, the side that evokes Holland.

The philosophical character of the sword, its association with the theme of immortality, has been noted in our analysis of *The Portrait of Emile Zola*. A direct connection with Rembrandt may have been suggested to Manet by an engraving of a portrait of Jan Six reading before a window (fig. 105), included in Blanc's *Ecole hollandaise*, the same book that provided him with an illustration of Dujardin's *Charlatans italiens*. In this picture (of which Blanc wrote, "All the

106. Robert Fleury, *Benvenuto Cellini dans son atelier*, 1841, present location unknown. Illustration taken from *L'Artiste*, vol. VII, 1841.

sightseers, all the artists, all the friends of art know the portrait of burgomaster Six. . . .") we see a sword, similar to Manet's, apparently suspended from a curtain, while the room contains a dais reminiscent of the platform in Dujardin's painting and a picture on the wall in the background. A sword similar in type and angle of suspension as it hangs from a wall may be seen in a painting by Robert Fleury entitled *Benvenuto Cellini dans son atelier* (fig. 106). Here the weapon is identified not only with the artist's studio but specifically with the artist's isolation and inwardness, and in this context it acquires an awesome character.

If Polichinelle and the sword, then, are antithetical but interrelated symbols similar to those of the preface of *Gaspard de la Nuit*, then the other two emblematic motifs should be related in similar fashion, for, as we know, Manet habitually exploited the possibilities inherent in the inversions of left and right, above and below. The balloon, which rises into the heavens, is quite naturally found at the top of the four-part design. Even without any particular knowledge of the popular associations with the balloon held during the 1860s, it is easy to interpret this object, apparently weightless and free from the normal earthbound restraints, as a symbol of the spirit and to assume that Manet used it here in much the same context as he would use the bird in the *Déjeuner sur l'herbe* the following year. It is instructive, however, to take into account the impact that the possibility of balloon travel had,

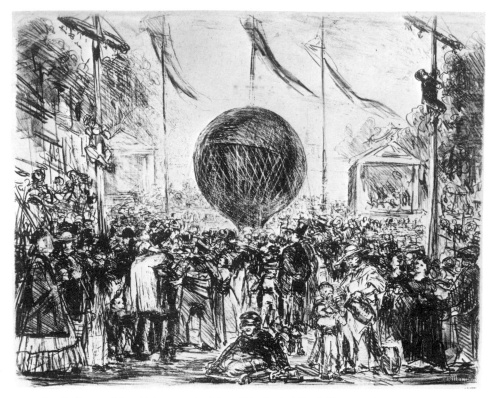

107. *Le Ballon*, 1862, lithograph, New York Public Library, Astor, Lenox, and Tilden Foundations.

not only on the larger public but on highly imaginative spirits who expressed their vision of the future in poetic terms. Victor Hugo, to mention only the outstanding name of the period, was moved to write a long poem entitled *Plein Ciel*,[16] in which he went so far as to envision the balloon as the saviour of mankind. Baudelaire had found such boundless faith in technological progress to be naïve in the extreme, and in a letter of 18 February 1860 speaks of Hugo's "superstitions comiques," including his belief in "le salut du genre humain par les ballons" [the salvation of mankind through balloons].[17]

For Baudelaire there could be no salvation, in the spiritual sense, through this kind of progress. However, concise emblems of modern technology around which new myths were growing up, such as the balloon, could provide Manet with a set of symbols that were entirely contemporary and could allow him to make references to timeless questions that, upon due reflection, would be understood by his public.

16. Victor Hugo, "Plein Ciel," *La Légende des siècles* (Paris, 1927), vol. 4, pp. 225–40.
17. Baudelaire, *O.C.*, p. 1732.

Manet gives us the proof of this in a lithograph, *Le Ballon*, also done in 1862 (fig. 107). This image of spectators at a balloon ascent, ostensibly a vivid scene of modern life, contains another level of meaning that has completely escaped detection. The verve with which the lithograph was executed and the feeling of spontaneity that it conveys obscure the fact that the picture is composed carefully and with greater symmetry than was usual for Manet. In fact, Barbey d'Aurevilly's observation about Baudelaire's *Les Fleurs du Mal* seems particularly appropriate to Manet's print:

> Artists who see the lines beneath the richness and splendor of color will discern very well that there is a secret architecture, a plan constructed by the meditative and thoughtful poet.[18]

Surrounding the central balloon are masses of people and five posts designed to support pennants or streamers. Three of these, the central ones, do fly banners and form a kind of niche or immediate frame for the balloon, accentuating its size and centrality. The other two are placed one each at the left and right edges of the print; they are different in character from the central three in that they support a ring at the top, somewhat in the manner of a Maypole. These rings, however, are bare and are drawn to appear like crossbars. On each of the two flanking posts is a figure who apparently has climbed up for a better view of the spectacle. Directly below the balloon, kneeling on the ground, is a crippled beggar who looks at us. No element in the composition is alien to the subject, yet by careful arrangement of the animate and inanimate objects, Manet has managed to present, within the theme of a balloon ascent in a familiar setting, a Crucifixion: the great central balloon rising between the side crosses (which also recall the torture wheels found in the paintings and prints of Peter Brueghel), directly above the image of human misery in the form of the crippled beggar below. The balloon is also flanked by a pair of puppet theaters in which the human comedy is naïvely and effectively retold day after day to the same public.

The association of a balloon ascent with religious meaning may have been further suggested to Manet by an illustration in the *Illustrated London News* of 28 June 1856, which depicts the celebration of the baptism of the French Prince Impériale (fig. 108). To mark the event, a great balloon was sent up from the esplanade of the Invalides, and bags of sweets were dropped to the people below. The picture shows the rising balloon, with crowds at the right and left, and the scramble for the gift from on high at the center. We also see two theaters, left and right (although they are not puppet theaters), and the flagpoles with figures clinging to them. In this case, the eternal life gained by the baptized infant results in a token benefit for mankind.

That Manet should have treated the subject of the Crucifixion is in itself not surprising. Not only had he already painted several images of Christ, but a short

18. "Les artistes qui voient les lignes sous le luxe et l'efflorescence de la couleur perceveront très bien qu'il y a une *architecture secrète*, un plan calculé par le poète, méditatif et volontaire." (Quoted in Enid Starkie, *Baudelaire* [Norfolk, Conn., 1958], p. 569.)

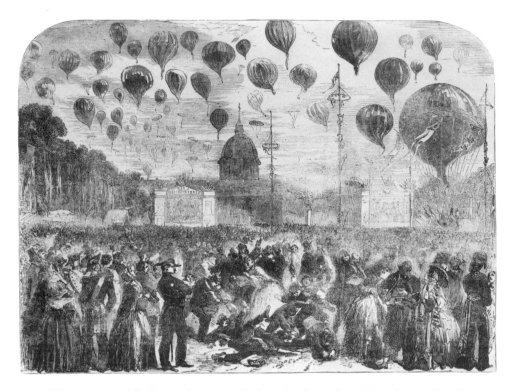

108. *The Ascent of Balloons from the Esplanade of the Invalides*, from *The Illustrated London News*, 28 June 1856.

while later (in 1864 and 1865) he submitted two monumental scenes from the Gospels to the Salon. Furthermore, Proust recalls Manet's specific reference to the subject in question:

> There is something I always had the ambition to do. I would like to paint a Christ on the cross. Christ on the cross, what a symbol! One can search until the end of time, we will not find anything like it. Minerva is good. Venus is good. But the heroic image, the amorous image will never equal the image of suffering. It is the core of humanity, it is its poem.[19]

Manet never fulfilled this ambition, but here, in the balloon print, he makes a reference to it, and in this strikingly original conception of the "salvation of mankind" Manet succeeded in "extracting the eternal from the transitory" of modern life.

19. "Il est une chose que j'ai toujours eu l'ambition de faire. Je voudrais peindre un Christ en croix. Le Christ en croix, quel symbole! On pourra se fouiller jusqu'à la fin des siècles, on ne trouvera rien de semblable. La Minerve, c'est bien, la Vénus, c'est bien. Mais l'image héroïque, l'image amoureuse ne vaudront jamais l'image de la douleur. Elle est le fond de l'humanité, elle en est le poème." (Proust, p. 123.)

109. Chapter heading illustration from Charles Blanc's *Histoire des peintres*.

In the frontispiece etching, the balloon at the top of the page rises between the symbols of the sensual and the spiritual life, suggesting their interdependence in the process.

At the bottom of the page, we have the basket containing the clothing and the guitar. In the context of the foregoing analysis, this last emblem, placed on the ground, can only signify the opposite of the balloon, the earthbound, mortal life, with the objects in the basket alluding to its vanities.[20] The allegory of vanity alone, even in the nineteenth century, was commonly associated with the arts. The chapter headings in Blanc's *Histoire des peintres* were accompanied, as a rule, by a portrait of the artist in question. When such a picture was unavailable, a little vignette was substituted, and this frequently represented some reminder of the passing of earthly things: mirrors, Father Time, an hourglass, a putto with pipe

20. The guitar is a prominent object in *La Chanteuse des rues* (Boston, Museum of Fine Arts), also painted in 1862. This figure, emerging from a tavern that we see in the background and self-consciously carrying some cherries to her lips, has been described as a "geisha" by Sandblad (p. 20). That the image may be an expression of the sensual life is further suggested by its contrast to *L'Enfant à l'épée* of the same year (New York, Metropolitan Museum) in which the boy, shown against a neutral ground, carries a sword with great solemnity. The poses of the two figures and the way in which they carry their respective attributes are related. Their starkness, particularly when viewed as a pair, renders them emblematic. Cherries, furthermore, are very much in evidence as a part of the still-life associated with the nude in the *Déjeuner sur l'herbe*—which, like *La Chanteuse des rues*, was posed by Victorine Meurend.

110. Frontispiece from the *Gazette des Beaux-Arts.*

and glass, etc. Often the same vignette was used for several artists (fig. 109).[21] In Manet's conception, heaven and earth, the eternal and the ephemeral of the upper and lower emblems are linked by the two sides of man's nature designated by the lateral images. A similar, if less subtle, configuration can be seen in the frontispiece of the *Gazette des Beaux-Arts* (fig. 110), in use since the first issue of 1859: the artistic objects at left and at right are asociated with the artist's *métier* and unite the emblems of Christian art (Leonardo da Vinci's portrait beneath a celestial light) above and pagan art (a segment of the Parthenon frieze) below.

To conclude the discussion of this frontispiece, we must take into consideration still another preface. In 1862, the year with which we are here concerned, Baudelaire published a number of his prose poems from *Le Spleen de Paris*, together with his dedication (which serves also as preface) to Arsène Houssaye. This dedication contains the following significant passage:

> I have a little confession to make to you. As I was leafing, for at least the twentieth time, through the famous *Gaspard de la Nuit*, of Aloysius Bertrand (a book known by you, by me, by some of our friends, doesn't it have the right to be called famous?) the idea came to me to attempt something similar and to apply to the description of modern life, or rather of a more modern and more abstract life, the method he applied to the description of ancient life, so strangely picturesque.[22]

Not only may we safely assume that one of Baudelaire's friends familiar with *Gaspard de la Nuit* was Manet (who, as we have seen, figures in the *Spleen de Paris* in a telling fashion) but, given the coincidence of the year and the idea of the use of the preface as a veiled indication of what follows, we have substantial grounds for assigning to Bertrand's book a major role in the conception of Manet's etching.

In his dedication to Houssaye, Baudelaire insists upon the unity of his collection of prose poems. Enid Starkie reminds us that he had done the same for *Les Fleurs du Mal*, and that this plan "is based on his belief in the dual nature of man."[23] If the nature of the content were not clear enough, Baudelaire's reference to Bertrand's *Gaspard de la Nuit* leaves no doubt that *Le Spleen de Paris*, which reiterates so many of the ideas of *Les Fleurs du Mal*, is based upon the same article of faith.

Reff has observed that the face of the actor in Manet's frontispiece has been made more human and expressive than is usually the case with a Pulcinella.[24] There is

21. See, in particular, Blanc's chapters on Andreas Both, Esaias van de Velde, Jan Ducq, and Hendrik Goltzius in the *Ecole hollandaise* (1861).

22. "J'ai une petite confession à vous faire. C'est en feuilletant, pour la vingtième fois au moins, le fameux *Gaspard de la Nuit*, d'Aloysius Bertrand (un livre connu de vous, de moi et de quelques-uns de nos amis, n'a-t-il pas tous les droits à être appelé fameux?) que l'idée m'est venue de tenter quelque chose d'analogue, et d'appliquer à la description de la vie moderne, ou plutôt d'*une* vie moderne et plus abstraite, le procédé qu'il avait appliqué à la peinture de la vie ancienne, si étrangement pittoresque." (Baudelaire, *O.C.*, p. 229.)

23. Enid Starkie, *Baudelaire* (appendix 3), pp. 569–74.

24. Reff, "Symbolism of Manet's Frontispiece Etchings," p. 184.

no doubt that something of each side of both antithetical pairs is suggested in its opposite. If the actor has a philosophical as well as a superficial quality, the sword, an awesome symbol, is often associated with the vanities as well as with Callot's strutting characters, as Bertrand states in his preface. It is really a matter of weighting each emblem with a predominance of one of two opposing characteristics. The balloon, too, bears a formal resemblance to the sombrero or hat below and, ultimately, all four motifs are linked by Manet's careful juxtapositions. This expresses the idea of a unit made up of opposing forces and also finds expression in Baudelaire's dedication to Houssaye:

> My dear friend, I am sending you a small work about which we could not say without unfairness that it has neither head nor tail, since everything in it, on the contrary, is at the same time head and tail, alternatively and reciprocally.[25]

And we find, once again, an expression of the reversibility of man's double nature that we identify with the poetry and prose of Baudelaire and the concise formulation attributed to Poseidonios, the philosopher of *Le Vieux Musicien.*

The notion of reversibility, as observed in chapter 1, is also inherent in the ancient Chinese formulation of the Yang-Yin, the division of all things into opposing principles, expressed most commonly as male-female, positive-negative, hard-soft, active-passive, black-white. If Manet was at all interested in Far Eastern philosophy, then the Taoist concept of the Yang-Yin polarity, in view of the recurrent theme of his art, could hardly have escaped his notice. Just as the Ukiyo-e prints, from which he learned a number of lessons, represent the "floating" or everyday world, so Manet must have sought a suitable expression for Baudelaire's "other half" of art, "the timeless, the immutable." The Yang-Yin principle and its symbolic expression were not only known to Manet's circle but were viewed by its members as common in Chinese and Japanese art. Edmond de Goncourt, in describing the lid of a small Japanese vase in his collection, tells an anecdote, allegedly of Far Eastern origin, that gives in naïve form the story of the original meeting of the two principles:

> The open-work lid is surmounted by a cube on which is represented the union of the *Ing*, the male principle and of the *Yang*, the female principle. [Obviously de Goncourt has them backward]
>
> This meeting of the male and female principle, which often decorates ancient objects, in the form of a tadpole in a circle, is also often found in a naïve legend of the Far East: the male essence walked on the left side, and the female essence followed on the right side. They met at the column of the Empire, and having recognized each other, the female spirit sang these words: "I am delighted to meet such a handsome young man." The male

25. "Mon cher ami, je vous envoie un petit ouvrage dont on ne pourrait pas dire, sans injustice, qu'il n'a ni queue ni tête, puisque tout, au contraire, y est à la fois, tête et queue, alternativement et réciproquement." (Baudelaire, *O.C.*, p. 229.)

answered in an angry tone: "I am a man. Thus it is right that I speak first: How dare you begin, you, a woman?" They separated and went on their way. Meeting again where they had separated, the male spirit intoned first these words: "I am happy to find a young and pretty woman."[26]

Finally, after more of this kind of tentative byplay, the mating occurs. What is striking about this tale, at least in the way de Goncourt tells it, is its strong suggestion of the mating of cats. In fact, it recalls specifically Champfleury's description of such an event in his highly successful book, *Les Chats*, published in 1869 with an illustration by Manet:

> The male and the female cat first stay at a certain distance from each other. They watch each other's least gesture and exchange green-eyed glances. . . .
>
> Both slowly crawl low on the ground and approach one another: but as soon as the tomcat approaches the female, she takes convoluted flight. . . . They stop again, look ardently at each other until the female springs on the male.[27]

In addition to his illustration, Manet designed a poster for Champfleury's book (fig. 111) that illustrates the chapter from which I have quoted, "L'Amour des chats." In the fourth edition of the book (1870), Manet's original illustration was omitted, and the image of the poster replaced it. Manet's picture is, if anything, closer to de Goncourt's description of the Yang-Yin principles than to Champfleury's mating cats. The black and white animals, each on its own side, cautiously stalk each other and, producing a circular movement, emerge as an extraordinary vivification of the ancient oriental emblem (fig. 112). In this context, the great chimney pot at the center, placed before a bright area, assumes a new importance. The head of the black cat and the tail of the white one cross over this central divider, so that the latter is directly above the former. Is this the "colonne de l'Empire" mentioned in the legend—the symbol of an original unity? ("How did the single

26. "Le couvercle à jour est surmonté d'un dé, ou est figurée la conjonction de l'*Ing* [*sic*], le principe mâle, et du *Yang*, le principe femelle.

Cette rencontre du principe mâle et femelle, qui ornemente si souvent les objets anciens, sous la forme d'une tétard dans un cercle, est aussi rencontrée dans une légende naïve de l'extrême orient: le génie mâle marcha du côté gauche, et le génie femelle suivit le côté droite. Ils se rencontrèrent à la colonne de l'Empire, et, s'étant reconnus, l'esprit femelle chanta ces mots: 'Je suis ravi de rencontrer un si beau jeune homme.' Le génie mâle répondit d'un ton fâché: 'Je suis un homme. Ainsi il est juste que je parle le premier: comment toi, qui es une femme, oses-tu commencer?' Ils se separèrent et continuèrent leur chemin. Se rencontrant de nouveau au point d'ou ils étaient partis, le génie mâle chanta le premier ces paroles: 'Je suis fort heureux de trouver une jeune et jolie femme.'" (Edmond de Goncourt, *La Maison d'un artiste*, 2d ed. [Paris, 1882], vol. 2, p. 261.)

27. "Chat et chatte restent d'abord à une certaine distance l'un de l'autre. Ils épient leur moindres gestes et se regardent dans le vert des yeux. . . .

"Tous deux lentement rampent contre terre et se rapprochent l'un de l'autre; mais à peine le matou est-il près de la chatte, que celle-ci prend la fuite avec des tours et détours. . . . Ils s'arrêtent de nouveau, entre-croisent d'ardentes prunelles, jusqu'à ce que la chatte s'élance sur le mâle. . . ." (Champfleury, *Les Chats*, 4th ed. [Paris, 1870], p. 261.)

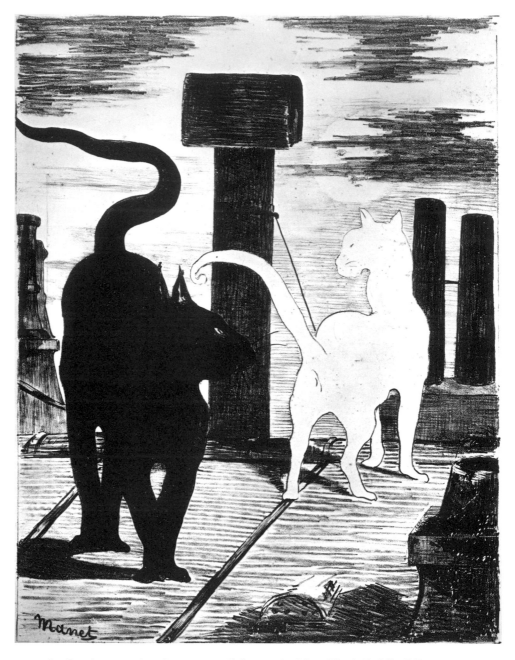

111. *Le Rendezvous des chats*, 1868, lithograph, New York Public Library, Astor, Lenox, and Tilden Foundations.

112. The Yang-Yin emblem. 113. Hermetic emblem, from Eliphas Lévi,
Dogme de la haute magie, 1855.

Father give rise to duality?" asked Baudelaire.) European mystic writers, claiming
the Emerald Table of Hermes Trismegistus as a basic source for their viewpoints,
commonly give the six-pointed star as the emblem of the correspondence of macro-
cosm and microcosm (see fig. 113). "Human unity is completed by the right and
by the left. Primitive man is androgynous," wrote Eliphas Lévi,[28] and the points of
antithesis are indicated diagonally across the emblem. At the center is the Tau
cross, representing the fundamental unity: "to separate through the poles, to unite
through the center."[29] Manet's common chimney pot resembles both a Japanese
architectural post and bracket and the androgynous Tau cross of the occult tradi-
tion. Furthermore, we find in Manet's image not only the strong antithesis of black
and white, male and female, but the interchangeability that the Yang-Yin emblem

28. Lévi, *Dogme et rituel*, p. 66. This widely read author makes much of the binary as an
expression of the eternal antagonism within an essential unity. He writes: "L'unité ne peut
se manifester que par le binaire (p. 66).... L'analogie des contraires c'est le rapport de la
lumière à l'ombre, de la saillie au creux, de plein au vide.... L'analogie est la clef de tous les
secrets de la nature et la seule raison d'être de toutes les révélations (p. 176)." [Unity can only
be demonstrated by the binary.... The analogy of opposites is the relationship of light to
dark, the convex to the concave, the full to the empty.... Analogy is the key to all the secrets
of nature and the only justification of all revelations.] He even speaks of the Yang-Yin polarity
in this connection, relating the two columns of the cabalistic Temple of Solomon, "Bohas"
and "Jakin": "Ces deux colonnes expliquent en cabale tous les mystères de l'antagonisme,
soit naturel, soit politique, soit religieux, et ils expliquent la lutte génératrice de l'homme et
de la femme" (p. 65). [These two columns of the Cabala explain all the mysteries of opposition,
be it natural, political, or religious, and they explain the generic struggle between man and
woman.] (For Baudelaire's involvement with Hermes Trismegistus, see Paul Arnold, *Das
Geheimnis Baudelaires* [Berlin, 1958].)
29. "... séparer par les poles, unir par le centre." (Ibid., p. 175.)

contains. It is the tail of the *white* cat and the head of the *black* one that are brought together, with the curl in the tail strongly stressed. It is at this point of immediate juxtaposition that the emblem of the Yang-Yin is actually contained, with the loop of the tail and the eye forming the antithetical points in each half of the divided circle. Of all the works in which Manet has concealed a philosophical point, this one is perhaps the most arcane and also the most obvious.

As Manet makes clear in his reference to the moral contained in the preface of *Gil Blas*, there are two levels of expression in his art. The one gives immediate pleasure, the other, once discovered, provides a more lasting benefit. Obviously, he did not expect the public-at-large to respond in the manner of the more thoughtful student of the parable. "Men able to appreciate original painting, exceptional painting when it appears, are not much more numerous than those who can produce it," said Manet to Théodore Duret.[30] This is true, of course, of the purely aesthetic level also, but Manet was surely referring to the total conception of his art. If he did not even obtain the small but understanding following he had hoped for, and if he could complain now and then about the pain of being constantly misunderstood, he nevertheless either refused to tell his biographers about the philosophic aspects of his painting or asked them not to divulge them. This is perfectly understandable. In the first place, such discursive explanations by an artist of a content that is intimately related to the structural aspects of his work would have been an admission of failure and would not, in all probability, have been correctly understood anyway. It was essential for the pictures to reveal themselves in the imaginative richness, subtlety, and logic of their creation. In the introduction to one of his puppet plays, Duranty mused upon the futility of explanations:

> Since a man must almost always expect to see his intentions misunderstood, it is preferable not to reveal one's intentions at all.[31]

Beyond this consideration, there is the matter of the nature of the concealed themes themselves. Metaphysical in character, meaningless or even ridiculous to a materialist society, they were meant ot be revealed only to those who were predisposed to understand them. Baudelaire complained in a letter that whenever he tried to talk about such things as his notion of universal analogy, he was generally regarded as deranged.[32] He did talk about it, however, and very eloquently, in his critical writings, but with the admonition that in art it is necessary to "express with an *indispensable obscurity* what is revealed in an obscure and ambiguous way."[33] Or, in the language of the mystics whom he read, the truth had to be veiled but not hidden from the public.[34] Manet has left us a picture that, once again, most

30. Théodore Duret, *Courbet* (Paris, 1918), p. 44.
31. "Tout homme devant s'attendre à voir presque toujours ses intentions méconnus, il est préférable de ne point dire ses intentions." (Duranty, *Théâtre de marionnetes*, p. 370.)
32. Baudelaire, *Correspondance générale*, vol. 1, p. 368.
33. ". . . il [V. Hugo] exprime avec *l'obscurité indispensable*, ce qui est obscur et confusément révélé." (Baudelaire *O.C.*, p. 704.)
34. Eliphas Lévi, *Histoire de la magie* (Paris, 1922), p. 84. The book was originally published in 1860.

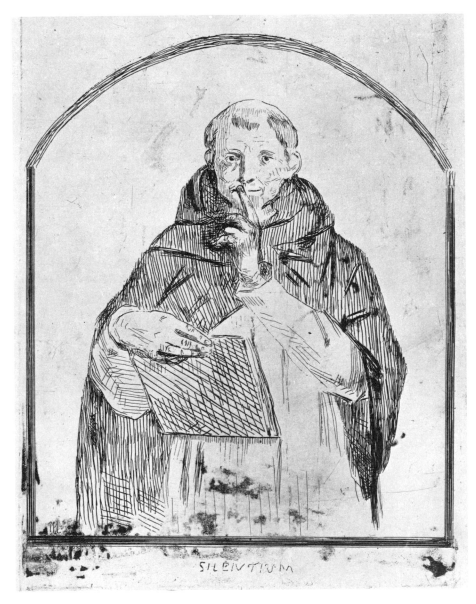

SILENTIVM

114. *Silentium*, ca. 1860, etching, New York Public Library, Astor, Lenox, and Tilden Foundations.

clearly conveys this conviction. It is the early etching of a monk with a finger placed against his sealed and slightly smiling lips, a work approximately contemporary with the *Etudiants de Salamanque*. Beneath this hermetic image is the title, *Silentium* (fig. 114).[35]

Finally, for the most poetically expressed explanation of a silence such as Manet's, let us return to the preface of Aloysius Bertrand's *Gaspard de la Nuit*:

> And if one asks the author why he doesn't print at the beginning of his book some handsome literary theory, he will be forced to answer that M. Séraphin has not explained to him the mechanism of his Chinese shadows, and that Polichinelle hides from the curious crowd the string that activates his arm.[36]

35. This etching is one of Manet's earliest efforts in the medium. It is more than probable that the image is related to a poem by Edgar Allan Poe, "Silence," since the central idea of that poem relates the concept of silence to that of duality:

> There are some qualities—some incorporate things,
> That have a double life, which thus is made
> A type of that twin entity which springs
> From matter and light, evinced in solid and shade.
> There is a two-fold *Silence*—sea and shore—Body and soul. . . .

Manet's *Silentium*, furthermore, was executed at about the same time as his etched portrait of Poe. (See Jean C. Harris, *Edouard Manet, Graphic Works*, New York, 1970, pp. 24–28.)

36. "Et que si on demande à l'auteur pourquoi il ne parangonne point en tête de son livre quelque belle théorie littéraire, il sera forcé de répondre que M. Séraphin ne lui a pas expliqué le mécanisme de ses ombres chinoises, et que Polichinelle cache à la foule curieuse le fil conducteur de son bras." (Aloysius Bertrand, *Gaspard de la Nuit*, p. 46.)

Bibliography

Ackerman, Gerald. "Gérôme and Manet," *Gazette des Beaux-Arts* 70 (1967), 163–76.

Adhémar, Jean. "Notes et documents; Manet et l'estampe," *Nouvelles de l'estampe* 7 (1965), 230–35.

Alazard, Jean. "Manet et Couture," *Gazette des Beaux-Arts* 35 (March 1949), 213–18.

Altmann, Robert. "Die Zitronenschale und das kosmische Theater," *Liechtensteinische Kunstsammlungen* 1 (1971), n. p.

Aristotle. *Natural Science*. Trans. and ed. Philip Wheelwright. New York: Odyssey Press, 1935.

Arnold, Paul. *Das Geheimnis Baudelaires*. Berlin: Henssel, 1958.

Arsenne, L. C., and Denis, Fernand. *Nouveau manuel complet du peintre et du sculpteur*. Paris: Roret, 1858. (In the series *Manuels-Roret*.)

Banville, Théodore de. *Histoire des petits théâtres de Paris*. Paris, 1845.

———. *Odes Funambulesques*. 2d ed. Paris: Michel Levy, 1859.

Bartsch, Adam. *Le Peintre-Graveur*. Vol. 14: *Oeuvres de Marc-Antoine*. Vienna: Degen, 1813.

Bataille, Georges. *Manet*. Trans. A. Wainhouse and J. Emmons. New York: Skira, 1955.

Baudelaire, Charles. *Correspondance Générale*. Ed. J. Crépet. 6 vols. Paris: Louis Conard, 1947.

———. *Oeuvres Complètes*. (Ed. Y-G. LeDantec, revised by Claude Pichois.) Paris: Pléiade, 1961.

Bazin, Germain. "Manet et la tradition," *L'Amour de l'art* 13 (1932), 145–84.

Bazire, Edmond. *Manet*. Paris: A. Quantin, 1884.

Bergström, Ingvar. *Dutch Still Life Painting in the Seventeenth Century*. Trans. Christina Hedström and Gerald Taylor. New York: Yoseloff, 1956.

Berrett, Paul. *Le Moyen-âge dans ' La Légende des siècles' et les Sources de Victor Hugo*. Paris: H. Paulin, 1911.

Bertrand, Aloysius (Louis). *Gaspard de la nuit; Fantaisies à la Manière de Rembrandt et de Callot*. Intro. by Roger Prévost. Paris: Delmas, 1953.

Biez, Jacques de. *Edouard Manet; Conference*. Paris: Baschet, 1884.

Blanc, Charles. *Histoire des peintres de toutes les écoles*. 14 vols. Paris: Jules Renouard, 1861–76.

Blanche, Jacques-Emile. *Manet*. Paris: Rieder et Cie., 1924.

———. *Propos de peintre: de David à Degas*. Paris: Emile-Paul Frères, 1927.

Bodkin, Thomas. "Manet, Dumas, Goya, and Titian" (letter), *Burlington Magazine* 50 (1927), 166–67.

Bowness, Alan. "A Note on Manet's Compositional Difficulties," *Burlington Magazine* 103 (1961), 276–77.

Bürger, Willem. (T. Thoré). "Exposition de tableaux de l'école française, tirés de collections d'amateurs," *Gazette des Beaux-Arts* 7 (1860), 258–77.

––––––. *Trésors d'art en Angleterre.* 3d ed. Paris: Renouard, 1865.

Burty, Philippe. "Les Sabres," *Le Japon Artistique* 1, no. 10 (1888), 119–30, and 1, no. 11 (1888), 135–42.

Busch, Günter. *Edouard Manet—Un Bar aux Folies-Bergères.* Stuttgart, 1956.

Champfleury. (Jules Fleury-Husson). "Catalogue des tableaux des Le Nain qui ont passé dans les ventes publiques de l'année 1755–1853." *Revue universelle des arts* 14 (1861–62).

––––––. *Les Chats.* 4th ed. Paris: Rothschild, 1870.

––––––. *Essai sur la vie et l'oeuvre des Le Nain, peintres Laonnais.* Laon: Fleury, 1850.

––––––. *Grandes Figures d'hier et d'aujourdhui.* Paris: Poulet-Malassis et Broise, 1861.

––––––. *L'Histoire de l'imagerie populaire.* Paris: Dentu, 1869.

––––––. *La Masquérade de la vie parisienne.* Paris: Librairie nouvelle, 1861.

––––––. *Les Peintres de la réalité sous Louis XIII, Les frères Le Nain.* Paris: Veuve Renouard, 1862.

––––––. *Souvenirs des Funambules.* Paris: Michel Levy, 1859.

Chesnais, Jacques. *Histoire des Marionnettes.* Paris: Bordas, 1947.

Chesneau, Ernest. "Le Salon des Refusés," *L'Art et les artistes modernes en France et en Angleterre.* Paris: Didier, 1864.

Colin, Paul. *Manet.* Paris: Floury, 1937.

Constant, Alphonse Louis. (Eliphas Lévi). *Dogme et rituel de la haute magie.* Paris: Editions Niclaus, N. Bussière Successeur, 1967.

––––––. *Histoire de la Magie.* Paris: Alcan, 1922.

Corradini, Giovanni. "'La Nymphe surprise' de Manet et les rayons X," *Gazette des Beaux-Arts* 54 (1959), 149–54.

Courthion, Pierre, and Cailler, Pierre (eds.). *Manet raconté par lui-même et par ses amis.* 2 vols. Geneva: Cailler, 1953.

Couture, Thomas. *Le Paysage. Entretiens d'atelier.* Paris: Guérin (printer), 1869.

––––––. *Thomas Couture (1815–1879) Sa vie, son oeuvre, son caractère, par lui-même et par son petit-fils.* Paris: LeGarrec, 1932.

Duchartre, Pierre-Louis. *La Comédie Italienne.* Paris: Librairie de France, 1924.

Ducuing, M. (ed.). *L'Exposition Universelle de 1867 illustrée.* Paris, 1867.

Duranty, Edmond. *Le Théâtre des marionnettes du Jardin des Tuileries.* Paris: Dubuisson, 1862.

Duret, Théodore. *Histoire d'Edouard Manet et de son oeuvre.* Paris: Floury, 1902.

––––––. *Les Peintres français en 1867.* Paris: Dentu, 1867.

Egan, Patricia. "Poesia and the 'Fête Champêtre,'" *Art Bulletin* 41 (1959), 303–13.

Eigeldinger, Marc. "Baudelaire et l'alchimie verbale," *Etudes Baudelairiennes* (Neuchâtel, 1971). Vol. 2, pp. 81–98.

Esquiros, Alphonse. *Les Fastes populaires ou Histoire des actes héroïques du peuple et de son influence sur les sciences, les arts, l'industrie et l'agriculture.* 4 vols. Paris: Administration des Publications Populaires, 1851.

Faison, S. Lane, Jr. "Manet's Portrait of Zola," *Magazine of Art* 42 (1949), 162–68.

Farwell, Beatrice. "A Manet Masterpiece Reconsidered," *Apollo* 78 (1963), 45–51.

Fehl, Philipp. "The Hidden Genre: A Study of the 'Concert Champêtre' in the Louvre," *Journal of Aesthetics and Art Criticism* 16 (1957), 153–68.

Feller, Gloria C. "A Study of the Sources for Manet's 'Old Musician.'" M.A. thesis, Columbia University, 1966.

Ferguson. George Wells. *Signs and Symbols in Christian Art.* New York: Oxford University Press, 1958.

Florisoone, Michel. *Manet.* Monaco: Documents d'Art, 1947.

––––––. "Manet inspiré par Venise," *L'Amour de l'art* 18 (1937) (whole issue).

Fournel, Victor. *Ce qu'on voit dans les rues de Paris.* Paris: Dentu, 1858.

Fried, Michael. "Manet's Sources: Aspects of his Art, 1859–1865," *Artforum* 7 (1969), 28–82.

Friedmann, Herbert. *The Symbolic Goldfinch*. Washington, D.C: Pantheon, 1946. (Bollingen Series 7.)

Füglister, Robert L. "Baudelaire et le Thème des Bohémiens," *Etudes Baudelairiennes*, (Neuchâtel, 1971). Vol. 2, pp. 99–143.

Gachet, Paul. *Cabaner*. Paris: Les Beaux-Arts (Edition d'études et de documents), 1954.

Gautier, Théophile. *Constantinople*, Paris: Michel Lévy, 1856.

———. *Emaux et camées*. Paris: Garnier frères, 1954.

———. *Guide de l'amateur au Musée du Louvre*. Paris: Charpentier, n.d.

———. *Poésies complètes*. Paris: Charpentier, 1855.

Gervais, André-Ch. *Marionnettes et marionnettistes de France*. Paris: Bordas, 1947.

Goncourt, Edmond de. *La Maison d'un artiste*. 2 vols. Paris: Charpentier, 1881.

Goncourt, Edmond and Jules de. *Manette Solomon*. Paris: Charpentier, 1897.

Guérin, Marcel. *L'Oeuvre gravée de Manet*. Paris: Floury, 1944.

Guitry, Sacha. *Deburau*. Paris: Fasquelle, 1918.

Gurewich, Vladimir. "Observations on the Iconography of the Wound in Christ's Side," *Journal of the Warburg and Courtauld Institutes* 20 (1957), 358–62.

Hamilton, George Heard. "Is Manet Still 'Modern'?," *Art News Annual* 31 (1966), 104–31; 159–63.

———. *Manet and His Critics*. New Haven and London: Yale University Press, 1954.

Hanson, Anne Coffin. *Edouard Manet*. Philadelphia: Museum of Art (catalogue), 1966.

———. "Edouard Manet, 'Les Gitanos,' and the Cut Canvas," *Burlington Magazine* 112 (1970), 158–67.

———. "Notes on Manet Literature," *Art Bulletin* 48 (1966), 432–38.

———. "Popular Imagery and the Work of Edouard Manet," *French Nineteenth Century Painting and Literature*. New York; Harper & Row, 1972, pp. 133–63.

Harris, Jean C. *Edouard Manet, Graphic Works: A Definitive Catalogue Raisonné*. New York: Collectors Editions, 1970.

Haskell, Francis. "The Sad Clown: Some Notes on a 19th Century Myth," *French 19th Century Painting and Literature*. New York: Harper & Row, 1972, pp. 2–16.

Held, Julius. *Rubens: Selected Drawings*. 2 vols. London: Phaidon, 1959.

Hopp, Gisela. *Edouard Manet, Farbe und Bildgestalt*. Berlin: De Gruyter, 1968.

Houssaye, Arsène. *Le Violon de franjolé*. 6th ed. Paris: Hachette, 1859.

Hugo, Victor. *La Légende des siècles*. 4 vols. Paris: Fasquelle, 1927.

Hugounet, Paul. *Mimes et Pierrots*. Paris: Fischbacher, 1889.

Hyslop, Lois Boe, and Hyslop, Francis. "Baudelaire and Manet: A Re-Appraisal," *Baudelaire as a Love Poet and Other Essays*. Ed. Lois Boe Hyslop. University Park: The Pennsylvania State University Press, 1969, pp. 87–130.

Ideville, Comte H. d'. *Gustave Courbet, notes et documents sur sa vie et son oeuvre*. Paris: Paris-Grave, 1878.

Jamot, Paul. "Manet and the Olympia," *Burlington Magazine* 50 (1927), 27–35.

Jamot, Paul, Wildenstein, George, and Bataille, M.-L. *Manet*. 2 vols. Paris: Beaux-Arts, 1932.

Janin, Jules. *Deburau, histoire du théâtre à quatre sous*, Paris: Gosselin, 1832.

Janson, H. W. "The Putto with the Death's Head," *Art Bulletin* 19 (1937), 423–49.

Jantzen, Hans. "Edouard Manet's Bar aux Folies Bergères," *Beiträge für Georg Swarzenski zum 11. Januar 1951*. Berlin: Mann; Chicago: Regnery, 1951, pp. 228–32.

Jayne, Sears Reynolds. "Marsilio Ficino's Commentary on Plato's Symposium," *University of Missouri Studies* 19, no. 1 (1944), pp. 11–247 (entire number).

Jedlicka, Gotthard. *Manet*. Zürich: Eugen Rentsch, 1941.

Klagsbrun, Francine. "*Thomas Couture and the 'Romans of the Decadence.'*" M.A. thesis, New York University, 1958.

Krauss, Rosalind E. "Manet's 'Nymph Surprised,'" *Burlington Magazine* 109 (1967), 622–27.

Kristeller, Paul O. *The Philosophy of Marsilio Ficino*. Trans. Virginia Conant. New York: Columbia, 1943.

Lagrange, Léon. "L'Atelier d'Overbeck," *Gazette des Beaux-Arts* (1859), 321–35.

Laran, Jean, LeBas, Georges, and Hourticq, Louis. *Manet*. Paris: Librarie centrale des Beaux-Arts, n.d. [1911?].

Léger, Charles. *Manet*. Paris: Crès, 1931.

Leiris, Alain de. "Baudelaire's Assessment of Manet," *Hommage à Baudelaire*. College Park: The University of Maryland (exhibition catalogue), 1968.

———. *The Drawings of Edouard Manet*. Berkeley and Los Angeles: University of California Press, 1969.

———. "Manet, Guéroult and Chrysippos," *Art Bulletin* 46 (1964), 401–4.

Lesage, Alain-René. *Gil Blas de Santillane*. Paris: Paulin, 1835.

Lowin, Joseph G. "Dreams of Stone: Disengagement and Binding in the Poetic Novels of Théophile Gautier." Ph.D. dissertation, University of Michigan, 1969.

Luciennes, Victor. "Le Théâtre de Polichinelle aux Tuileries," *L'Artiste* (15 October 1861).

Lugt, Frits. *Musée du Louvre: Inventaire générale des dessins des écoles du Nord*. Paris: Palais du Louvre, 1949. Vol. 2.

Magasin Pittoresque, 1 (1833), pp. 99–102, 379–81; and 2 (1834), pp. 115, 189.

Marx, Roger. "Le rôle et l'influence des arts de l'extrême orient et du Japon," *Le Japon artistique* 3, no. 35 (1891), 141–48.

Mathey, François. *Olympia*. Paris: Ed. du Chêne, 1948.

Mauner, George L. "Manet, Baudelaire and the Recurrent Theme," *Perspectives in Literary Symbolism, Yearbook of Comparative Criticism*. Ed. J. Strelka. University Park: The Pennsylvania State University Press, 1968. Vol. 1, pp. 244–57.

Maur, Karin von. "Französische Kunstler des XIX. Jahrhundert in den Schriften der Brüder Goncourt." Ph.D. dissertation, University of Tübingen, 1966.

Meier-Graefe, Julius. *Edouard Manet*. Munich, 1912.

Melançon, Joseph. *Le Spiritualisme de Baudelaire*. Montreal and Paris: Fides, 1967.

Mesnil, Jacques de. "'Le Déjeuner sur l'herbe' di Manet ed 'Il Concerto Campestre' di Giorgione," *L'Arte* 37 (1934), 250–57.

Michaelis, Adolf T. F. *Der Parthenon*. Leipzig: Breitkopf und Hartel, 1871.

Mistler, Jean, Blandez, François, and Jacquemin, Andre. *Epinal et l'Imagerie Populaire*. Paris: Hachette, 1961.

Moreau-Nélaton, Etienne. *Manet raconté par lui-même*. 2 vols. Paris: Laurens, 1926.

Mortimer, Raymond. *Un Bar aux Folies-Bergères in the National Gallery*. London: Lund Humphries, 1944.

Nochlin, Linda. "Gustave Courbet's *Meeting*: a Portrait of the Artist as a Wandering Jew," *Art Bulletin* 49 (1967), 209–22.

Nodier, Charles. "Polichinelle," *Contes de la Veillée*. Paris, n.d.

Nordström, Folke. *Goya, Saturn and Melancholy*. Uppsala: Almquist and Wiksell, 1962.

Orienti, Sandra. *L'Opera Pittorica di Edouard Manet*. Intro. by Marcello Venturi. Milan: Rizzoli, 1967.

Panofsky, Erwin. *Studies in Iconology*. New York: Harper & Row, 1962.

Pauli, Gustav. "Raffael und Manet," *Monatshefte für Kunstwissenschaft* 1 (1908), 53–55.

Péricaud, Louis. *Le Théâtre des Funambules: ses mimes, ses acteurs et ses pantomimes depuis sa fondation jusqu'à sa démolition*. Paris: Léon Sapin, 1897.

Perruchot, Henri. *La Vie de Manet*. Paris: Hachette, 1959.

Piérard, Louis. *Manet l'incompris*. Paris: Sagittaire, 1946.

Piggott, Juliet. *Japanese Mythology*. London: Hamlyn, 1969.

Pommier, Jean. *La Mystique de Baudelaire*. Paris: Les Belles-Lettres, 1932.

Proust, Antonin. *Edouard Manet, Souvenirs*. Ed. A. Barthélemy. Paris: H. Laurens, 1913.

Reff, Theodore. "Manet and Blanc's 'Histoire des Peintres,'" *Burlington Magazine* 112 (1970), 456–58.

———. "'Manet's Sources': A Critical Evaluation," *Artforum* 8 (1969), 40–48.

———. "The Meaning of Manet's Olympia," *Gazette des Beaux-Arts* 63 (1964), 111–22.

———. "The Pictures within Degas Pictures," *Metropolitan Museum Journal* 1 (1968), 125–66.

———. "The Symbolism of Manet's Frontispiece Etchings," *Burlington Magazine* 104 (1962), 182–87.

Rewald, John. *The History of Impressionism.* Rev. ed. New York: Museum of Modern Art, 1961.

Rey, Robert. *Manet* (Translated by E. B. Shaw). New York: French and European Publications, 1938.

Rich, Daniel Catton. "The Spanish Background for Manet's Early Work," *Parnassus* 4 (1932), 1–5.

Richardson, John. *Edouard Manet.* New York and London: Phaidon, 1958.

Ronchaud, L. de. "Les Statues du Parthenon," *Gazette des Beaux-Arts* 9 (1861), 148–66.

Roscher, Wilhelm Heinrich. *Ausführliches Lexikon der Griechischen und Römische Mythologie.* 6 vols. Leipzig: B. G. Teubner, 1884–1909.

Rosenthal, Léon. *Manet aquafortiste et lithographe.* Paris: Le Goupy, 1925.

Rossetti, William Michael. *Fine Art: Chiefly Contemporary.* London and Cambridge: Macmillan, 1867.

Rousseau, Jean-Jacques. *Les Confessions.* 2 vols. Paris: Flammarion, n.d. [ca. 1909].

Sainte-Croix, Camille de. *Edouard Manet.* (No. 19 of series *Portraits d'hier.*) Paris, 15 December 1909.

Sandblad, Nils Gösta. *Manet: Three Studies in Artistic Conception.* Trans. W. Nash. Lund: C.W.K. Gleerup, 1954.

Schapiro, Meyer. "The Apples of Cézanne," *Art News Annual* 34 (1968), 38.

———. "Courbet and Popular Imagery," *Journal of the Warburg and Courtauld Institutes* 4 (1940–41), 164–91.

———. Review of Joseph C. Sloane, *French Painting Between the Past and the Present; Artists, Critics, and Traditions, Art Bulletin* 36 (1954), 163–65.

Schick, Constance Gosselin. "The World of Théophile Gautier's Travel Accounts." Ph.D. dissertation, The Pennsylvania State University, 1973.

Schick, Rudolf. *Arnold Böcklin, Erinnerungen.* Berlin: Fleischel, 1903.

Schlotterback, Thomas. "Manet's 'L'Execution de Maximilien.'" *Actes du XXII^e Congrès international d'histoire de l'art—1969.* 2 vols. (Budapest, 1972).

Seznec, Jean. "The Romans of the Decadence and their Historical Significance," *Gazette des Beaux-Arts* 24 (1943), 221–32.

Slive, Seymour. "Realism and Symbolism in Seventeenth-Century Dutch Painting," *Daedalus* (Summer 1962) (issued as vol. 91, no. 3, of the *Proceedings of the American Academy of Arts and Sciences*, pp. 469–500).

Sloane, Joseph C. *French Painting Between the Past and the Present: Artists, Critics, and Traditions.* Princeton: Princeton University Press, 1951.

Smidt, Hermann. "Die Buddha des Fernöstlischen Mahayana," *Artibus Asiae* 1 (1925), 6–31.

Southey, Robert. *History of the Peninsular War.* 3 vols.; new ed. London: J. Murray, 1828–37.

Starkie, Enid. *Baudelaire.* Norfolk, Conn.: New Directions, 1958.

Sterling, Charles. "Manet et Rubens," *L'Amour de l'art* 13 (1932), 290.

Tabarant, Adolphe. *Manet: Histoire Catalographique.* Paris: Editions Montaigne. 1931.

———. *Manet et ses oeuvres.* Paris: Gallimard, 1947.

Trapier, Elizabeth Du Gué. *Goya and His Sitters.* New York: Hispanic Society of America, 1964.

Trianon, Henry. "Victor Vibert: la gravure d'après le tableau 'Le Bien et le Mal' de Victor Orsel," *Gazette des Beaux-Arts* 2 (1860), 226–37.

Valéry, Paul. "Le Triomphe de Manet" (Preface to the retrospective exhibition at the Musée de l'Orangerie). Paris: Musées Nationaux, 1932.

Vaudoyer, J.-L. *Edouard Manet.* Paris: Ed. du Dimanche, 1955.

Wind, Edgar. *Pagan Mysteries in the Renaissance.* Rev. ed. New York: Norton, 1968.

Zeller, Edouard. *Die Philosophie der Griechen.* Leipzig: Reisland, 1923. (1st Edition 1844–52.)

Zervos, Christian. "A propos de Manet," *Cahiers d'art*, nos. 8–10 (1932), 309–25.

Zola, Emile. *Les Oeuvres complètes d'Emile Zola: Oeuvres critiques.* Paris: Fasquelle, 1928.

Picture Credits

Index